Digital Printing Start-Up Guide

Digital Printing Start-Up Guide

Author & Series Editor: Harald Johnson
Technical Editor: C. David Tobie

THOMSON

COURSE TECHNOLOGY

Professional ■ Trade ■ Reference

A DIVISION OF COURSE TECHNOLOGY

Digital Printing Start-Up Guide

ISBN: 1-59200-504-7

Library of Congress Catalog Card Number: 2004106601

Printed in the United States of America

04 05 06 07 08 BU 10 9 8 7 6 5 4 3 2 1

SVP, Thomson Course Technology PTR:
Andy Shafran

Publisher:
Stacy L. Hiquet

Senior Marketing Manager:
Sarah O'Donnell

Marketing Manager:
Heather Hurley

Manager of Editorial Services:
Heather Talbot

Senior Acquisitions Editor:
Kevin Harreld

Senior Editor:
Mark Garvey

Associate Marketing Manager:
Kristin Eisenzopf

Marketing Coordinator:
Jordan Casey

Project Editor:
Dan Foster, Scribe Tribe

Technical Reviewer:
C. David Tobie

Copy Editor:
Kim Benbow

Interior Layout Tech:
Jill Flores

Cover Designer:
Nancy Goulet

Indexer:
Kevin Broccoli

Proofreader:
Jenny Davidson

THOMSON
COURSE TECHNOLOGY
Professional ■ Trade ■ Reference

Thomson Course Technology PTR, a division of Thomson Course Technology
■ 25 Thomson Place ■ Boston, MA 02210 ■ http://www.courseptr.com

Dedication

To my wife, Lynn, for all your support, partnership, and especially your patience.

Acknowledgments

First, I thank all the energetic people on the publishing side who provided their professional and enthusiastic support. The Course Technology publishing and marketing teams includes Andy Shafran, Kevin Harreld, Sarah O'Donnell, Heather Hurley, Kristin Eisenzopf, Jordan Casey, and the sales staff. On the production side, my kudos go to Dan Foster, Jill Flores, Kim Benbow, and Jenny Davidson, who contributed to the making of this book.

Technical Editor C. David Tobie again provided his insightful and knowledgeable input.

I called on many other experts and information sources while writing this book, and although they are too numerous to list individually, I am nonetheless grateful for their help.

More thanks go to all the product and brand managers, PR managers and outside PR reps, and owners of the companies who supplied me with information, material, and encouragement.

Finally, I want to acknowledge the many photographers, artists, imagemakers, and printmakers who contributed their images and their stories to this book.

About the Author

Harald Johnson has been immersed in the world of commercial and fine-art imaging and printing for more than 25 years. A former professional photographer, designer, and creative director, Johnson is an imaging consultant, the head of his own marketing communications agency, and the creator of DP&I.com (www.dpandi.com), the digital printing and imaging resource for photographers and digital/traditional artists.

Contents

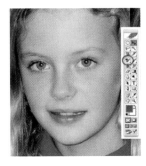

6 What About Print Permanence? 101

7 Selecting an Inkjet Printer 121

Introduction

I've been fascinated by digital imaging and printing ever since I bought my first desktop inkjet printer a few years ago. I had heard about this new way of creating images, and I wanted to try it so I could send prints to my family and share them with my colleagues and friends.

While pleased with my initial success, I knew there was more to learn about digital printing, and I quickly discovered that I was not alone in needing help and guidance. There are countless image-makers out there who are looking for the answers to some of the same questions I had. They want to know how to create, print, and share their images by using the new digital technologies that are changing our lives. If you're one of those people, you've come to the right place!

—Harald Johnson

Whom This Book Is For

Written for photographers, artists, and imagemakers of all types, *Digital Printing Start-Up Guide* is your introduction to the new world of digital photo printing. If you're an amateur or serious hobbyist, and if you want to learn more about this powerful visual medium, this book is for you.

Note: *This book discusses techniques for and uses images created on both Windows and Macintosh platforms. Some of the screen-shot images may look different from what you see, depending on your computer setup. You'll also notice that the book's figures and illustrations show different types of interfaces and dialog boxes depending on the operating system and software versions used. I like variety!*

How This Book Is Organized

Digital Printing Start-Up Guide is divided into 12 chapters and an appendix, as follows:

- Chapter 1: Navigating the Digital Landscape
- Chapter 2: Understanding Digital Printing
- Chapter 3: Comparing Digital Printing Technologies
- Chapter 4: Creating and Processing the Image
- Chapter 5: Understanding and Managing Color
- Chapter 6: What About Print Permanence?
- Chapter 7: Selecting an Inkjet Printer
- Chapter 8: Choosing Your Consumables
- Chapter 9: Making a Great Inkjet Print
- Chapter 10: Finishing and Displaying Your Prints
- Chapter 11: Using a Print Service
- Chapter 12: Special Printing Techniques
- Appendix

Keeping the Book's Content Current

Everyone involved with this book has worked hard to make it complete and accurate. But, as we all know, technology waits for no one, especially not for writers and book publishers! Digital imaging and printing is a moving target, and it's hard for anyone to keep up with its dizzying pace of change. This book can only be a snapshot of the techniques and technologies and products and models currently available. For updates, errata, and other information related to the content of the book, please visit the following sites:

- www.courseptr.com/digitalprinting
- www.dpandi.com (DP&I.com—the author's online, digital-printing and imaging resource)

1

Navigating the Digital Landscape

The world of image creation, sharing, and output—or "snap, scan, share, print" as some call it—is undergoing a surge in popularity and is also going through a technological revolution. People are printing images on home printers; going to photo labs, drugstores, and other retailers; and sharing pictures over the Internet. With these new practices, techniques, and ideas, everyone wants to know more about what digital printing is all about. This chapter puts digital printing into context and gives you a basic understanding of its role in the image-making process.

Birth of the Digital Printing Revolution

In the old, traditional days, very few people had the equipment or ability to make their own color photographic prints. Black and white yes, but not color. Typically, you had to go to your professional color photo lab to have prints made. And this meant that part of the creative process was outside of your control. But now, with digital imaging and printing, anyone with an inkjet printer can print lab-quality, color prints on their own, whenever and wherever they want. Or, if you like, you can still go to the photo lab or retail store, except that they have now also converted to digital printing as well.

Traditional black-and-white printing in a chemical darkroom.

Courtesy of Seth Rossman

I call this the "democratization" of image-making, which gives you so many more choices for creating, displaying, and sharing your favorite images.

It all started when the paths of six people—a rock star and his best friend, an art publicist, a sales rep, a computer wizard, and a silkscreen printer—unexpectedly intersected in early 1989 in California. Rock musician Graham Nash (of the legendary group Crosby, Stills, and Nash) had been quietly collecting photographs

for years. On the road with the band, Nash and his best friend Mac Holbert, who was also CSN's tour manager, would always hit the local galleries and swap meets looking for visual treasures. In the process, Nash amassed a world-class collection of vintage and contemporary photographs.

When Nash decided to sell his collection, and at the same time have an exhibition of his own photography in New York City, he ran into the problem that he had no way to make the exhibition prints from the digital images he was working with on his Macintosh computer. No photo lab had yet figured out how to print from digital files, and the existing digital print devices just weren't up to the task of high-resolution output.

So he put together a team of experts in various fields, focusing their efforts on something called an IRIS printer, which was used in the printing and graphic arts industries. The team (including Charles Wehrenberg, Steve Boulter, David Coons, and Jack Duganne) was able to print Nash's images onto thick, Arches watercolor paper just in time for the April 24, 1990 New York gallery show. (The following day, Sotheby's brought in $2.17 million for his original photo collection, a record at the time.) The world's first series of all-digitally printed, photographic fine art drew crowds and raves in New York and, as the show traveled, in Tokyo and Los Angeles. (A set of those prints later sold at auction at Christie's for $19,500.) Digital prints were officially on the map.

Jack Duganne (front) and Mac Holbert working with IRIS printers at Nash Editions, 1993.

Courtesy of Nash Editions

The Revolution Takes Off

Moving a little closer to home, the first photorealistic desktop digital printer didn't come onto the scene until Epson introduced their Stylus Color inkjet printer in 1994. The quality wasn't perfect, but it was the first of a long line of printers that could be purchased by anyone (those original IRIS printers cost $125,000!) and that could produce photo prints in the comfort of their own homes.

Today, there are hundreds of thousands of individual "imagemakers," photographers, and artists, from amateurs to pros, plus many more regular consumers, moms and dads, and scrapbookers who are able to print high-quality images in their own studios, homes, and offices. No longer constrained by the inconvenience and high costs of traditional printing methods, the production of photographic prints has been put in the hands of the people themselves.

Defining Digital Printing

Just what is digital printing anyway? I'll break it down into its components. This may seem like an elementary exercise, but it's important to understand the territory we're about to enter.

Digital

Here's the basic concept: *Digital* means using numbers to represent something, and that's exactly what a computer does. A normal image is converted into numerical data (a long string of ones and zeros) that describe or quantify each sample point or "pixel" (short for *pic*ture *el*ement, the basic unit of image information) in terms of certain attributes such as color and intensity. This data can be stored, manipulated, and ultimately transformed with digital printing technologies back into a normally viewed image (see Chapter 2, "Understanding Digital Printing," for an in-depth look at this).

The author's digital print, *Pelican Jetty*.
© *2001–2005 Harald Johnson*

Printing

Traditional (analog) printing is a mechanical process that uses a physical master or "matrix" for making repeatable prints. Commercial and even traditional fine-art printing presses use pressure or impact to transfer the image from a carrier, plate, or blanket—the matrix—to the receiving paper. Similarly, with old-style photography, the negative or a transparency is the matrix through which light travels to expose the print.

Digital printing is different, however. There is no pressure or impact, and there is no *physical* matrix. The matrix now sits in the computer in the form of digital data that can be converted repeatedly, with or without any variation, into a print by any imagemaker who either does his own printing ("self-printing") or who uses an outside printing service, lab, or retailer.

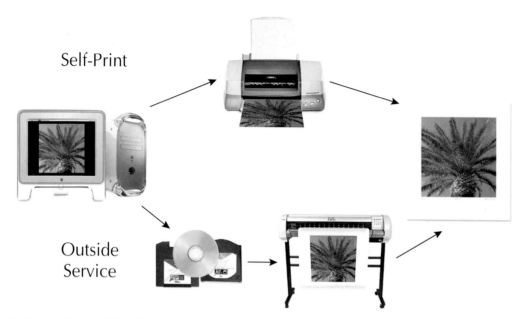

Self-Print

Outside
Service

Digital printing workflow: from digital matrix to hardcopy print.

Why Go Digital?

Digital imaging and printing have changed the rules of visual communication. Making original prints or reproductions (see below), especially at a large size and in color, used to be costly, cumbersome, or difficult for any individual photographer or artist. No longer. The advantages of digital printing are clear:

Cost

Once the initial setup and proofing stage is complete, digital prints can be made on an as-needed basis. This is true "print on demand." You want one print? No problem. You want 100? Also no problem. By contrast, conventional non-photographic, print production methods require the entire print run to be produced all at once.

Consistency

Because digital source files are stored on computer hard disks, or onto other digital storage media, they can be reused over time to produce identical results, assuming the media, inks, and hardware/software have not changed. In theory, the first and last prints produced over a 10-year period should look identical.

Printing Cousins: Offset and Digital Offset

Offset Lithography: Offset lithography is frequently used in printing art or photo reproductions, usually only in large quantities (more than 1,000) where economy of scale brings the unit cost down. This is how everyday art posters (as well as brochures, magazines, and newspapers) are printed. The "offset" part of the name comes from the principle of transferring the image from the revolving plate to a rubber blanket before final transfer to the paper.

Digital Offset/Indigo: Indigo is a brand of digital offset color—a new printing technology. Originally an Israeli/Dutch company, it is now a division of HP. Indigo (see Figure 1.1) uses a laser imager, special liquid ink (ElectroInk), and a thermal offset system to print the image. It's fully digital from creation to printing, which means that it uses no film, no imagesetters, no plates, and no photo-chemicals.

Figure 1.1 The HP Indigo Press 3050.

Courtesy of Hewlett-Packard Company

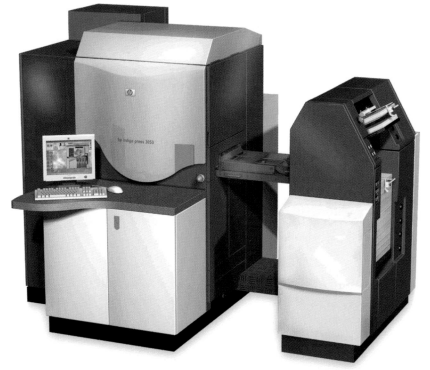

You're mostly likely to find an HP Indigo Press at a normal print shop, and it produces offset-litho-like quality but for short-run jobs (100-1,000 is a good average range) and in full color. And, because it's all-digital, each piece can be unique. This is a great new way to print catalogs, calendars, and invitations.

Storage

Related to the above, digital images take little physical room when stored on disk. Digital files can be long-lasting *if* the digital data remains intact and there is a way to read it. Another benefit is for those of you who are artists working with traditional media who can have your completed originals scanned and stored for future use in print editions. Not only does this safeguard the image, but it allows artists to sell their originals without having to worry about reclaiming them later for reproductions.

Larger Sizes

Size is not much of an issue with digital, especially with wide-format inkjet printers, which come in four-, five-, and even six-feet-wide models. Printing on roll paper, the length of an inkjet image is only limited by the printer's software. For even larger prints, images can be "tiled" and assembled in pieces. And, of course, the same digital source file can be cropped, blown up, or shrunk, and printed in many sizes.

Artistic Control

If you print your own images, you have complete control of the process. You decide on the best machine to use, you select the best paper-and-ink combination, you decide if you want to run the colors a little heavier on the next print. You have no one else to blame or to praise. You also get the immediate feedback of seeing what's working in print and what's not.

Photographer John Livzey has the flexibility to print what he wants when he wants in his own home studio.
Courtesy of John Livzey Photography/www.livzey.com

Freedom & Flexibility

With desktop printing equipment, almost anyone has the freedom to print what he wants, when he wants. Using the same image file, imagemakers can experiment with different sizes, croppings, or unconventional media. New images, variations, or new editions can be sampled and tested at minimal cost and with little risk, one at a time.

Who's Doin' Digital?

The digital revolution (including the Internet) has created opportunities for photographers, artists, and all types of imagemakers to create, edit, print, and share their work in ways that were not even dreamed of 10 or even 5 years ago. While some don't like categories, it's still useful to attempt some kind of lumping together, if only to allow more understanding of the widespread reach of digital imaging and printing. So here goes my attempt at classifying the *creators*—from amateurs to pros—of digital prints. (Print-service providers, as a group, get their own special chapter—Chapter 11).

Photographers

The digital wave has definitely broken over the photographic field, and most photographers are riding it (they'll drown if they don't). It's only logical, considering that photography was born out of the technological innovations of Niépce, Talbot, Bayard, and Daguerre in the nineteenth century. Some say that the digital revolution is as important as the invention of color photography, even photography itself. Of course, there will always be the few purists and hold-outs who thumb their noses at technological advances, but if you are reading this book, you are probably not one of them.

Some of the photographers who are emerging from their smelly darkrooms and into the digital light are merely using digital printing to output their existing work with little intervention. Others are playing a more active digital role, either shooting with a digital camera or scanning in their film-based images before beginning the work of color correcting, retouching, and in general, improving what they have. Many are taking full advantage of what digital imaging, and especially printing, can offer them.

A good example is Gary Goldberg, a new Toronto resident (from Florida) who covers a lot of bases in the digital game. He's a professional photographer now shooting all-digitally and working with ad agencies, record companies, and other types of businesses to create his portrait, fashion, and advertising images. However,

he also photographs weddings, digitally restores damaged photographs, and markets his own fine-art prints at art shows and through online services. It's those last two job categories, in addition to printing his portfolios, that put his several inkjet printers to most use.

Goldberg also does not hesitate to use the online display and marketing services of DigiLabs.biz and Pictage.com, both of whom utilize the digital printing technologies covered in this book for their products (read more about this in Chapters 3 and 11).

Left: Photographer Gary Goldberg creates images in a wide range of sub-specialties, including fashion and beauty. Right: Goldberg checks a print in his Florida studio.
Courtesy of Gary Goldberg Photography/www.garygoldbergphoto.com

Traditional Artists

The painters, watercolorists, and sketch and pastel artists who have taken up digital printing techniques to publish and reproduce their work are currently producing a large number of commercially sold, digital prints. An artist can either have a transparency made of his original work, take it to a digital printmaker for direct digital scanning, or digitize it himself with his own digital camera or scanner (if the original is small enough). The digital file is then typically printed on either paper (watercolors, drawings, or pastels) or canvas (oils or acrylics) to produce an edition.

American artist Steve Bogdanoff is known for his interpretive *fresco secco* paintings. (*Fresco secco*, where the artist applies paint to dried plaster, is one of the two classic fresco techniques. *Buon fresco*, which is the art of painting on freshly spread, moist lime plaster with pigments suspended in a water vehicle, is the other.) Influenced by ancient Greek art among others, Bogdanoff replicates in his own version of the fresco from scenes depicted in myriad wall murals, friezes, reliefs, and statues, starting with the Greek Bronze Age through the end of the Renaissance.

Bogdanoff has his frescos photographed, scanned, and put on a CD. He then does all the image editing on his computer in preparation for his own digital prints on paper via inkjet printing in his New Orleans studio. In this storefront gallery, he displays not only his fresco originals but also his limited-edition prints, some of which are hand-embellished with acrylic washes. The prints have definitely become a hit, and Bogdanoff admits that a substantial part of his revenue comes from them.

 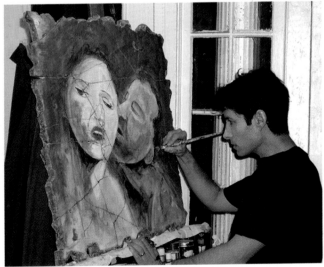

Left: *Blue Bird*, available as a fresco and also as a limited edition giclée and hand-embellished print. Right: Traditional artist Steve Bogdanoff works on one of his unique frescos in his New Orleans studio. *Courtesy of Bogdanoff Gallery/www.bogdanoff.com*

Digital Artists

A blurry, hard-to-define kind of group, this includes artists who draw or paint on the computer, who heavily manipulate and alter their photo-based art, who create "machine art" with mathematical formulas or fractals, or who combine traditional and digital techniques to produce new forms of hybrid, mixed-media art. Since their originals exist only in the computer, digital printing is the primary method used to output their work.

These are the artists who are truly partners with the computer, using it as a tool no differently than Monet used a brush. This is what used to be called "computer art," but that term is much too old-fashioned and imprecise now to cover the amazing range of today's digital artists.

New Mexico artist Ursula Freer has a traditional art background, but seven years ago she went all-digital. "It has totally changed my way of creating art," she says. "The medium is quite amazing; there seems to be no end to the possibilities for creative expression and great freedom for communicating ideas."

In her studio, Freer works with digital photos taken with her digital camera, software and filters, and also what she calls "screen painting" by using a digital graphics tablet. She produces her own inkjet prints on fine-art paper, and she markets them through galleries and her website. In addition, Freer has started to do digital art photography and printing for other artists in her local area.

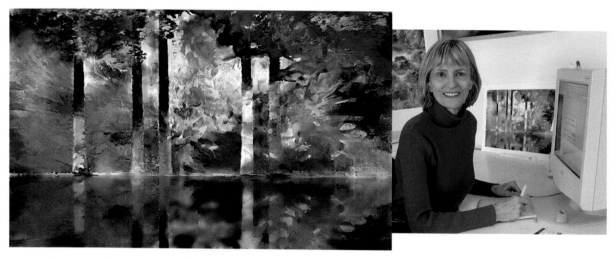

Left: *Reflections*, available as a made-to-order print, either signed and dated or in limited edition. Right: Digital artist Ursula Freer at work in her New Mexico studio.
Courtesy of Ursula Freer/www.ursulafreer.com

Consumers, Scrapbookers, and Other Imagemakers

This large and varied group includes parents, and particularly moms, who Epson likes to call the Chief Memory Officers of the family. A recent Epson survey revealed that 93 percent of mothers felt it was important for parents to take family photos so their kids would have memories from their childhoods. And a growing number of those parents are using digital cameras to take those photos.

An offshoot or subsection of family photo-taking is scrapbooking, which involves organizing and storing important and favorite photos along with other memorabilia into an album or scrapbook. Using photo prints plus special papers and stickers, scrapbooks are wonderful legacies for families to pass on to the next generations.

One example of a mom who fits both above descriptions above is Karen Morgan from Austin, Texas. She's a mom of two girls, Katie and Kira, and she loves to try new and better ways of creating and preserving her family's memories. She not only takes digital photos but prints them out both in her home on an inkjet printer and uses online and retail print-service providers.

Karen Morgan of Austin, Texas, spends one day a month organizing her family's photos, all printed digitally, either at home on an inkjet printer or at retail at her local grocery store.

Courtesy of Shelley Kurgan

Gaining Ground: A Question of Acceptance

While the digital printing boom includes everyone from aging Baby Boomers who are creating family photo prints in their home offices to professional artists selling fine-art prints through galleries, it is the latter group who is pushing the edges of print quality, durability, and acceptability. However, it has not been an easy road to gain the public's and the art community's acceptance.

A seminal event on the path to digital acceptance was the printmaking artist-in-residency, *Digital Atelier: A Printmaking Studio for the 21st Century*, at the National Museum of American Art of the Smithsonian Institution (now the Smithsonian American Art Museum) in Washington, D.C., which ran for three weeks in 1997

(see Figure 1.2). All five founding members of Unique Editions (Dorothy Simpson Krause, Karin Schminke, Bonny Lhotka, Helen Golden, and the late Judith Moncrieff) were present, and this was probably the first time the public got to interact with computers in a workshop setting at a major museum (this event is now part of the permanent collection of the Smithsonian). Krause, Schminke, and Lhotka would go on to be Digital Atelier, a well-known printmaking collective (see more about them in Chapter 12).

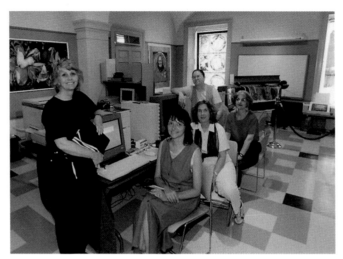

Figure 1.2 Unique Editions, aka Digital Atelier, in the learning center at the groundbreaking event *Digital Atelier: A Printmaking Studio for the 21st Century* at the National Museum of American Art of the Smithsonian Institution in Washington, D.C., in 1997. From left: Dorothy Simpson Krause, Karin Schminke, Bonny Lhotka, Helen Golden, and the late Judith Moncrieff (in back).

Courtesy of Digital Atelier
www.digitalatelier.com

More recently, the Brooklyn Museum of Art staged its *Digital: Printmaking Now* exhibition that ran from June through August, 2001. The second-largest art museum in the U.S. put its stamp of approval on digitally created art.

Digital prints (primarily inkjets) are now part of the permanent collections of New York's Metropolitan Museum of Art, the Museum of Modern Art, the Whitney Museum of American Art, the Corcoran Gallery in Washington, D.C., and the Art Institute of Chicago. Even the Louvre, the Musée D'Orsay, the Hermitage, both National Galleries (U.S. and UK), and the Library of Congress are now reproducing some of their most important holdings by way of digital printing.

However, digital printing is not just for museums. The proof is in the acceptance of digital printing technologies by large and small art galleries, mini and custom photo labs, online photo services, and by e-commerce businesses that are providing art buyers with high-quality prints that fit somewhere between inexpensive posters and unobtainable originals.

Then, there are the hotels, shops, corporations, and other businesses that have gotten into the digital act, commissioning, purchasing, and displaying both original and reproduction digital prints for customers and clients to enjoy (see Figure 1.3).

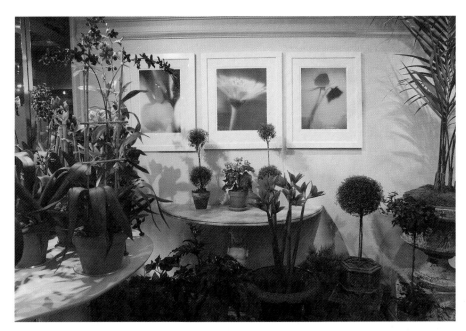

Figure 1.3 This exhibition of photographer Andrew Darlow's limited-edition inkjet prints on watercolor paper took place at Renny & Reed, world-renowned florist and event design firm on Park Avenue in New York City in 2004.

Courtesy of Andrew Darlow
www.andrewdarlow.com

And more local and regional art festivals, shows, and contests are adding "digital" categories to their official entry rules, although their definitions and requirements are sometimes confusing to artists.

To be sure, there were questions and problems with digital printing early on. The first IRIS inks were notorious for their ability to fade right off the paper. But subsequent improvements in ink formulations and in ink/paper matching have ended most of those arguments. Probably the remaining obstacle to the full acceptance of digital print methods today is the faulty perception that this type of art is "mechanical" and, therefore, inferior in some way. Nothing could be further from the truth.

The computer and other digital tools are just that—tools. Used in the hands of a perceptive, talented artist or photographer, a computer is not subordinate to brushes, palette knives, or enlargers. The fact is, the imagemaker's own hand lies heavily on most of the steps in the making of digital art. Using cameras, scanners, digital tablets, and a whole host of image-editing software, photographers and others have a personal and intense relationship with their images as they guide them through the various stages of creation, manipulation, and finally, printing. The aesthetic decisions are always the imagemaker's. In most cases, this is not mechanical art; this is imagery that emanates directly from the mind and the soul of the imagemaker.

Digital Decisions

People involved with digital printing tend to fall into a couple of large groups. Knowing what these are up front and matching your interests to them can help you better navigate through the digital landscape.

Doing It Yourself versus Sending It Out

If you want to get involved with digital printing, you must soon make an important decision: do the printing yourself or send it out to a print-service provider or an online printing service. There are advantages, disadvantages, and consequences to each route.

Doing Your Own Printing

Some imagemakers love the thought of working with their own printing equipment. Photographers especially, with their tradition of working in a darkroom full of enlargers, timers, and other technical equipment, are a driving force in the growth of "self-printing." However, as already mentioned, consumers and families are also joining the self-printing trend.

Advantages of Printing Your Own Images

- **Personal involvement, flexibility, and full control of the entire process.**
 It's your printer, your paper, your inks, your everything. You can change settings, paper, anything you want, when you want. You are in control. Doing it yourself, once you've figured out the system, gets you on the road to making prints very quickly. You can also fine-tune and output your prints on your schedule, one at a time, or in small quantities.

Professional photographer Steven Katzman in full control in his digital darkroom. Photography by A.F. Uccello.

Courtesy of Steven Katzman www.stevenkatzman-photography.com

- **Print costs can be less.** After you've made up the initial investment in buying a printer, and you've locked down your workflow settings and procedures, the extra cost of making additional prints is marginal—only the cost of paper and ink.

Disadvantages of Self-Printing

- **Learning curve and time commitment to acquire the skills of printmaking.** Serious digital printing is both an art and a craft, and just having the equipment does not guarantee you will know what to do with it. (Consumer-level solutions are easier to handle.) Learning a new technology takes time, and this is time that could be spent creating more images!

- **Sometimes significant upfront investment in hardware, software, and consumables (especially for the larger formats).** Add to that the perpetual, ongoing costs of self-printing that include your time or labor, consumables (paper, inks), maintenance, software/hardware upgrades, and possibly continuing education and training. Again, this is for the more serious form of digital printing.

If you are doing this as a hobby or in your off-time, then these obstacles are less of a consideration.

Using an Outside Printing Service

Because printing techniques can sometimes be complicated, many imagemakers use either a "print-for-pay" service, professional printmaker, online service, lab, or retail store to create their digital prints. (Read more about this in Chapter 11.)

Advantages of Using an Outside Print Provider

- **You work with printing professionals and take advantage of top-of-the-line technology that is more quickly updated.** Experienced printmakers or labs bring to the table a knowledge of materials and approaches that have been tried and tested many times before you walk in the door.

- **Drop it off and don't worry about it.** Once you either drop off or send online your digital files to a printing service, there's nothing to do until the finished prints come back. (If you are using a professional digital printmaker, you will also want to approve initial proofs.) This is time that can be spent doing other things!

Mark Staples (right) of Staples Fine Art in Richmond, Virginia, confers with artist Durwood Dommisse about the digital prints Staples is producing from Dommisse's landscape oil paintings.
Courtesy of Mark Staples
www.staplesart.com

Disadvantages of Using an Outside Print Provider

- **Loss of some control and flexibility.** The print is in the print provider's hands, not yours. The final result will depend, in part, on their skill level and your ability to communicate what you want to them. If they think it's good enough, but you don't, you have a problem.

- **Time delays going back and forth.** No matter how good and fast an outside print service is, there is still back-and-forth downtime between you and them.

Reproductions or Original Prints?

If you are hoping to sell or exhibit your digital prints at an art fair, camera club competition, or in a gallery, this is an important question. While there continues to be debate about this, many art professionals have come to the following definitions: A *digital reproduction* is a multiple print or exact copy of an original work of art that was created by conventional means (painting, drawing, etc.) and then reproduced by using any of the digital print technologies described in this book. A *giclée* print (see "What's in a Name" below) of an original oil painting, for example, is a digital reproduction.

An original digital print uses the same output methods, except the original does not exist outside of or apart from the computer. There is still an original, but it's in the computer. Or as some would have it: the "printing matrix" exists only as a digital file. (This is similar to the definition of traditional printmaking, which states that the impression or print is made directly from the original material by the artist or pursuant to his or her directions; the image does not exist unless it is printed.) Therefore, a print made from a digitally captured, scanned, or manipulated photo is an original digital print or just "print" in the art world. So is a print made from what a digital artist creates with a digital graphics tablet or related software.

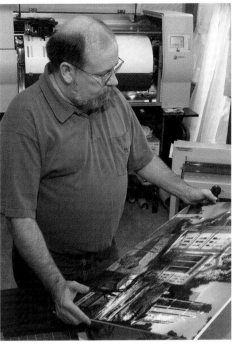

Printmaker Lester Wilson of Greencastle Photo Service, Greencastle, Indiana, checks a digital reproduction from his ColorSpan Giclée PrintMaker FA inkjet printer (in background).

Courtesy of Seth Rossman

An original print of JD Jarvis' *The Unwoven Tale* was featured in a group exhibit at the Cork Gallery at Lincoln Center, New York City in 2004.

Courtesy of JD Jarvis
www.dunkingbird-productions.com

These two main divisions represent two different ways of looking at the digital printing process. (Of course, there are other ways, too.) Why is all this nit-picking important? If you're only interested in creating scrapbooks or family albums, it's not. However, in the world of professional art, the idea of "original-ity" is carefully considered by many galleries, art festivals, and art buyers. Just as the label "photograph" can affect a work's desirability, acceptance, and price, so too do the labels "reproduction" or "original print."

What's in a Name: The Story of Giclée

One thing that became quickly apparent to the early digital-printmaking pioneers was the lack of a proper name to describe the prints they were making. By the close of the 1980s, new digital printmakers like Maryann Doe of Harvest Productions and Jack Duganne wanted to draw a distinction between the beautiful prints they were labor-ing over and the utilitarian proofs the commercial printers were cranking out on IRIS printers. They needed a new label, or, in marketing terms, a "brand identity." The makers of digital art needed a word of their own.

In 1991, they got it. Duganne had to come up with a print-medium description for a mailer announcing California artist Diane Bartz's upcoming show. He wanted to stay away from words like "computer" or "digital" because of the negative connotations the art world attached to the new medium. Taking a cue from the French word for inkjet (*jet d'encre*), Duganne opened his pocket Larousse and searched for a word that was generic enough to cover most inkjet technologies at the time and hopefully into the future. He focused on the nozzle, which most printers used. In French, that was *le gicleur*. What inkjet nozzles do is spray ink, so looking up French verbs for "to spray," he found *gicler*, which literally means "to squirt, spurt, or spray." The feminine noun version of the verb is *(la) giclée* (pronounced "zhee-clay"), or "that which is sprayed or squirted." An industry moniker was born.

giclée (zhee-clay) *n.* 1. a type of digital fine-art print. 2. Most often associated with reproductions; a giclée is a multiple print or exact copy of an original work of art that was created by conventional means (paint-ing, drawing, etc.) and then reproduced digitally, typ-ically via inkjet printing. First used in this context by Jack Duganne in 1991, Los Angeles, California.

Giclée logo from Staples Fine Art.
Courtesy of Mark Staples/www.staplesart.com

State of the Art: The Digital Revolution

Digital printing, although only a dozen or so years old, is enabling imagemakers around the world to print their favorite images in ways never thought possible before: conveniently, inexpensively, and with superb and consistent quality.

The industry and the technology are still embryonic; there is a lot of change and evolution yet to come. Even though people are taking more pictures and creating more images than ever before, we're still only in the early stages of this amazing story. And glimpses of what is on the horizon show a future that is truly astounding. Wireless and camera-phone printing, more colors, better software, more control—we all have a lot to look forward to.

Now that we've discovered and taken in a bird's-eye view of the digital landscape, it's time to explore the essential, start-up information you'll need before you start printing, digitally.

2

Understanding Digital Printing

Like any production or reproduction process, digital printing requires the right tools and the right information to make the right choices. I'll begin at the beginning.

A Digital Primer

A journey into the digital image-making realm has to start with the digital image. Some of the following may be difficult to grasp at first reading, but do your best to understand the concepts. Re-read as required.

Anatomy of a Digital Image

Ninety-five percent of all the images that imagemakers end up printing digitally are binary images, also called *raster* images, also called pixel-based images, also called bitmaps. Confused yet?

To put it simply, a bitmapped image is a collection of pixels (**pic**ture **el**ements) arranged on a rectangular grid (it's a *map* of a bunch of *bits*); see Figure 2.1. Think of it like a sheet of graph paper with colors in each square. Each pixel can be described or "quantized" in terms of its color and its intensity or value. The more pixels there are and/or the more the depth of information per pixel, the more binary digits (the little ones and zeros that the computer understands) there are, and the more detailed the image (see "Pixels and Bit Depth" below for more about this).

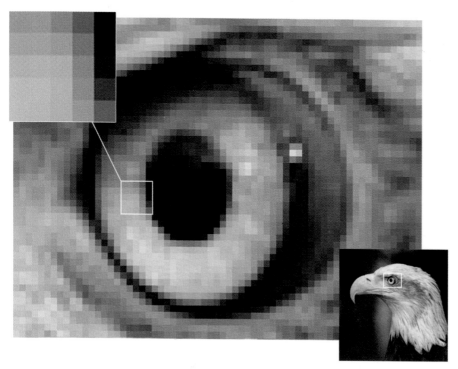

Figure 2.1 Pixels—the building blocks of all bitmapped images.

© 2001 Gregory Georges

There are three things you need to know about bitmaps to fully understand the nuances of printing digital images: *pixels and bit depth, resolution,* and *halftoning and dithering.* (Color is another issue, but because it's such a huge subject, it gets its own chapter—see Chapter 5, "Understanding and Managing Color.") I'll take them one at a time.

Pixels and Bit Depth

Pixels are the basic elements that make up a bitmap image. Pixels actually have no shape or form until they are viewed, printed, or otherwise "rendered." Instead, they are little points that contain information in the form of binary digits or "bits" (ones and zeros). Bits are the smallest unit of digital information.

A 1-bit image is the lowliest of all bitmaps. There are only two digits to work with—a 1 and a 0—which means that each picture element is either on or off, black or white. (I'm keeping this to a simple one-color example to start with.) But a 2-bit image is much more detailed. Now you have four possibilities, or values, for each pixel: 00, 01, 10, 11 (black, white, and two shades of gray). Keep going, and you see that three bits yields eight values, four bits 16, eight bits 256, and so on (see Figure 2.2). Generally speaking, a one-color digital image needs to be at least 8-bits (256 tones) to be "photorealistic" or "continuous-tone" in appearance. Study the eye image variations in Figure 2.2, and you'll see what I mean.

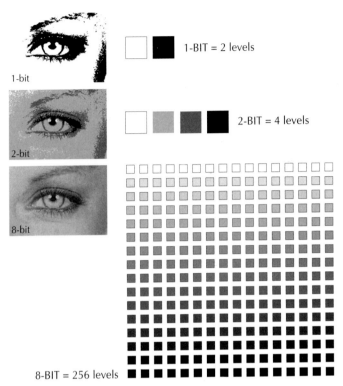

1-BIT = 2 levels

2-BIT = 4 levels

8-BIT = 256 levels

1-bit

2-bit

8-bit

Figure 2.2 The more bits, the more realistic the image.

Digital Equivalents

8 bits=1 byte

1024* bytes=1 kilobyte (KB)

1024 kilobytes=1 megabyte (MB)

1024 megabytes=1 gigabyte (GB)

1024 gigabytes=1 terabyte (TB)

*It's 1024 and not 1000 because of the way the binary system works with its powers of two—in this case, 2^{10}.

So far, we've only talked about bits in terms of black, white, or gray. Since most people work in color, you now have to apply the same thinking to *each color component of the image*. So, in a 24-bit (8 bits per color) RGB image, there are 256 possible values of Red, 256 of Green, and 256 of Blue, for a grand total of—are you ready?—16,777,216 possible values, tones, or colors for *each pixel* (see Figure 2.3).

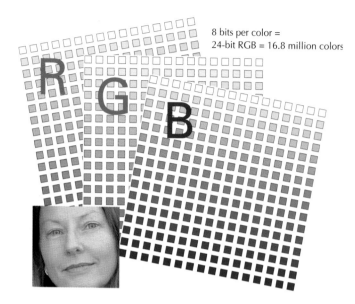

8 bits per color =
24-bit RGB = 16.8 million colors

Figure 2.3 Color bit depth.

Whether an image has one, two, four, eight, or even more bits of information per pixel per color determines its *bit depth.* The higher the bit depth, the more detailed and realistic the image.

Resolution

This seems to be the single most confusing word in all of the digital imaging world. And it doesn't help that there are different terms and definitions for camera resolution, scanner resolution, monitor resolution, file resolution, and printer resolution. Since this is a book about printing, I'll concentrate on the last two: *file resolution* and *printer resolution.*

File or Image Resolution

In basic terms, the resolution of a digital, bitmapped image is determined by how many pixels there are. If you have a digital image and can count 100 pixels across (or down) one inch of the image (remember, bitmapped images actually have no physical size until they are rendered into a tangible form; at that point, you can measure them), then the resolution is 100 pixels per inch or 100 ppi. Technically, it's pixels per inch (*ppi*) when you're talking about image files, monitors, and cameras. But it's dots per inch (*dpi*) when it comes out of a printer because, if it's an inkjet, the printer's software translates the pixels into tiny little marks or dots on the paper (see the "Dots, Drops, & Spots" box).

An image's resolution will, in part, determine its quality or the degree of detail and definition. The more pixels you have in a certain amount of space, the smaller the

pixels and the higher the quality of the image. The same image with a resolution of 300 ppi looks much different—and better—than one of 50 ppi at the same relative output size (see Figure 2.4).

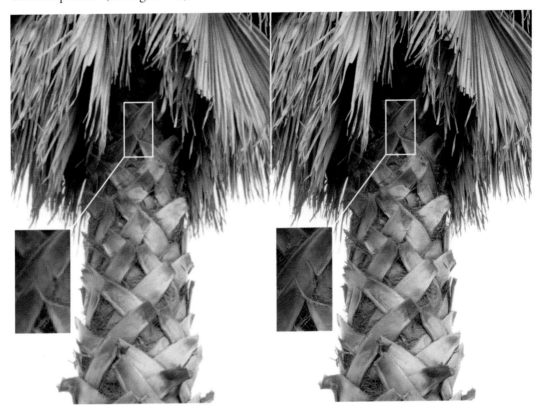

Figure 2.4 Image resolution affects detail and definition. Left: 50 ppi. Right: 300 ppi.

However, there's a downside to more pixels. The higher the ppi and/or the greater the bit depth, the more space the files take up, the slower they are to edit and work with, and the harder they are to print because extra pixels are simply discarded by the printer or can cause it to choke, stall, or even crash. The goal is to have a file that's just big enough for the job, but not so big that it causes extra headaches.

So what is the best file or image resolution for digital printing? There is no standard rule of thumb for all digital devices. Epson now recommends *300 ppi at the size you intend to print* as their current Magic Number; if you get to 240 or less, you start to see a difference in image quality, and conversely, you won't see much improvement with bitmapped images by going over 360 ppi. Hewlett-Packard (HP) claims that scientists doing satellite photo reproduction for the government on their printers typically find that 125 ppi is adequate. In my own experience, 200–300 ppi is a good image resolution target range for most HP inkjet printers.

Canon says that an image must be greater than 180 ppi "to avoid pixelation that shows as staggering in contrast points." They go on to recommend 200 ppi (see Table 2.1) as the target with 300 ppi as the maximum needed for their inkjets.

Table 2.1 The Magic Numbers of Inkjet File Resolution	
Brand	**Manufacturer's Recommendation** *at Final Size*
Canon	200–300 ppi
Epson	300–360 ppi
HP	150–300 ppi

For continuous-tone printers that don't use halftoning or dithering (explained below), try to have your image resolution match the printer resolution. Most dye sublimation printers are around 300 dpi, so make your final image also 300 ppi. This is the same for most of the digital printers found in retail store photo departments and online photo-printing services.

Chances are that if you are anywhere between 240 to 360 ppi in terms of image resolution at final print size, you're going to be fine with most digital print devices, although the best answer is to either test several resolutions with the intended output device and evaluate the resulting prints, or ask a print provider for recommendations if you're using an outside printing service.

Printer Resolution

Pull on your tall boots because you're now going to be wading in deep!

How capable is the printing device of reproducing the information in an image? You may have the highest-resolution image imaginable, but if the printer isn't able to output all the fine details you've worked so hard on, you've wasted your time.

Addressable Resolution

Digital printers have to translate all those nebulous image pixels you learned about into real dots of ink or spots of dyes. The number of different positions on the paper where the printer is able to place the little dots per unit area is its *addressable resolution*. Think again of graph paper and of each dot or spot having its own address on the paper. And all of this is measured in dots per inch (dpi).

Do you know the story of the blind men and the elephant? Six blind men encountered an elephant for the first time. Each touched a separate part of the beast and was then asked to describe the whole animal. They did so but in very different ways. The elephant was either like a snake, a wall, a spear, a fan, a tree, or a rope, depending on which blind man spoke.

Measuring Image Resolution

Here are the most common measurement methods:

- **By pixel array or dimension.** Some people just say, "Here's a 1600×1200 image." (That it's pixels is understood.) Once you're familiar with certain files sizes, you'll automatically know what a 1600×1200-pixel image (or any other size) will do.

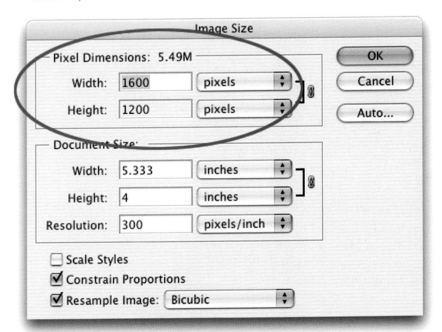

Pixel dimensions are one method of measuring image resolution.

- **By total number of pixels.** Multiply the number of horizontal pixels by the vertical ones, and you've got the total number of pixels or the pixel dimensions. A 1600×1200 image totals out at 1,920,000 pixels.

- **By pixels per inch and image size.** As long as you know both the intended output size and the ppi, you're set. For example, an uncompressed, 24-bit, RGB, color 300-ppi image set to an output size of 4×5 inches is just over a 5-megabyte (MB) file.

- **By file size.** Take the total number of pixels (pixel dimensions), multiply that by 3 (total RGB color bit depth—24 divided by 8), and you've got the file size in *bytes* (1 byte is 8 bits). Divide that by one million, and you have the *approximate* final file size in megabytes. Example: 1600×1200 pixels = 1,920,000 pixels. 1,920,000×3 = 5,760,000 bytes or 5.76 MB. Pretty close.

And so it is with "addressability" and dots per inch. Those numbers you see listed on every print device's spec sheet and in every advertisement only give you part of the picture. And each print-device manufacturer talks about it differently.

Take inkjet printers. The Epson Stylus Photo R800 printer's maximum resolution is listed as 5760×1440 dpi. (Note: Virtually all digital-printing devices have multiple modes that allow for more than one resolution setting; naturally, only the maximum is advertised. The smaller the resolution numbers, the faster the printing, but the lower the image quality.) The maximum resolution on the HP Photosmart 8450 is 4800×1200 dpi. For the Canon i900D, it's also 4800×1200 dpi.

So what do these numbers mean? The 5760, 4800, or 2400 refer to the horizontal axis and is the maximum number of dots the printer can cram into one inch *across* the paper, or in the direction of the printhead's travel (see Figure 2.5). The other number (1440 or 1200) is the maximum number of dots the printer can place in one inch *down* the paper (in the direction of the paper feed). Keep in mind that these are not separate little dots standing all alone; they are frequently overlapping or overprinting on top of each other.

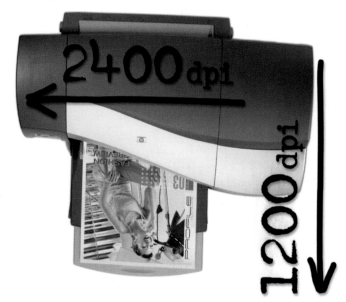

Figure 2.5 Inkjet printers have the higher-resolution numbers in the horizontal or printhead-travel direction.

Printer image courtesy of Hewlett-Packard Company

The theory is that higher printer resolutions produce finer details and smoother tonal gradations. This is true up to a point, but you eventually reach a position of diminishing returns. The negatives of high dpi—slower printing speeds and increased ink usage—eventually outweigh the positives, especially if you can't really see the differences. (For more about this, see "Viewing Distance & Visual Acuity" below.)

When it comes right down to it, the dpi resolution numbers on a spec sheet are irrelevant. They only tell a very small part of the story, just like the blind men's elephant. There are many factors that go into what really counts—the *image*

quality a particular printing device is capable of producing. Factors like printer resolution, the number of ink colors, the size of the ink droplets, the precise positioning of the dots, how the inkjet nozzles are arranged and fire, the order of the colors, the direction of printing, and the screening or dithering pattern of the image pixels—they all come into play. My advice: Don't put too much stock in the dpi numbers alone, and don't use them to compare printers of different types or brands. Instead, use dots-per-inch resolution only to weigh different models of the same brand. Then, at least you're talking the same language.

Dots, Drops, & Spots

If all this talk of dots, drops, and spots is making your head hurt, it's time to sort all this out. I asked inkjet expert Dr. Ray Work, an internationally recognized authority on the subject, to help me clarify the differences from an inkjet printing point of view.

- **Dots.** A dot is the mark on the paper or other inkjet receptive material resulting from the printing of one or more drops of ink. It is the smallest component of an inkjet-printed image.

- **Drops.** A drop (or droplet) is that small amount of ink that's ejected from the orifice in the inkjet printhead that lands on the paper and forms a mark or dot.

- **Spots.** With printing, a spot is the same as a dot.

When inkjet printers translate pixels into printed dots, it's not a 1:1 conversion. Each pixel typically requires lots of dots depending on its color and value.

In addition, inkjet printers can place multiple drops per dot. Some HP printers can generate up to 32 ink drops for every dot yielding over 1.2 million colors per dot.

And there's more. Inkjet printers can eject drops from their printheads one at a time and place them at different positions on the paper or on the same position. They can eject one or more drops on the same position to form one dot. They can eject drops of different sizes, which results in different-size dots. They can eject bursts of drops that combine in flight prior to landing on the paper to form a single dot.

All of these amazing options are in play with the inkjet printers on the market today. (Learn more about inkjet printers in Chapter 3, "Comparing Digital Printing Technologies.")

Dots produced by Epson 3.5 picoliter drops, some overlapping to give secondary colors.

Courtesy of Epson America, Inc.

What About Type?

Any type or text that's part of a bitmapped image is no different than the rest of that image, and it will print with the same resolution of the image file. Although other factors such as paper surface quality and the kind of printing technology used can definitely have an impact, it's the printer's addressable resolution that mainly determines the quality of the printed, *bitmapped* type. A high dpi (dots per inch) will generally yield higher-quality type with smoother edges while a low dpi produces type with ragged edges (see Figure 2.6).

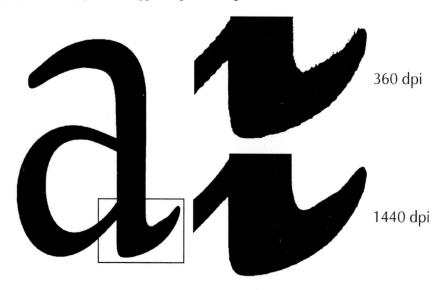

360 dpi

1440 dpi

Figure 2.6 Printer resolution affects type quality as seen in these scanned blowups.

For Advanced Users

If you're printing from a drawing or page-layout program, the rules change somewhat. Programs like Quark XPress need PostScript font support from a utility program like Adobe Type Manager (ATM) if your operating system doesn't already have PostScript font support built in. Adobe Illustrator and InDesign (version 1.5 and later) don't require a PostScript interpreter for good-looking type. In any of these cases, if you're printing through an inkjet's native printer driver, the type quality will still vary with the resolution of the printer. However, as soon as you bring in a PostScript interpreter, things improve significantly.

Viewing Distance & Visual Acuity

Another aspect of printer resolution commonly overlooked is the relationship between *viewing distance* and *visual acuity.*

- **Viewing Distance.** It matters how close you or your viewers are to your prints. Consider the ubiquitous billboard that *could* be printed at a high resolution but never is. If you've ever seen a billboard up close, you know that the dots are huge. Yet billboards are perfectly readable at the distance from which they are meant to be viewed—across the street or driving down the road.

The key point here is that you don't need more printer resolution than you need. Normal people will stand back to view a large image, and they will get up close to view a small one. This means that larger or fewer dots are more acceptable on big prints destined to be viewed from further back.

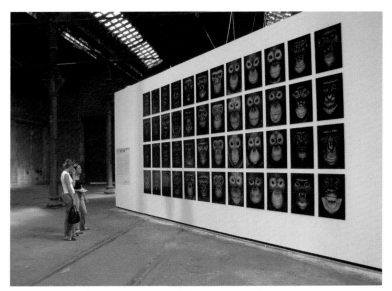

Viewing distance can have an impact on the choice of printer resolution. (James Mollison's *James and Other Apes* inkjet print exhibition at the 2004 Arles Rencontres Photo Festival)

Viewing distance, however, is only one-half the story.

- **Visual Acuity & Maximum Resolving Power.** The ability of the human eye to distinguish fine detail is called *visual acuity,* and it is directly related to distance. As you move farther away from the visual source, you reach a point where you no longer see the detail, and everything merges together. Skipping over all the science behind the maximum visual resolution possible for most humans, the conclusion is that at any given viewing distance, you gain nothing by having higher resolution than the maximum resolving power of the eye because no finer details can be perceived. This is the upper limit, so there's no point going beyond that. This explains how inkjet printing with all those tiny dots, drops, and spots works. When viewed at a normal distance, the inkjet dots merge into one continuous-tone image.

Halftones, Contones, and Dithers

There are three common ways to produce continuous-tone images, such as photographs, with any printing method, whether analog or digital: *halftone screening, contone imaging,* or *alternative screening (dithering)*. All three have roles in the digital printing process, and each printer manufacturer uses its own method and guards it closely. This is the real Secret Sauce of digital printing.

Halftone Screening

Since the late nineteenth century, continuous-tone (or "contone") images have been rendered by the process of *halftoning*. Since smooth transitions of grays or colors are impossible to print with analog or even digital devices (remember, all computers and digital printers use binary information that is either on or off, one or zero), images that use halftoning have to be broken down into tiny little dots or spots. (I use the two words interchangeably.) The darker portions of the image have larger spots with less space between them; the lighter areas have smaller spots with more space to reveal the paper underneath (see Figure 2.7).

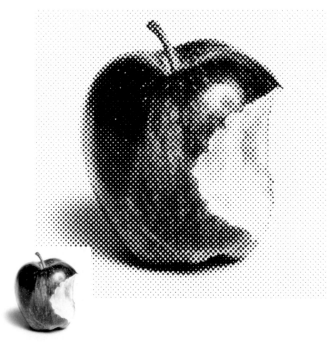

Figure 2.7 Halftones are optical illusions that trick you into thinking you're seeing continuous tones.

At the right viewing distance, our brains then merge all the spots together to give us the impression that what we're seeing is one, smooth image. (Hold the page with the apple farther and farther away from you to see.) It's just a trick, an optical illusion.

Commercial digital printing systems, imagesetters, and some binary digital desktop printers, such as color and black-and-white lasers, use digital halftoning as part or all of their image-rendering methods.

Contone Imaging

Digital continuous-tone or *contone* imaging, most clearly seen in digital photo print and dye sublimation devices (explained in the next chapter), works differently. Image pixels are still involved, but instead of using halftoning as a middleman to break the various tones in an image apart, contone devices translate the pixel information directly through the printer to the paper. As the image is being rendered, the printer is, in essence, asking each image pixel, "which color and how much of it?" Therefore, the more pixels or the higher the bit depth, the better the image. Because the printed image is made up of overlapping dyes of each primary color with no spaces between them, the color transitions are very smooth and the resulting images are very photorealistic (see Figure 2.8).

Figure 2.8 Contone imaging, in this case with a Durst Lambda digital laser imager, produces photorealistic images with overlapping dye colors.

Courtesy of Durst U.S.

Alternative Screening (Dithering)

Certain branches of digital printing, specifically inkjet and electrophotography, now use a relatively new screening type, called *stochastic screening*, to produce near- or at-continuous-tone images where the dots are smaller and more irregular than halftone dots. Perfectly shaped, regularly spaced halftone dots are replaced with more randomly shaped, irregularly placed ones (see Figure 2.9).

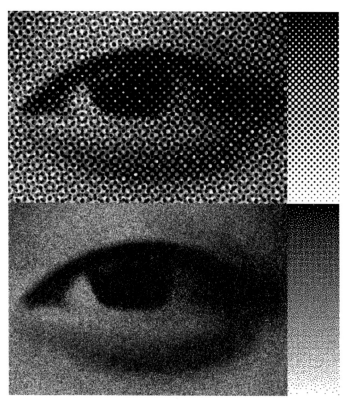

Figure 2.9 A simulation comparing halftone screening (top) with frequency modulated screening (bottom), 30× magnification.

Eyes courtesy of Martin Juergens; panels courtesy of Wasatch Computer Technology

This is where dithering comes in. In the dictionary, dithering means "nervously excited or confused." Dithering is simply an alternative to halftoning and is the process of breaking down a continuous-tone image into a bunch of tiny, confused, excited little spots in a "stochastic," or random, arrangement. Dithering, sometimes in combination with halftoning, has been successfully implemented by inkjet and color laser printers to output a full range of tones and image detail.

The bottom line is that when you're at the upper end of digital printing quality, including inkjet, you've pretty much entered the world of continuous-tone imaging. The dots touch with no space between them, and the four or six (or more) colors are layered next to or on top of each other to blend together and form a smooth image. The dividing line between continuous-tone and screened images, at least with high-quality digital printing, is disappearing.

Printer Drivers

This section is primarily for those doing their own printing through a computer. If you use an outside printing service, they'll be responsible for knowing all about this, but it can't hurt for you to understand the basics.

Printer Drivers and Printing Software

Before you can print from a computer using any sort of program or application, the printer software program, called a "printer driver," must be correctly installed on the computer. Every print device requires a particular driver for the specific operating system of the computer. (Note that it's your computer's operating system you match to the printer, not the software application you're using.) You must have the right driver for your printer in order to support all the printer's features and to tell the print engine how to correctly render the image's digital data. If you change your operating system, you may need to install an updated printer driver, which you can normally download from the printer manufacturer's website.

When you select Print from your application's File menu, what you get is a series of menu screens and dialog boxes for that particular printer driver (see Figure 2.10). If you have a PostScript printing device, you need to use a PostScript driver and select it. (We'll get into more step-by-step printmaking details in Chapter 9.)

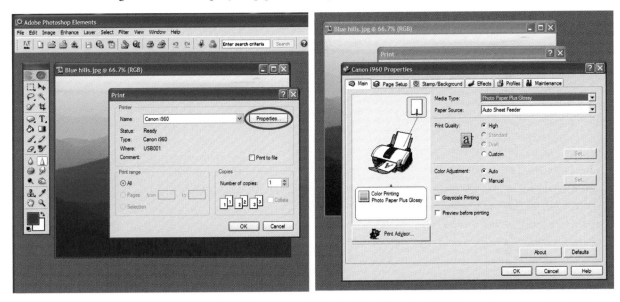

Figure 2.10 The printer driver at work. Left: The basic print dialog box from Windows XP Home when accessed via Adobe Photoshop Element's "Print" command. Make sure the proper printer is selected (Canon i960 inkjet printer), then click Properties (red oval). Right: The Properties screen lets you specify that printer's important options and settings, or it will open further screens as needed.

What About PostScript and RIPs? (Advanced)

PostScript. Adobe PostScript refers to both a page-description language and a processor that "interprets" PostScript data. PostScript files describe and locate all bitmapped images, vector art, and type on a rectangular page by X and Y coordinates. You can create PostScript files by saving files created in drawing and page-layout programs through a PostScript engine in your imaging application or as a standalone application.

Do you need to be worried about PostScript? Probably not. If you're creating professional ads, color separations, or contract proofs destined for the commercial prepress or printing industry, then yes, you'll need to involve PostScript somewhere in your workflow. However, if you are printing normal bitmapped files to your own non-PostScript printer (which is what most desktop printers are), you won't need it.

RIPs. A Raster Image Processor (RIP) can give you a significant amount of control over certain aspects of your output, but only if you are an advanced user. "Ripping" includes telling the printhead where and how to place the dots and remapping the RGB colors to CMYK or whichever subtractive colors are used.

Optional RIPs are available from print device manufacturers or from third-party sources. When a RIP is called on, it takes over the functions of the regular printer driver.

Do you need a RIP? As with PostScript, it all depends. For normal desktop printing of bitmapped images, no. But, if you want access to advanced color management with individual ink-limits and channel controls, if your files are very large or complex, if you need to print to unusual output sizes, if you have PostScript elements in your file, or if your printing crosses over into the commercial prepress world at all, then you will want a RIP. (Read more about RIPs in Chapter 12.)

To make informed digital printing decisions, you have to know your options. In the next chapter, you'll look at what the major print technologies are.

3

Comparing Digital Printing Technologies

Imagemakers have always experimented with new printmaking materials and techniques, and a list of them would be a long one. But the process of creating high-quality digital prints has, for the majority of imagemakers working today, coalesced around four major output methods or technologies: *digital photo print, dye sublimation, electrophotography,* and *inkjet.* To be sure, there are plenty of other digital processes that can be used (blueprint reprographics to name just one), but these are either more obscure, more expensive, or too low on the quality scale, so I won't be covering them here in any detail.

Naturally, there are different ways to categorize all these technologies. One is by format size: *narrow* (or desktop) format is anything under 24 inches in width; *wide* (or large) format is everything 24 inches wide or more (this is media size, not the size of the printer). What I've chosen to do, instead, is to group them by their logical (in my opinion) imaging characteristics. (Note: Products, brands, and models are current at the time of this writing.)

Digital Photo Print (Laser Imaging)

Until recently, and apart from the IRIS printing process, photographers who wanted actual photographic output produced from their digital files had to make an intermediate negative or transparency with a film recorder, then use a conventional enlarger to make the final print. But in 1994, a new type of printer was developed that could print directly from a digital file without the need for the intermediate transparency step. The photo processing industry has never looked back.

Table 3.1 Snapshot: Digital Printing Technologies

Type	Examples	Max. Output Size	Inks/Dyes	Media
Digital Photo Print (laser imaging)				
Wide-Format	Durst Lambda	50"×164"	Photo dyes	Photo paper
	Océ LightJet	76"×120"	Photo dyes	Photo paper
Digital Minilabs	Fuji Frontier	12"×18"	Photo dyes	Photo paper
	Noritsu QSS	12"×18"	Photo dyes	Photo paper
Dye Sublimation				
	Olympus P-440	8"×10"	Ribbon: dyes	Special paper
	Kodak Pro 8500	8"×10"	Ribbon: dyes	Special paper
Electrophotography				
	Xerox Phaser 7750	12"×47"	Dry toner	Normal paper
Inkjet				
Drop-on-Demand:				
Thermal	HPs, Canons, Lexmarks	All sizes	Dye or pigment	Large range
Piezo	Epsons, Rolands, Mimakis, Mutohs	All sizes	Dye or pigment	Large range
Solid Ink	Xerox Phaser 8400	Letter/legal	Solid resin ink	Many options

Divided into narrow and wide-format sizes with different brands and models in each category, this is top-of-the-line, continuous-tone photo output, and you'll only find the pricey devices for doing this in photo labs, repro shops, service bureaus, and "imaging centers." In fact, you may not realize it, but most photo labs and photo minilabs today use the same technology to print everything from Grandma's snapshots to professional prints. These are the ubiquitous "digital mini-labs" found at many photo retailers, drugstores, and big-box merchandisers, like Wal-Mart and Costco.

How Does It Work?

Either using color lasers (red, green, blue—RGB) or RGB light-emitting diodes (LEDs), these printers produce extremely high-resolution prints on conventional, light-sensitive, color photo paper that's processed in the normal wet-chemistry photographic manner.

Digital minilabs made by Agfa, Noritsu, and Fuji are the standard at many pho-tofinishing labs and the new online processors described in Chapter 11. The Fuji Frontier (see Figure 3.1) was the first digital minilab used for the mass retail market. It's a complete system that takes input from conventional film, digital camera, digital media, or prints (with onboard flatbed scanner) and outputs to digital media or prints via wet-chemistry processing. There are several different models of the Fuji Frontier, and the largest output is 10×15-inch prints.

For Self-Printing? Cost	Image	Comments Quality
No	Excellent	A standard for high-quality digital output for many
No	Excellent	photographers. Limited media choices. Print costs are high.
No	Excellent	Found in photolabs and discount chains; perfect for
No	Excellent	inexpensive, high-quality photo prints.
Yes	Very good	Used by pro and advanced-amateur photographers for low-
Yes	Very good	volume, high-quality images and proofs. Fast.
Maybe	Up to very good	Great for comps, proofs, and general design work.
Yes	Up to excellent	The most common type of inkjet printer; found everywhere.
Yes	Up to excellent	The other common type of inkjet printer, including all Epsons.
Yes	Up to very good	A popular option for designers and illustrators; produces very saturated colors; fast.

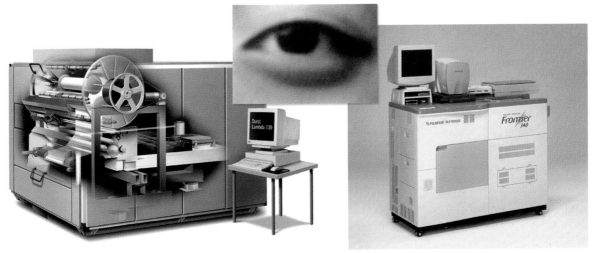

Figure 3.1 Left: Durst Lambda 130 digital laser imager. Eye inset: Blow up of a Durst Lambda 76 print. This use of the human eye, which includes a full range of tones from highlights to shadows, as a visual reference for making image-quality comparisons comes from photography conservator Martin C. Juergens. Right: Fuji Frontier 340 digital lab system.

Courtesy of Durst U.S. (left), Martin Juergens (center), and Fuji Photo Film USA, Inc.

Digital Photo Print: For What and for Whom?

Photographers like the output from digital photo print because it looks like a real photograph. In fact, it *is* a real photograph! Larry Berman, a photographer who is a regular on the art show circuit, has most of his prints done on a Noritsu digital printer at his local Costco. Berman pays only $2.99 for a 12×18 print that can also yield two 8×10s. The costs for the wide-format variety (Lambda, LightJet, Chromira) are comparable to wet-darkroom prints from a custom photo lab, but the digital versions will soon be replacing the traditional ones as their materials become extinct.

The primary negatives with digital photo print are that paper choices are limited, and you can't do this yourself because the devices are much too expensive for self-printers to own.

Dye Sublimation

Dye sublimation (also known as "dye diffusion thermal transfer" and typically called "dye sub") is for high-quality photo and digital snapshot printing. Dye-sub printing has a loyal following among some photographers who prefer it to inkjet printing.

How Does It Work?

With dye sub, a single-color ribbon containing dye is heated by a special heating head that runs the width of the paper. This head has thousands of tiny elements that, when they heat up, vaporize ("sublimate") the dye at that location. The gaseous dye spot is then absorbed into the surface of the paper. Since the paper receives separate cyan, magenta, yellow, and sometimes black passes of the dye ribbons to make up the final image, the resulting layering of color provides a smooth, seamless image. Photo dye-sub printers only have 300 or so dpi resolution, but they can deliver continuous tone images because of this layering and the way the dyes diffuse, or "cloud," into the paper. Some dye subs add a protective layer (a clear UV laminate) as a fourth and final step after the single-color passes.

Examples of dye-sub printers include Olympus P-440 (see Figure 3.2) and P-10, Kodak Pro 8500 and Photo Printer 6800, Mitsubishi CP-3020DU, and Sony DPP-EX50.

Dye Sub: For What and for Whom?

Dye sub is popular with advanced-amateur (and pro) photographers who want continuous-tone, photographic image quality. Print speeds can be very fast: 20 seconds per 5×7 on the Kodak 6800, or 75 seconds for letter size on the Olympus P-440. In addition, certain types of dye-sub prints are more scratch-resistant than with inkjet.

Figure 3.2 The Olympus P-440 Photo Printer is a dye-sub printer for smooth, realistic, continuous-tone images.

Courtesy of Olympus America, Inc.

While dye sub yields photographic quality to the naked eye, disadvantages are the high cost of the larger-format or specialized printers—Kodak's 6800 is targeted to event photographers and studios, and it's priced at $3,000, the high cost of the consumable supplies, and the limited choice of special papers and ribbons (glossy and matte only).

Electrophotography

Also called "xerography" ("xeros" for dry, "graphos" for picture), electrophotography involves the use of dry toners and laser printers or printer/copiers.

How Does It Work?

Many color lasers use hair-thin lasers to etch a latent image onto four rotating drums, one each for the four printing colors (see Figure 3.3). The drums attract electrically charged, dry, plastic-based pigment toner, then transfer the image to an intermediate transfer belt, and then to the paper where it is fused. Other laser printers transfer the toner directly to the paper without the intermediate step.

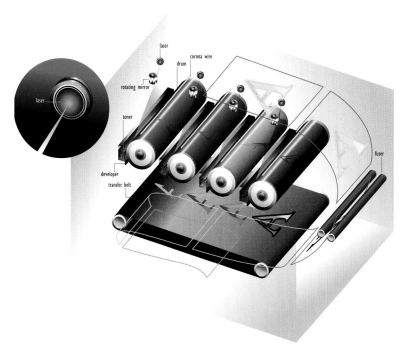

Figure 3.3 Single-pass, color laser print technology by Xerox.

Courtesy of Xerox Corporation

Older-technology devices image one layer/color at a time; the trend now is to "single-pass" printing, which speeds up the process considerably. Maximum output size is typically 12×18 inches, although the Xerox Phaser 7750 can handle 4×6-inch postcards up to 12×47-inch banners. And in some printers, laser imaging is replaced with light-emitting diodes (LEDs).

Most color lasers these days offer up to 1200×1200 dpi resolution.

Examples of electrophotographic printers include color lasers from the Xerox Phaser, Canon CLC, and Konica Minolta Magicolor lines.

Xerox Phaser 7750 color printer.

Courtesy of Xerox Corporation

Electrophotography: For What and for Whom?

Color laser printers are becoming more like short-run printing presses in quick-print shops as well as other businesses. They are also used as primary color output devices in graphic arts departments and design studios, and now, by individual imagemakers—especially photographers.

Electrophotographic printing is fast and reasonable, with 8×10 prints under $1.00 at many retailers, and images can be printed on a small range of substrates, including matte paper and commercial printing stocks. The main disadvantages of electrophotography are the limited maximum output size (usually 12×18 inches) and the high initial cost of the machines if you're self-printing. The image has a slightly raised surface when viewed at an angle, especially on glossy or cast-coated stock, but the colors can be very bright and saturated. Depending on the type of screening and resolution used, prints sometimes have a lined or halftone-dot look.

Inkjet

For the most flexibility in terms of choices of printer brands and types, inks, papers, sizes, and third-party hardware and software support, you can't go wrong with inkjet. As far as quality goes, I've seen high-resolution desktop, thermal and piezo inkjet prints on glossy and semi-gloss paper that rival—even surpass—any traditional photographic print. In addition, certain inkjet print combinations exceed all other standard, color-photo print processes in terms of projected print longevity or permanence.

Simply described, inkjets use nozzles to spray millions of tiny droplets of ink onto a surface, typically paper. While earlier devices had an obvious digital signature, the newer printers are so much further along that many inkjet prints can now be considered continuous tone for all practical purposes.

There are three main categories of "drop-on-demand" inkjet printing: *thermal*, *piezo*, and *solid ink*.

Thermal

This process, which was invented in 1981 by Canon ("Bubble Jet Printer"), is based on the heating of a resister inside the printhead chamber (see Figure 3.4). As the resister heats up, a vapor bubble surrounded by ink is formed, and the increase in pressure pushes an ink droplet out of the nozzle in a printhead. After the bubble collapses, more ink is drawn in from the ink reservoir, and the cycle repeats.

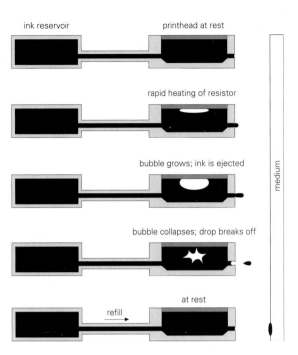

ink reservoir printhead at rest

rapid heating of resistor

bubble grows; ink is ejected

medium

bubble collapses; drop breaks off

at rest

refill

Figure 3.4 The thermal inkjet process.

Courtesy of Martin Juergens

Inkjet printers have printheads that move back and forth on a rail or bar over the paper, which is pushed incrementally by a stepper motor after each head pass. Some printheads with their nozzles are integrated into the ink cartridges and are replaced with each ink change. Others are separate from the inks but still need replacing. Still others come in the form of a monolithic printhead assembly that sits underneath the ink cartridges. See Figure 3.5 for all three types.

Figure 3.5 Three types of thermal printheads and ink carts: (left) HP integrated print cartridge with ink tank and printhead, (center) HP separate printhead and ink cartridge, and (right) Canon ink tanks and one-piece printhead and holder (inset).

Examples of thermal inkjet printers include (for the desktop category) Canon i9900, HP PhotoSmart 8450 and Designjet 30, and Lexmark P707; included in the wide-format category are HP Designjet 130 and 5500, Canon imagePROGRAF W6200 and W8200, and ENCAD NovaJet 1000i.

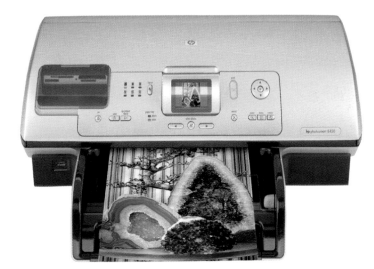

The HP Photosmart 8450 eight-ink-color printer.

Courtesy of Hewlett-Packard Company

Thermal Inkjet: For What and for Whom?

The largest number of inkjet printers sold in the world today fall into this category. They're affordable and widely available with up-to-excellent image quality that rivals photographic prints.

Piezoelectric

When certain kinds of crystals are subjected to an electric field, they undergo mechanical stress, i.e., they expand or contract. This is called the "piezoelectric effect," and it's the key to this popular brand of digital printing, called "piezo" for short (and not to be confused with "piezography," which is described in Chapter 12). When the crystalline material deflects inside the confined chamber of the printhead, the pressure increases, and a tiny ink droplet shoots out toward the paper (see Figure 3.6). The returning deflection refills the chamber with more ink.

Both desktop and wide-format models of piezo printers come only in versions with the printhead assembly going back and forth over the paper to create the image. Piezo printheads are typically single units with all colors included; they are a permanent part of the machine and usually need no replacing.

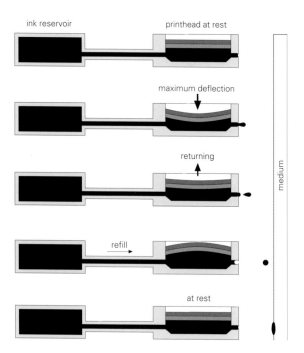

Figure 3.6 The piezoelectric inkjet process.

Courtesy of Martin Juergens

Examples of piezoelectric inkjet printers include (for desktop) Epson Stylus C86, Stylus Photo R800, and PictureMate; included for wide-format are Epson Stylus Pro 4000, 7600, and 9600; Roland Hi-Fi JET Pro-II, Mimaki JV4, and Mutoh Falcon II.

Epson's PictureMate, a personal photo lab that allows digital camera owners to print 4 × 6-inch photos at home at an affordable cost.

Courtesy of Epson America, Inc.

Piezo Inkjet: For What and for Whom?

In the desktop category, there's only one piezo player, and that's Epson. With six- to seven-color inks in dye and pigment versions, these are the printers that have historically owned a significant share of the photographer-artist, self-printing inkjet market. Other manufacturers join Epson in the larger wide-format category. As with thermal, piezo inkjet printers are widely available and produce up-to-excellent image quality.

Solid Ink

Formerly called "phase change," solid ink technology is the inkjet oddball. The Xerox Phaser 8400 (Xerox is the only real player in this category) is a true piezo-electric inkjet, but there are several surprises. First, the pigmented colors come in the form of solid blocks of resin-based inks, although the ink still ends up as a liquid after heating (hence the term "phase change"). These printers also have the affectionate nickname "crayon printers," from the resemblance of the ink sticks to children's crayons.

The inner workings of the Xerox Phaser 8400 solid-ink color printer.

Courtesy of Xerox Corporation

Instead of a smaller, reciprocating printhead assembly, there is a single printhead that extends nearly the width of the paper with 88 nozzles in each of four rows. The same piezo substance you've already learned about shoots the ink droplets out as before, but in another twist, the ink doesn't go onto the paper; instead, the ink goes onto a turning offset drum that is kept warm so the ink doesn't solidify. The drum then transfers (in a single pass) the still-molten ink to the paper under pressure to form the image.

Solid Ink: For What and for Whom?

With ink that sits on top of the paper creating a definite relief effect, the colors are brilliant and sharp, since the ink drops don't spread or bleed. However, even at 2400 dpi, "near-photographic" might better describe the image quality. Solid ink inkjet is fast, it prints on a variety of media, and it yields highly saturated images that some photographers, designers, and illustrators love. Disadvantages include limited output size (letter/legal) and relatively poor image permanence (Xerox claims only "a year or more" with office lighting, "over several years" with dark storage).

———————

With all this new, accumulated information about pixels, hardware, and printing technology under your belt, I'll move your attention to what it takes to create and process a digital image.

4

Creating and Processing the Image

Images and technology have never been more intertwined than they are now. Digital technology may be the tool, but the act of creation springs from the mind—and heart—of the imagemaker. Let's look at how digital images are created and processed.

Image Input

Most imagemakers work with source material. Photographs, sketches, scans—these are the raw materials that, when combined with a creative vision, end up as an image worth printing.

It's like making a fire. Before the flames can blaze, you've got to go out and gather the wood. And if you've spent much time camping, you know that the drier and higher-quality the wood, the bigger and better the fire.

As with many things digital, the boundary lines between categories are not hard and fast. For example, digital cameras do the same basic thing that scanners do. But because the digital world has decided that a camera is one thing, and a scanner is another, I'll break image input down similarly.

Note: For a description of the equipment you'll need for setting up your own print studio, see Chapter 9.

Scanning

Scanning is done by scanners, and here's how they work. Light generated in the scanner itself is either reflected off or transmitted through a piece of art or film via a mirror-and-lens system (see Figure 4.1) and onto a grouping of light sensors, which are actually tiny CCDs (charge-coupled devices) or in some cases CMOSs (complementary metal oxide semi-conductors) or CISs (contact image sensors). The thousands of individual sensor elements, one per image pixel, are either arranged in single or triple rows, called, respectively, linear or tri-linear arrays.

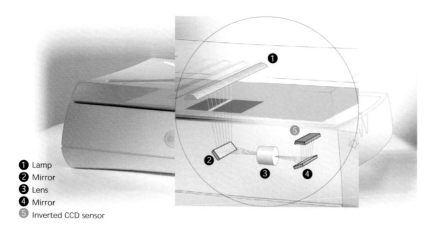

1 Lamp
2 Mirror
3 Lens
4 Mirror
5 Inverted CCD sensor

Figure 4.1 Flatbed scanners use lamps, mirrors, lenses, and sensor arrays to produce digital files. The Creo iQsmart has a unique inverted CCD sensor that minimizes dust accumulation on the CCD surface.

Courtesy of Creo

The scanner's image is then formed (in the case of CCDs) like this: As the scan progresses line by line down the original object, the light that is reflected or transmitted strikes each sensor, which transfers that information in the form of increasing voltage to something called an A/D (short for analog/digital) converter. The A/D converter then transforms the voltage into the binary values (our favorite ones and zeroes) that are sent to the computer. Once inside the computer, the scan is now a digital file that can be viewed, manipulated, and printed.

In the context of digital printing, the type and quality of a scan can be critical to the final, printed output. Therefore, let's start off with an overview of some important things to know about the scanning process. The types of scanners and what they do follows.

What You Need to Know about Scanning

There are some key issues about scanners and printers that need to be understood by anyone hoping to become proficient with high-quality digital imaging and printing. These issues or factors are *color depth*, *dynamic range*, and *resolution*.

Color Depth

Remember your friend bit depth from Chapter 2? Color depth is just another way to say bit depth for scanners, and the same principles apply. A normal color original (print or film) will require a minimum 24-bit scan (8 bits of information per

RGB channel; all scanners scan in RGB) to reproduce with adequate fidelity. This is the old "millions" scanner setting (actually, it's 16.8 million as you learned earlier). However, since some of the scanned bits are invariably corrupted or lost to electronic noise, using a scanner with a higher color depth like 36-bit is preferred. A 36-bit or "high-bit" scanner records 12 bits per color channel, which translates into 68.7 *billion* possible values or colors per pixel. (Most modern scanners are 12-bit scanners. Even some that say they're 16-bit are really only using 12 bits of data carried in a 16-bit format that is more efficient for computers.)

Dynamic Range

Many people get the terms color or bit depth and dynamic range confused. Both are important and related, but they are different. Think of a stairway: The number of steps is a function of the bit depth (8-bit equals 256 steps), and the height of the entire stairway is the dynamic or density range from Dmin to Dmax (see Figure 4.2).

Density range is the difference in density between the lightest and darkest areas of an image. It's the numerical range from the minimum density (Dmin) to the maximum density (Dmax). If the Dmin is 0.3 and the Dmax (also called *optical density*) is 3.9, then the density range is 3.6 D.

Density range applies to digital input devices like scanners, but it can also describe imaging material, such as printing paper and photographic film, which have their own inherent density ranges. Photographic prints, for example, have an average range of around 2.0 D; watercolors have even less.

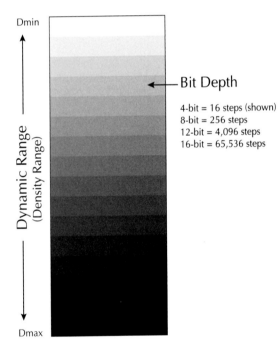

Figure 4.2 The digital stairway. The number of steps is a function of bit depth; the height of the stairway is the dynamic/density range.

Bit Depth

4-bit = 16 steps (shown)
8-bit = 256 steps
12-bit = 4,096 steps
16-bit = 65,536 steps

How does all this affect scanning? Several ways. First, you need to make sure you consider what type of art you will be scanning before deciding on a scanner to purchase or a service to use. And for that, density range and D values are important factors. When dealing with slides or transparencies with very dense blacks, you'll want the widest density range and the highest Dmax you can get so that you can pull out the details from those dense areas. But with certain kinds of reflective art, it's not as critical because the prints themselves have a low density range,

and many low- to mid-priced scanners will do the job. (Unfortunately, because of a lack of standards, advertised density ranges and Dmax specs, as with "resolution" on inkjet printers, serve mostly for marketing purposes. Use them to compare scanner models by the same manufacturer, but be leery of any cross-brand comparisons. In fact, price is usually the best indicator of scanner performance.)

A scanner with a wide density range will help pull details out of the top of this retouched photo of a banyan tree in South Florida.

Scanner Resolution

I've saved the best for last. Or I should say, the most complicated. Some of this necessarily overlaps what was discussed in the chapter about image and printer resolution, but I'm adding another piece of the resolution puzzle.

Most of the sales information for scanners highlights the dots-per-inch (dpi) resolution. Technically, there are no dots in scanning, just samples. It should really be "samples per inch" (spi) or pixels per inch (ppi), but that battle of terminology has been lost to the scanner industry. Whenever you hear anyone mention dpi in the context of scanning (as I tend to do), understand that they are also saying ppi. It's still about pixels.

The more sensor elements per unit area, the higher the *optical resolution* of the scanner, and, in general, the more information and detail the scanner is capable of capturing. Flatbed scanners use the same naming system as inkjet printers to

trumpet their resolutions: 2400×4800 dpi, for example. In this case, 2400 means the number of CCD elements across the bed of the scanner. They don't really cover the full width of the scanner, only a portion of it, because they receive the image focused by a lens. The 4800 refers to the other dimension and is achieved, as with inkjets, by motor stepping (sometimes called "hardware resolution"). It's the lower number—the optical resolution—that counts. Film scanners also use dpi, but they usually only list one number, such as 4000 dpi.

Many scanners also list an *interpolated resolution* (see Figure 4.3), which is invariably a larger number. Here, sophisticated software is used to add extra pixels where there were none before. However, this is fudging the pixel data, and it should not be a consideration when weighing scanning or scanner choices.

Figure 4.3 This 2400-dpi Epson scanner provides various resolution presets. Custom resolutions can also be used.

Going Out for Scans

Not everyone has their own scanner, and even if you do, there will be times when you'll want to send out your images to a scanning service for "digitizing." This can include everything from a digital printmaker to a photo lab to a discount retailer with a print kiosk. In any of these cases, you can ask the scanning provider about the specs for their scanner and see if they meet your needs. Or, just make a trial scan, and you'll see the results with your own eyes.

Types of Scanners

There are two basic types of scanners or scanning systems to consider for average consumer printing purposes: *film* and *flatbed*. (There are also drum and other specialty scanners, but I won't be covering them here.)

Film Scanners

These specialized desktop scanners have become very popular with imagemakers who want to do their own scanning of negatives or transparencies. Here, the film moves ever-so-slightly past the light source, which with many brands is a cold-cathode, mercury fluorescent lamp, or, in other cases, an array of LEDs. Depending on the price, film scanners can handle 35mm up to 4×5-inch sizes.

Because film has to be enlarged more than prints, and also because film has a wider density range and more contrast, most film scanners have correspondingly higher optical resolutions. A maximum resolution of 3–4000 dpi is standard for many desktop film scanners with others going even higher.

Two of Konica Minolta's 35mm film scanners. Left: DiMAGE Scan Elite 5400 with an impressive 5400-dpi optical resolution and built-in Kodak DIGITAL ICE image correction. Right: DiMAGE Scan Dual IV with 3200-dpi resolution and Digital Grain Dissolver.

Courtesy of Konica Minolta Photo Imaging USA

A different type of film scanner is made by Denmark's Imacon, and their Flextight models have a unique way to handle the artwork (several models also scan reflective prints). The film is bent in a drum-like shape except there is no drum! There's only air between the sensor and the film, which is held in place by its edges. They call it a "virtual drum," and there's no need for the mounting liquids, gels, or tape that drum scanners require. The resolution is high (up to 8000 dpi, non-interpolated) and with a price tag to match.

Other desktop film-scanner makers include Nikon, Canon, Microtek, and Polaroid.

Flatbed Scanners

Like photocopiers, flatbed scanners are basically boxes with a flat glass plate that you put the artwork on (face down). This can be photo or artwork prints, books, even 3D objects like seashells (see "Scanograms" box below). A moving CCD array travels the length of the bed, scanning as it goes. Earlier flatbeds could only scan reflective art, but the newer generation can now do a decent job with transparencies and film negatives as well; these are sometimes called "dual-media" scanners. These either use an adapter or special lid construction that allows light to shine from above onto the CCD sensors (see Figure 4.4).

Figure 4.4 In addition to the normal flatbed scanning functions, the Epson Perfection 2580 Photo is good for digitizing and restoring stacks of negatives in just a few simple steps with its easy-to-use Auto Film Loader.

Courtesy of Epson America, Inc.

Several manufacturers such as Microtek, Canon, HP, Agfa, Umax, and Epson make a wide range of flatbed models with resolutions from 600×1200 dpi to 4800×9600 dpi.

"Scanograms"

"Photograms" have been around since the invention of photography, but it seems as though they're being resurrected through digital imaging and printing. I call them "scanograms." Just lay any not-too-thick object on a flatbed scanner and have at it. Of course, scans made this way can also be incorporated into any subsequent artwork as backgrounds or whatever is desired. Let your imagination run wild!

A "scanogram" made from leaves and manipulated on the computer with image editing software.

Photography

Since photography in general, and digital photography in particular, are subjects that fill many worthy books, I'll only hit the highlights as they relate to digital printing.

Photographers have the most experience in this area because capturing images is already their primary activity, either with analog or digital cameras. Traditional artists, on the other hand, are mainly concerned about digitizing finished artwork, and they tend to rely on outside professionals, such as printmakers or photographers. And finally, many digital artists and other image-makers use cameras (and scanners) for inputting image elements that are later manipulated on the computer.

There are two main ways to capture images with photography: traditional *film photography* and *direct digital capture.*

Film Photography

Although film is losing ground steadily in the face of the digital onslaught, many photographers still like to work with film and then scan it. Some prefer the "feel" of film, or they may have boxes and albums full of older negatives and slides just waiting to be brought back to life.

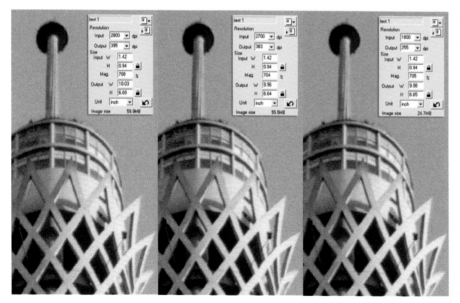

Advanced-amateur photographer Mark Segal in Toronto scans his archive of 35mm color negatives with a Konica Minolta DiMAGE 5400 film scanner before printing them on his Epson Stylus Pro 4000 desktop inkjet printer. Shown is one of his tests to determine the best scanning resolution.

Courtesy of Mark Segal

Advantages of Film Photography

- Traditional, universal workflow with reliable results.
- Medium- and large-format film advocates claim film still has the quality edge over digital.
- Film (if transparency) is its own proof; nothing else is required to view it.

Since the ultimate goal of a film-photography-based workflow is to end up with a digital file, the obvious question is, Why not just start off with digital to begin with?

Digital Capture

Digital cameras are all the rage and are gradually replacing their analog ancestors (film cameras). Here are some reasons why:

Advantages of Digital Capture

- There's no lag time from exposure to the final image. You see it, you got it.
- Lack of film grain means digital captures are very smooth and clean.
- Since there's no film, you don't have to buy it, store it, or process it. And you don't have to worry about it being X-rayed at airports!

While the debate continues over whether film or digital is better for the highest-quality imaging and printing (many feel that digital equals or exceeds 35mm quality but film still wins in larger formats), capturing images with either a digital-capable camera or what's called a "digital camera back" continues as a growing trend.

What You Need to Know about Digital Cameras

Using lenses to focus light and create an image in the same way film cameras do, digital cameras or "digicams" are basically little scanners, and all the things you've learned about pixels, file sizes, and resolution apply here equally as well (i.e., more is better). The main difference is that the cameras in this category are primarily "area array" devices. A single, light-sensitive sensor (CCD or CMOS), which is made up of tiny elements in a checkerboard or mosaic pattern that are individually coated to be sensitive to red, green, or blue light, is exposed through a lens to the light reflecting off the subject. The camera converts the analog signal into binary information, and bingo, you have a digital file.

Digicams come in myriad styles and types. Pick up a photography magazine or walk into any camera store, and you'll see that there are point-and-shoots, "prosumer," professional, and studio cameras for every possible use and occasion. They are usually categorized and marketed by their maximum number of recorded pixels, e.g., 2048 × 1536 (that's horizontal by vertical). This is the advertised CCD resolution, which is arrived at by simply multiplying the two numbers together and rounding off to the closest million-pixel decimal. For example, 2560 × 1920 pixels equals 4.9 or just 5 megapixels (abbreviated as 5 MP).

Two digital-camera sensor technologies. Left: A small 2 Megapixel CCD sensor and a simulated area array pattern of the individual elements. Right: The newer Foveon X3 layered chip.

Right: © 1998-2002 Foveon, Inc.

A 5-MP camera is considered to be the minimum for capturing images that can yield decent quality at moderate print dimensions. Consider a 5.1-MP camera like the Nikon Coolpix 5700 that has a maximum resolution of 2592 × 1944 pixels. An opened and decompressed file at 300 ppi would yield a very good 6.4 × 8.5-inch print but not much more unless you reduce the ppi (cut the ppi to 150 and the print size doubles).

If you move up to something like Canon's PowerShot Pro1 (see Figure 4.5), you're dealing with 8 MP and a maximum resolution of 3264 × 2448 pixels resulting in an 8 ×11-inch print (or more if you reduce the ppi).

The next step up with digital cameras is to the top-of-the-line digital SLRs. This is the rarefied world where the flagship cameras of the major brands live: Olympus' E-1 (5 MP), Nikon's D100 (6.1 MP), Canon's EOS 1Ds (11.1 MP), Fuji FinePix S3 Pro (12 MP), and the Kodak DCS Pro SLR/n (13.5 MP). One main advantage of these dSLR cameras (besides the higher pixel count) is the ability to interchange lenses, just like traditional SLR cameras.

With a few exceptions, such as the use of a camera-RAW file format, a file from a digital camera is treated exactly the same as a file from a scanner. And it isn't only the pixel count that matters (although that's an important part of the equation).

Figure 4.5 Canon's 8-MP PowerShot Pro1 digital camera.

Courtesy of Canon USA

Other factors that affect image, and ultimately print quality, include the quality of the lenses, the size and type of the image sensors (most sensors are still smaller than a 35mm film frame), the type and size of individual sensor elements (Fuji offers two sensitivities in its Super CCD SR sensors), and the camera software that processes the images.

You basically get what you pay for, which means that as you spend more, the CCD pixel count goes up, and your ability to print larger, higher-quality images increases. See Table 4.1 for a summary of print sizes in relation to pixel dimensions.

Table 4.1 Pixels & Print Sizes*

Image Resolution	Megapixels	Printed @ 200 ppi	Printed @ 300 ppi
640×480 pixels	.3 MP	3.2×2.4 in.	2.1×1.6 in.
1024×768	.8	5.1×3.8	3.4×2.6
1280×960	1.2	6.4×4.8	4.3×3.2
1600×1200	1.9	8.0×6.0	5.3×4.0
2048×1536	3.2	10.2×7.7	6.8×5.1
2592×1944	5.0	13.0×9.7	8.6×6.5
3264×2448	8.0	16.3×12.2	10.9×8.2
4256×2848	12.1	21.3×14.2	14.2×9.5

* Does not include any special scaling programs, use of RIPs, etc.

Digital Drawing/Painting

Not really a way to acquire or capture an image, digital drawing or painting involves artists and photographers creatively inputting their ideas directly into the computer. It can be done with drawing or painting software applications, image-editing programs, or the many niche programs, plug-ins, and filters that are available to artists working digitally.

Let me admit right up front that there is a lot of overlap between this category and the next one, image editing. The dividing line where image creation becomes image processing is very fuzzy. Much art is made with a feedback loop of trying something, going back and fixing it, then trying again. And that's one of the main advantages of working digitally. Experiments and variations with a computer can be done quickly, and if done right, they're reversible.

One way to get a handle on digital drawing and painting work is to look at the software used to create it. I'll give a short summary of some of the major program players to give you a feel for them. And again, keep in mind that my category dividing lines are not impermeable. Many programs can both help create and edit images, and many imagemakers own several types of software and use them all, even in a single image. (See Table 4.2 for an overview of the major image editing software applications, including drawing/painting programs.)

Painter

Corel Painter is a digital painting program that simulates traditional media. With 30 mediums and more than 400 new brushes in Painter 8, this is the premier "natural-media," digital painting and sketching tool. It's a complex program that is a little daunting for some, but the results are pretty amazing if you hang in there long enough to explore it.

You can create images from scratch, or you can enhance photographs or what you already have, and Painter is completely compatible with Photoshop so you can exchange layers between the two. Digital artist Bobbi Doyle-Maher, for example, moves between Painter and Photoshop as she develops her photo-based and layered images (see Figure 4.6).

Other Paint Programs

There are many other digital drawing and painting programs that imagemakers use. A couple popular ones are described here.

CorelDRAW/PhotoPaint. Primarily used as an illustration/page-layout program, CorelDRAW is now packaged with Corel PhotoPaint (for image editing and painting) and R.A.V.E. (for creating animations and vector effects for the web) into the CorelDRAW Graphics Suite. While originally a dual-platform application, Version 12 of the Graphics Suite is for Windows only.

Figure 4.6 Above: Bobbi Doyle-Maher's digitally painted and layered *Homestead* image, which started off as a photograph of some neighborhood cows. Below: Using Painter's Mixer palette to paint highlights on the backs of the cows.

Courtesy of Bobbi Doyle-Maher/www.rabbittwilight.com

Digital artist Carol Pentleton, who also runs the online gallery The Digital Artist, uses CorelDRAW exclusively in the creation of her images (see Figure 4.7). She loves the flexibility, the transparency of use, and the quality of the tools; her favorite feature is the infinite mutability of fills she can get with the program. Pentleton outputs her images to both IRIS and a proprietary digital-oil-on-canvas printing process. "I love the color saturation and the smoothness of the transitions of the prints," she says.

NaturePainter. The new Windows-only NaturePainter Digital Canvas (NaturePainter.net) is a moderately priced, entry to mid-level painting

Figure 4.7 Carol Pentleton used CorelDRAW to create this image entitled *The Fountain.*

© 2001-2004 Carol Pentleton www.thedigitalartist.com

program. It's designed to be more for learning how to paint; you can paint in any style with tools like brushes and a palette knife, and you have the ability to mix paint and to experiment with color. "NaturePainter is a brilliant, user-friendly pro-

gram," says UK amateur artist Malcolm Randall. "It has a very short learning curve, but it can suit the most seasoned digital artist, as well as the beginner. The end result can look just like an oil painting."

Machine Art

I learned the term "machine art" from digital printmaker and New Mexico-based artist JD Jarvis, although let's be clear—the machine doesn't make the art. Machine art includes three-dimensional modeling where 3D artists can use programs to create entire universes that only exist at the interface of the computer software and their imaginations. This is also the world of fractal mathematics and algorithmic art (see Figure 4.8). Using filters, texture and pattern generators, commercial or free software, custom computer coding, scripts, or pure mathematical equations, digital artists spend hours, days, and weeks with precise calculations that are performed by the computer and ultimately rendered into print or other 2D or 3D forms.

Figure 4.8 Digital artist Renata Spiazzi's *My Golden Eagle*, from her series *Impossible: Works I Wish I Could Sculpt*, which was created mainly with a filter program called KPT5 Frax 4D.

Courtesy of Renata Spiazzi www.spiazzi.com

Image Editing

Once you have the raw materials of an image in your digital workspace, you're ready for image processing or editing. Image editing can be as simple as taking a single image and making sure it looks the way you want it to look: that it's the right size, and that it has the correct file format. But for many, that's just the beginning. This is where many imagemakers spend most of their time in creating their complex imagery. Compositing, layering, montage/collage—this is where it all happens. This is the stage on which much digital art and image-making is played out.

Image editing is a full-length subject on its own, so I'll only concentrate on two aspects of it: *software* and *plug-ins and filter*.

Image Editing Software

Most digital imagemakers use some form of image editing software. This is not an absolute requirement—you could print an image from a word-processing program if you wanted, but to get the most out of your images and your printing, you'll want to have and use an image editor.

Table 4.2 Image Editing & Painting Software

Program	Maker	Platform	Used for
CorelDRAW/PhotoPaint	Corel	PC + Mac	DRAW: page layout, illustration
		Suite12 : PC only	PhotoPaint: image editing, painting
NaturePainter Digital Canvas	Urban Pursuit	PC only	Painting
Photoshop	Adobe Systems	PC + Mac	Image editing, painting, web graphics
Photoshop Elements	Adobe Systems	PC + Mac	Image editing, photo retouching, web graphics
Painter	Corel	PC + Mac	Painting, photo and image editing
Paint Shop Pro	Jasc Software	PC only	Painting, photo and image editing, web graphics
Qimage	Digital Domain	PC only	Image-viewing/printing software

Which is the best image editor? There is no easy answer to that question. Besides the obvious requirement that you be able to drive a printer from the software—or be able to place the image into another type of program (page-layout, for example) that drives a printer, the other requirements of an image editing program depend on what you want to do to process or improve your images. Minimum features to look for are layer editing, support for various file and input/output formats, masking, cloning, painting and retouching, Photoshop plug-in compatibility, and color management support.

Here is a summary of the most popular image editing software used to help you process and prepare your images for printing. (If you're using a paint program, many image editing functions are available within that program, although you will still want to consider having a separate image editor, too.)

Photoshop

Adobe's Photoshop is the gold standard of image-editing software for most serious digital photographer-artists. It's the most expensive, the most complex, and for many, the most intimidating piece of software they will ever own.

I was intimidated at first, too. I had Photoshop 2.1 sitting in a corner unused for a couple of years; I was scared to death of it. Then I upgraded to version 5.5 and decided it was time to learn it. Many, many hours later, the veil finally lifted. Now,

with the later versions, including version 8 ("CS"), I don't know how I existed without Photoshop. I use it constantly for image editing, and because of that, it's as familiar as an old sweater. Not that I know everything there is to know about it. I don't. I consider Photoshop a lifetime learning experience.

In basic terms, if you're in the *business* of digital imaging and printing, you'll want Photoshop. If not, you may not need all the horsepower that Photoshop offers. Depending on your goals, one of the following software programs may be all you require.

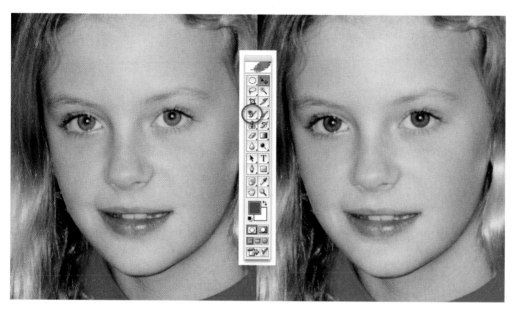

Photoshop CS's Color Replacement tool lets you change color (notice the eyes) while retaining the original texture and shading.

Photo courtesy of Karen Inga Morgan

Photoshop Elements

Adobe's Photoshop Elements is a trimmed down Photoshop targeted to those doing digital photography. If that's all you're doing, then Elements may be all you really need. It combines image editing, photo retouching, and web graphics creation. It has most of the core functions of Photoshop like Levels, Color Balance, and other features that are in some cases only available through the use of outside work-arounds.

It is possible to get very satisfactory results from Elements without the tremendous learning curve and sticker shock associated with the full-blown Photoshop that, honestly, is just too much for many to handle. Elements sometimes comes bundled with other hardware or software, and one secret that many don't know about is that it also supports some Photoshop plug-ins that work on RGB images.

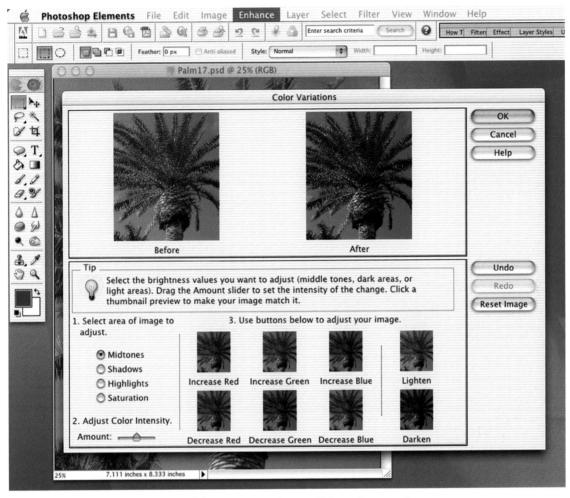

Adobe Photoshop Elements is a powerful yet easy-to-use image editing software package.

Paint Shop Pro

Paint Shop Pro ("PSP") by Jasc Software is a great program for the average user, especially for the price, which is about a sixth of Photoshop's. You can both create and edit images with it. There are text and drawing tools, photo and perspective correction and enhancement tools, a fast background eraser, web design tools, and a powerful full-blown scripting engine that allows users to record, play, and edit any series of repetitive or creative tasks within the program (similar to Actions in Photoshop). And as with Photoshop, there are layers, adjustment layers, and layer blending modes. It's very Wacom-compatible, and it even has Levels and Curves adjustments. On the professional-only drawback side, Paint Shop Pro lacks the 16-bit support, CMYK, LAB, and other advanced modes of Photoshop, and it offers only the simplest of color management, but compared to Photoshop, PSP is very easy to use. My main complaint is that it's only for the PC; there is no Mac version.

Jasc Software's Paint Shop Pro is a lower-priced, image editing alternative to Photoshop.
Courtesy of Jasc Software

Qimage

Qimage fills it own unique category. It's a powerful image-viewing and printing software package (PC only) that optimizes print quality, especially from low-resolution images. As such, I will discuss it in more depth in Chapter 12.

Professional Online Image Editing

Don't want to do your own image adjustments? Plenty of online photo sites now offer simple editing, including corrections such as red-eye removal, but one online service provides professional-level image editing. Image-Edit & Art by DigitalCustom (www.image-edit.com) can handle serious projects remotely, including face and skin repairs, motion effects, color changes, photo restoration, and digital hand coloring. The company stresses that the work is artist-executed, not automated, and performed by skilled digital artists.

Plug-Ins and Filters

There are dozens and dozens of plug-ins and filters that add to and extend the range of other software. Most are algorithm-based and made for changing, tweaking, and wholesale modifying of images. I can't mention them all, but here are some popular ones that I or friends and colleagues of mine have used to work with Photoshop and most other image editors.

- **DIGITAL ROC, SHO, and GEM (Kodak).** Photoshop plug-ins that automatically correct, restore, and balance the color and contrast/brightness of digital images (ROC); reveal the detail in the shadows and automatically optimize contrast and exposure (SHO); and reduce digital image noise and grain (GEM).

- **PhotoKit (Pixel Genius).** A photographer's plug-in toolkit comprised of 141 effects that offer accurate digital replications of analog photographic effects. PC or Mac.

- **buZZ (Fo2PiX).** Image-editor plug-ins for adding painterly filter effects to images. Can be stacked to combine effects. Remove distracting detail from an image. Turn a so-so photograph into a work of art. PC or Mac.

- **Photo/Graphic Edges (Auto FX Software).** Version 6.0 includes a suite of 14 artistic effects for photographs, including the flagship "10,000 edges" (that's right; 10,000!—see Figure 4.9). Plug-in for Photoshop, Photoshop Elements, Paint Shop Pro, and CorelDRAW, or stand-alone application. PC or Mac.

Figure 4.9 One of 10,000 edge effects using Auto FX Software's Photo/Graphic Edges program on a photograph by the author.

File Formats, Image Compression, and More. . .

Image processing also requires an understanding of file formats and image compression before a final image can be printed, transported, or stored.

File Formats

Image files are stored, shipped, saved, and opened in specific formats. Depending on which platform you're on (PC or Mac) and which version of Photoshop or other major image editing programs you have, there might be up to two dozen file formats to choose from. But for most imagemakers working with digital printing, there are only a few real choices.

Native Format

If you do a lot of work in Photoshop CS or Elements, the native format (PSD) is the one to use for preliminary work (CDR is CorelDRAW's native format; RIFF is Painter's). It saves all layers, channels, paths, etc., in the most flexible way. However, native files can get very unwieldy with all the layers and adjustments, and while you can usually print from PSD, final work destined for output is usually saved in a format like TIFF.

TIFF

Tagged Image File Format (TIFF) is the standard image file format accepted by virtually all painting, image editing, and page layout programs. And starting with Photoshop 6.0, TIFFs have most of the same layers, vector shapes, paths, and

channels that exist in the native PSD format. What most people do is store the master, layered PSD file and make a flattened TIFF copy for sending to the printer (yours or anyone else's) or for importing into a page layout program. TIFFs also compress nicely and support color management profiles. Macs and PCs each deal with TIFFs differently; if you're sending your file out for printing, make sure you find out which version they want (see Figure 4.10).

Figure 4.10 Photoshop CS offers plenty of options for saving in TIFF format.

PDF

PDF (Portable Document Format) is gradually becoming the standard transport format for complex graphics, including text and images. With a PDF, all the fonts and images have been converted to objects that can be seen by anyone with Acrobat Reader, which is freely available. PDF file sizes are tiny, and this file format will continue to play a large role in all types of digital printing. To make a PDF, you'll need to use Adobe Acrobat or some form of PDFWriter, if your software program includes it; some applications also create PDFs directly.

There are also plenty of other file formats out there, but they're used mostly for specific purposes that usually have little applicability to the digital printing of high-quality bitmapped images. Examples: DCS, a version of EPS; PICT (Mac)/BMP (PC), mainly for internal Mac or PC use; GIF and PNG, primarily for Web compression; and PCX, for limited Windows use.

(For information about color models such as RGB and CMYK, see the next chapter, "Understanding and Managing Color.")

Name That File

File extensions are those three- or four-digit characters after the dot on file names. The problem is, Macs don't need them (and until OS X, Macs didn't use them at all), and PCs require them. This isn't an issue if you are staying in your own closed-loop world: your computer and your printer. But as soon as you have to send a file to someone else—a professional printmaker or photo lab, for example, you have to make sure everyone is speaking the same language.

PC users won't be able to recognize a file without the correct file extension. And Macophiles can have the same problem with PC files, depending on its type and name. So the safest thing to do is consistently name your files correctly right off the bat all lowercase, no weird characters, no spaces, and use the correct file extension.

Image Compression

Compression is used primarily to shrink a file's size for transport or storage. There is normally no reason to compress a file while you're working on it, but if you have to compress, it's critical to understand the difference between the two categories: *lossless* and *lossy*.

The lossless variety compresses without removing any color or pixel data from the file. Lossy removes data. (Obviously, lossless is the way to go whenever possible.) The most common file format compression techniques are as follows.

LZW

LZW (which stands for Lemple-Zif-Welch, in case you're wondering) is a lossless compression process. It's part of the TIFF format (GIF, too) and can be used whenever you're saving a file. (It's one of the few TIFF options available prior to Photoshop 6, 7, and CS.) It doesn't compress as much as JPEG and is not supported by all output devices or outside service bureaus. Use it sparingly or not at all.

ZIP

ZIP is another lossless TIFF compression option in later versions of Photoshop and Elements. It works best with images containing large areas of single color.

JPEG

JPEG is the standard *lossy* format for bitmapped images. You can easily adjust the amount of compression and, with it, the quality of the image. The more you compress, the worse the image gets, eventually showing visible artifacts and breaking up into small image blocks. Amazingly, and as my test in Figure 4.11 shows, even JPEGs set to "Low" can produce useable results, while the "0" (lowest) setting can

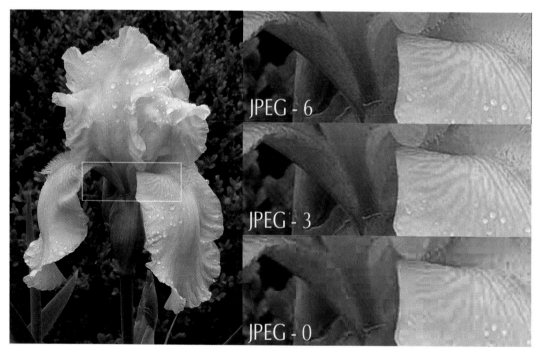

Figure 4.11 A low-resolution digicam image as an uncompressed TIFF (left), with, from top, medium to low JPEG compressions. The "0" (lowest) quality shows obvious compression blocks.

CAUTION! While it's fine to print from JPEG, avoid opening a JPEG file and resaving it in the JPEG format. Depending on the quality setting, you will lose data each time, and if you keep doing it, you could end up with a bowl of digital mush. The best thing to do is open a JPEG and immediately Save As to a TIFF or a native image editing format.

reduce a file's size more than 94 percent (although you would rarely use this setting because of the poor quality). Keep in mind that JPEG compression (or any compression option except LZW) of TIFF files will make them un-openable to many programs, including older versions of Photoshop. In addition, all layers are lost with JPEGs.

File Transport, Storage, and Archives

The files that imagemakers create tend to be large. No, huge is a better word. Like dust balls, image files constantly accumulate, and when they're also large, they can become a problem when you have to take or send them somewhere, or when you want to store and archive them for the future.

Transporting

If you need to get an image file to someone, you have three basic choices: send it electronically (e-mail, FTP), drop it in the mail or call FedEx, or get in the car and take it yourself. If you're sending it electronically, you could use one of the lossless archiving utilities such as StuffIt (Mac) or Zip (PC); just make sure that the person on the other end has the same program, or they may not be able to open it. JPEGs are also a possibility, if made with high compression settings.

If you're physically sending or taking your files, CD-Rs (700 MB), CD-RWs (650 MB), DVDs (4.7 to 9.4 GB), and even digital camera memory cards are commonly used to move files around. However, if you're sending your files out to a print service provider, make sure you talk to them first about acceptable file and transport formats (as well as resolution, color management profiles, and such).

Storing

All the above methods will also work for storing your in-progress as well as finished image files. You can either save files onto transportable media and store them somewhere safe (in a separate location, if you're a stickler for security), or you can buy auxiliary hard drives and/or tape backup systems to do the same thing. Many digital imagemakers do both: using external hard drives with capacities of up to 1 terabyte for primary storage and removable disks like CDs or DVDs as extra backups. With data storage space becoming less costly all the time, many power users are now even moving to multiple hard drives in a RAID (Redundant Array of Inexpensive Disks) configuration to store their huge files.

Archiving: Managing Your Images

Sometimes, the biggest problem with archiving is not the storage space, but knowing where everything is. This is called "digital asset management" or "image management," and there are lots of software products available to help you keep things straight.

A couple of built-in image managers include Photoshop CS's enhanced File Browser and Apple's iPhoto for Macintosh (only). Photoshop's and Elements' File Browser may not be as powerful as third-party asset management software, but it's sometimes easier to work with files directly in the program where you're likely to be using them. File Browser lets you view, sort, and process image files, and you can use it to rename, move, and rotate images. It uses flags, key words, and editable metadata to quickly organize and locate "image assets."

Adobe Photoshop Album is a separate (and inexpensive) software package that's designed to integrate with Photoshop Elements. It organizes and finds images by date or keyword tags, and it also does basic image editing like cropping, adjusting brightness, and removing red eye. (Windows only.)

Other lower-priced options for image management are these "picture viewers" or image browsers: ACDSee (ACD Systems), ThumbsPlus (Cerious Software), and IrfanView (shareware). All these are Windows-only.

Serious digital asset managers also use more sophisticated third-party programs like Extensis Portfolio (see Figure 4.12), Canto Cumulus, and iView MediaPro.

Figure 4.12 This screen shot from the Mac OS X version of iView MediaPro illustrates the thumbnail view with medium-sized thumbnails (256×256 pixels). Under each thumbnail are lines with customizable fields (in this case showing the file name and modification date). To the left, in the Organize Panel, is file information including an automatic sorting function based on embedded file information. Keywords can also be created easily with drag-and-drop simplicity.

Courtesy of Andrew Darlow www.andrewdarlow.com

To fully understand the digital printing process, you have to become an intimate friend of color. It's now time to tackle one of the most important and complex digital subjects of all.

5

Understanding and Managing Color

Color—and how it affects your printing—is one of those bottomless subject pits. Many people have a hard time wrapping their minds around digital color, so as I've done before, I'll break it down into bite-size pieces.

Color Basics

To understand color, we need a quick course in color theory.

What Is Color?

Color is what happens when our eyes perceive different wavelengths of light, which is that part of the electromagnetic spectrum that occurs roughly between 380 and 760 nanometers. A nanometer ("nm," or one billionth of a meter) measures the distance between the crests of a light wavelength. Wavelengths shorter than 380 nm are outside our ability to see them, and they're called ultraviolet or UV. Wavelengths just over 760 nm are likewise invisible and are called infrared or IR.

There are lots of other types of electromagnetic radiation like X-rays, microwaves, radar, and radio, and those are also invisible because our eyes and the rest of our vision apparatus are sensitive only to a tiny slice of the energy pie (380-760 nm). This is called the *visible spectrum*, or more commonly, just *light* (see Figure 5.1).

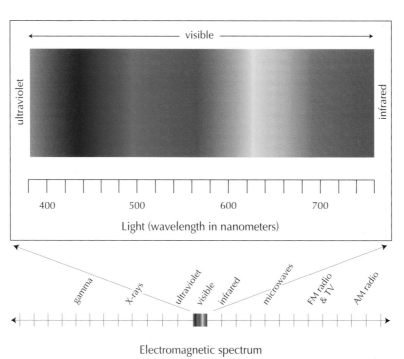

Figure 5.1 Light is only a small sliver of the electromagnetic spectrum.

The basis of color is *trichromacy*, which refers to the three color channels or receptors of the human retina. What this means is that with only three primary colors in either the subtractive or additive color systems, all—or most—of the other colors can be created.

With *subtractive color*, light is reflected off objects that absorb some of its wavelengths and let others continue on. Our eyes interpret those remaining wavelengths as color. In other words, the color of an image on a piece of paper is what's left over *after* the ink and the paper have absorbed or subtracted certain wavelengths (see Figure 5.2). If green and red are absorbed, what we end up seeing is blue, which is in the 400–500 nm range. If cyan and magenta are absorbed, we see yellow. If we keep subtracting wavelengths by piling on more dyes or pigments, we end up with black. (See Chapter 8 for a more in-depth look at printing inks and color.)

The subtractive primary colors are cyan, magenta, and yellow. The secondaries are red, green, and blue (see Figure 5.3).

The *additive color* system, which applies to light coming from a computer monitor or stage lighting, is different in that, if you add colors, you ultimately end up with white, not black. The additive primaries are red, green, and blue. The secondaries are cyan, magenta, and yellow.

Figure 5.2 When full-spectrum white light that contains all wavelengths (left) strikes the sky portion of the print, the red wavelengths are absorbed (subtracted), and the green and blue wavelengths are reflected back to produce the cyan color we call "sky blue." All the wavelengths are reflected back from the white clouds since there are no dyes or pigments there.

Here's how color is created on computer monitors. Traditional cathode-ray-tube (CRT) monitors have "guns" that shoot electron beams toward the inside of the screen where they strike a phosphor coating. When a beam hits a red phosphor, it gets excited and emits light—light of a wavelength perceived as red. The same thing happens with the green and blue phosphors. As the voltage of a gun changes, so does the intensity of the light. (Flat-panel, LCD monitors work differently by using filters to either block the light or allow it to pass. There are no electron guns; instead, tiny transistor switches—one each for red, green, and blue—sit in front of each screen pixel and control the light through polarization.)

Corresponding to the binary data in the digital file, each pixel on a monitor screen is made up of combinations of red, green, and blue in varying intensities (256 levels in 8-bit mode). All the other secondary colors come from differing combinations and values of the three primary colors. As the intensities (brightness) of the individual colored pixels increase, they get lighter.

Subtractive Color

Additive Color

Figure 5.3 The subtractive primaries (left) and the additive primaries (right). Notice how the overlaps (secondary colors) become the primary colors of the other system (and at the same time the complement of the remaining primary).

Color Attributes

One way of defining color is by the three attributes of *hue*, *saturation*, and *brightness*. Each plays an important role and shows up over and over again in the image-making process.

- **Hue** is a primary descriptor of a color. Red is a hue. Yellow is a hue. A hue is the name from that region of the spectrum where most of a color's wavelengths dominate. A spectral curve diagram showing reflected red would show wavelengths peaking around the 700 nm range.

- **Saturation** (also called "chroma" by traditional artists) describes how pure or vivid the color is. Since most real-world colors combine more than one wavelength, the fewer the extraneous colors, the more saturated the color.

- **Brightness**, a primary function of vision, means how light or dark a color is.

These three attributes are visually represented by color spaces, which I'll discuss next.

Color Spaces

One of the problems with color is that it's so subjective. In order for people all over the world to talk about color in the same way, what's needed is a common language to quantify and discuss it. In 1931, an international group called the Commission Internationale de L'Eclairage (CIE) met in England and developed a method to describe color for the "standard observer." This effort resulted in the very powerful tool called color spaces.

Color spaces (sometimes called *color models*, although they are technically different things) are crucial to working with and communicating about digital color. They exist to quantify it; to take it out of the subjective and give it names and numbers.

A color space is an abstract, three-dimensional range of colors. Photographer Joseph Holmes describes it as something like a football standing on its end with white at the top and black at the bottom. A line drawn top to bottom through the center includes all the grays. The various hues of the visible spectrum wrap around the ball as the colors go from gray on the inside to their most colorful (saturated) on the outside.

Color consultant C. David Tobie uses the analogy of a tent. The three corners of the tent are attached to the ground with three tent pegs: red, green, and blue. How far you move the pegs out determines the size of the tent or color space. The tent is held up in the center by a pole, which is its gray axis. Raising or lowering the tent on the pole changes the gray balance and the *white point*, which is where the pole supports the top of the tent. Colors further away from the pole are more saturated, those closer, less saturated.

You'll notice that the two color space descriptions just given closely match the three color attributes of hue, saturation, and brightness.

Somewhere between a football and a tent, this wire-frame representation of the sRGB color space shows LAB coordinates and L-dimension toning. To get the full effect, ColorThink (www.chromix.com) allows you to spin the graph to see the 3D volume in motion.

Graphing by CHROMiX ColorThink

Following are the two most important color spaces for imagemakers.

RGB

RGB is the dominant color space for digital imagemakers. It's based not only on the viewable colors on a television screen or computer monitor, but also on the fact that red, green, and blue form the basis of the *tristimulas* model of color perception, which scientists have now discovered corresponds to how our nervous systems perceive color.

RGB is the default space for most digital cameras and scanners (*all* scanners scan in RGB), and it's the preferred space for digital photo print and most desktop inkjets. That last one may surprise you, but even though inkjets must print real inks on real paper in CMYK fashion, they prefer RGB files, and some people actually call them "RGB devices." I wouldn't go that far, but it is true that Epson printers, for example, are RGB-based, and if you send CMYK information to an Epson through its normal printer driver, it will first convert the data to RGB and then back again to CMYK for printing! (The CMYK section is next.)

RGB is *device-dependent*, which means that the color you end up with depends on the device you send it to or the RGB space you define it in. This is what I call "The Circuit City Phenomenon." Go into any appliance store like Sears or

Circuit City, and pay a visit to the television department. Stand there in front of the wall of TVs for a moment, and you will instantly understand the problems of working with color. Even though every TV may be set to the same channel, all the screens look different! The same with digital devices. Some have large color gamuts, some don't. Some clip colors, some don't. Fortunately, advanced image editors like Photoshop, Elements, and others help you control some of these uncertainties.

Note: RGB can also come in several sub-varieties called RGB working spaces (in Photoshop, they are: Adobe RGB (1998), ColorMatch RGB, AppleRGB, and sRGB), however not all image editing programs provide this capability. The full version of Adobe Photoshop does.

Color Space Gamuts

One of the important, distinguishing characteristics of each color space is its *color gamut*, which defines the entire range of possible colors in that system (it can also apply to material and devices like monitors and printers). The larger or "wider" the gamut, the more colors available. Although most people believe that the gamut of RGB is larger than that of CMYK, that isn't exactly true, as both have portions outside the other. Figure 5.4 shows how some CMYK colors fall outside the RGB gamut, making them unviewable or *clipped*. This is also called being *out-of-gamut*, or in color tent terms, outside the tent.

Also realize that these 2D diagram plots don't tell the whole story, since they represent only one view of a 3D color space.

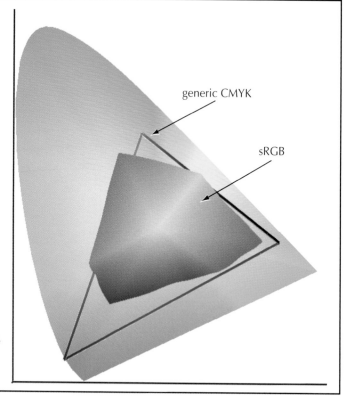

Figure 5.4 The different gamuts of two sample RGB and CMYK color spaces.

Graphing by CHROMiX ColorThink

CMYK

CMYK is another device-dependent color space. CMYK is short for Cyan, Magenta, Yellow, and Black ("K" for Key), which are the four, subtractive, process printing colors. CMYK is the de facto standard of the commercial printing industry, so you might run into CMYK any time you want to create an advertisement, a brochure, or any project that will end up being printed on an offset lithography press. The full version of Photoshop has a "Soft Proof" function that, in combination with ICC profiles, allows you to get a fairly good monitor representation of how things will look in a particular CMYK without permanently committing yourself to that printing space. This keeps you from being surprised at the final printing step, and it lets you make appropriate image adjustments in advance. Unfortunately, not all image editing software programs have this capability.

Tape the following Color Cheat Sheet to your monitor until you have it memorized:

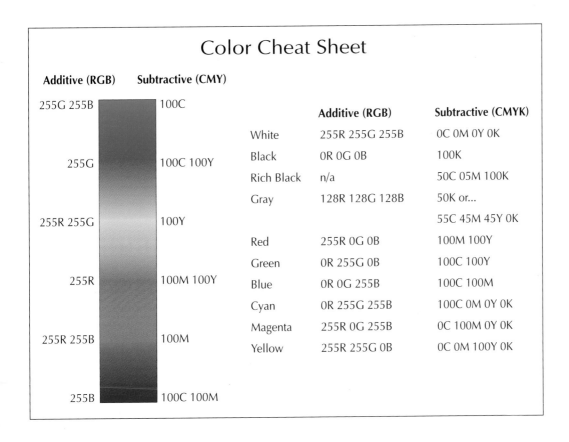

Color Cheat Sheet

Additive (RGB) **Subtractive (CMY)**

	Additive (RGB)	Subtractive (CMYK)
White	255R 255G 255B	0C 0M 0Y 0K
Black	0R 0G 0B	100K
Rich Black	n/a	50C 05M 100K
Gray	128R 128G 128B	50K or...
		55C 45M 45Y 0K
Red	255R 0G 0B	100M 100Y
Green	0R 255G 0B	100C 100Y
Blue	0R 0G 255B	100C 100M
Cyan	0R 255G 255B	100C 0M 0Y 0K
Magenta	255R 0G 255B	0C 100M 0Y 0K
Yellow	255R 255G 0B	0C 0M 100Y 0K

Additive (RGB) gradient labels: 255G 255B (100C), 255G (100C 100Y), 255R 255G (100Y), 255R (100M 100Y), 255R 255B (100M), 255B (100C 100M)

What Is Color Management?

Color management is one of those terms like health maintenance. Everyone has a vague idea of what it is, and most admit it's important, but few actually understand it. The crux of the problem is this:

- Human eyes can see more colors than can be reproduced by digital devices—scanners, cameras, monitors, or printers.

- The color gamuts of all scanners, cameras, monitors, and printers are *different*. The color you see depends on the device that's producing it. Monitors can display more colors than can be printed; some printing colors cannot be seen on a monitor.

- Color reproduction is like a funnel. As you move down the art production line from input to onscreen display to final print, the color gamut, in general, shrinks (you lose colors).

- Monitors and printers see color in completely different ways. Monitors use the additive color system; printers use the subtractive. Colors printed on paper look dull and dreary compared to their brighter and more energetic monitor counterparts.

The result of this quadruple threat is that images don't always end up the way you imagine them in your mind or how you see them on the monitor.

The goal, then, behind managing your color is simple enough—WYSIWYP— What You See Is What You Print. Color management in its most generic and simplistic form merely means rendering color across different devices—digicams, scanners, monitors, print devices—in a predictable, repeatable way.

Sometimes you're lucky. You buy a new inkjet printer, you hook it up, and your prints come out looking gorgeous right off the bat. (Note: Seiko Epson has a technology called PRINT Image Matching System—P.I.M.—that helps P.I.M.-enabled digital cameras and certain Epson printers work together for improved printing.) However, the reality is this: An image can pass through many hands and be affected by many variables on its way to final output—digital cameras, scanners, computer hardware and operating system, image editing software, the viewing environment, monitors, and printer software. At any one of those checkpoints, an image can be compromised. Even at the last step of printing, you could be dealing with different inks, paper, and even different printing technologies. A lot can go wrong on an image's path to glory, and, unfortunately, it usually does.

Enter *color management systems* (CMS). A CMS is a software solution to the problems facing all digital imagers. It's a way to smooth out the differences among devices and processes to ensure consistent color all along the art production chain.

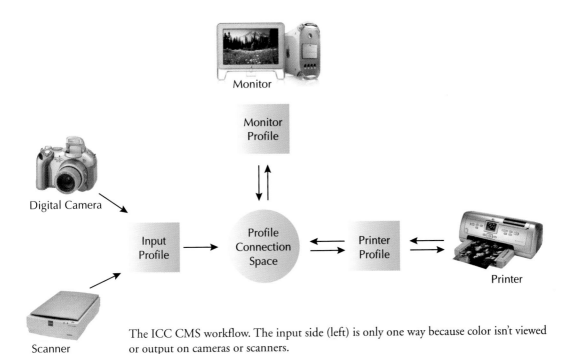

Monitor

Monitor
Profile

Digital Camera

Input
Profile

Profile
Connection
Space

Printer
Profile

Printer

Scanner

The ICC CMS workflow. The input side (left) is only one way because color isn't viewed or output on cameras or scanners.

Instead of using eyes and a brain, which are easily fooled, a color management system utilizes cold, hard, unbiased numbers. A CMS helps you calibrate, characterize, and finally print your images accurately and predictably. It's more than WYSIWYP, it's WYSIWYPET—What You See Is What You Print, Every Time. At least, that's the theory.

A quick note: To utilize a CMS, you also need to have an ICC-savvy image creation or image-editing software program. (ICC stands for International Color Consortium, a vendor-sponsored group hoping to make color consistent and clear.) There are actually three possible places to do color management: (1) at the printer driver level, (2) at the application level, and (3) at the operating system level. The application level is best.

Photoshop is the ultimate ICC-aware software since Adobe, its maker, is a founding member of the ICC. (Adobe Photoshop LE is not ICC-aware, but Photoshop Elements is in a limited way.) Painter, CorelDRAW, PhotoImpact, and Paint Shop Pro are also ICC-aware to varying degrees. You also need an ICC-friendly operating system, but with the exception of Windows NT, virtually all currently used ones are.

Assuming that you now believe in color management, let's see how it actually works with our two main areas of device concern—monitors and printers.

Monitor Calibration and Profiling

Good monitor-to-print coordination starts with the monitor in a two-step process: calibration, then profiling. The point of monitor calibration is to bring the screen back to a group of standard settings for white point (the blended color of white), white luminance (the brightness of white), gamma (a simple curve to relate to the eye's non-linear response to light), black luminance (which defines the detail in darks and avoids black clipping), gray balance (neutrality of grays), and tonal response (how evenly a gray ramp runs from black to white). When you calibrate a monitor (more accurately a "display" that includes the monitor and video card and driver), you actually change its settings and its behavior. Those new settings are then in effect every time you start up the computer. And that, in turn, affects how you view and correct your images. If, for example, your monitor is set too bright, then your prints may end up too dark because you erroneously tried to darken them onscreen to look better. That's why monitor calibration is so important for a correctly color-managed digital workflow.

Monitor profiling is step two, which measures and describes the personality of *that* particular monitor. Profiling doesn't actually change anything, it just keeps track of how the monitor is set up. You calibrate *before* you profile, although in many instances, calibration and profiling occur in a continuous process, especially if you're using third-party software packages.

Monitors should be calibrated and profiled regularly; weekly is a good target. Some imagemakers keep a schedule of calibrating their monitor first thing Monday morning (after letting it warm up first).

There are two basic ways to calibrate and profile a monitor: eyeballing it visually using software alone or using a measuring tool on the monitor.

Eyeballing It

Adobe Gamma (a Photoshop accessory for Mac and Windows) or Monitor Calibrator (an Apple OS utility) is a straight-forward, wizard-like, visual calibration process (other image editing applications have their own versions of this), so I'm not going to walk you through it. After a series of steps that include adjusting the monitor for white point, contrast and brightness, and phosphor RGB output levels, you end up with a monitor profile that Photoshop and other ICC-savvy applications must have to display colors correctly on screen.

The main reason I'm giving Adobe Gamma (or similar visual procedures) scant mention is because I don't think it's the best way of calibrating a monitor. It's very dependent on the viewing environment; plus many people have a hard time evaluating and comparing colors, and that's partly what these built-in software calibrators rely on. In addition, even at its best, Adobe Gamma does not cover all the functions that hardware monitor calibration controls.

To be sure, eyeballing it is better than no calibration at all, but if you have the option, go with a third-party, instrument-based calibration/profiling system.

Using a Measuring Device

This is a better way to do monitor calibration and profiling because it's based on objective measurements, not just your visual opinion about how good your monitor's display looks.

Hardware-based profile-generating programs do two things for monitor color: (1) calibrate your monitor by automatically measuring test patches and adjusting a combination of the RGB guns and the video board, and (2) create a monitor ICC/ICM profile that your editing software refers to when displaying images. When a display or monitor profile is correctly stored on your system, any ICC-aware application can use the profile to tweak the onscreen display and make it more objectively accurate. If you also have a printer profile (see below), that profile is added to adjust the display of your images onscreen.

Where is this profile stored? For Windows, it's in the Color directory, at locations differing with various versions of Windows. For Mac OS X, it's in the Profiles folder inside the ColorSync folder, in the root-level Library, and the similar folder in your User Library.

Because profiling is such a hot topic, there are lots of companies competing for your color management dollars, including ColorVision, X-Rite/Monaco, and GretagMacbeth.

CAUTION! Make sure you only use a measuring device made for the type of monitor you have. Suction cups should never be adhered to LCD screens.

X-Rite's MonacoOPTIX^{XR} colorimeter for calibrating and profiling CRT and flat panel displays.

Courtesy of X-Rite, Inc.

Printer Calibration and Profiling

As with monitors, getting printers to output what you want consistently is, at its best, a two-part process: *calibration* and *characterization* (or *profiling*).

Printer Calibration

The reason I qualified the sentence above with "at its best" is because while printer calibration is always desirable, it is not always possible, nor common. In the context of color management, calibration means changing the printer's behavior to bring it into a predictable state where ink densities and tonal values are known and stable. However, while many high-end digital printers offer printer calibration with the use of on-board measuring devices, many inkjets do not have a built-in form of calibration. One of the few desktop inkjets to offer this function is the HP Designjet 30/130 inkjet printer, which has its own automatic, closed-loop color calibration procedure.

The thing to do with any printer that cannot be calibrated is simply to re-profile it if colors start to drift or look wrong. This is what Epson suggests for its desktops.

Is not being able to calibrate a printer a major issue? It's more important for printers that are used for professional proofing and press emulation where there's no room for color error. For normal bitmap image printing with inkjets, it's not as vital, although still desirable.

Printer Profiling

In a color-managed workflow, this is where *output device or printer profiles* come into play. Compared to monitor profiling, you're dealing with an even wider range of variables with printers. Fortunately, all these variables are taken into account by printing, and then measuring, targets with an instrument and creating ICC profiles from those measurements. When you're ready to print using *those exact same* settings, inks, and paper, you select that ICC profile in your image editing software, and out comes a much-improved print! (see Figure 5.5)

One thing to emphasize about printer profiling is that it's not the printer that's profiled! Instead, it's the combination of printer resolution and driver settings, ink, and paper. Change one variable, and you need a new profile. That's why it's common for digital imagemakers to have many different printer profiles, one for each printer/ink/paper combination.

Where do printer profiles live in the computer? The locations vary depending on platform and OS version. They are basically the same as with the monitor profiles.

Figure 5.5 To profile a color printer, first print the color management target, then measure the target using a device connected to the color profiling package to create an ICC profile. Popular instruments for profiling include the ColorVision SpectroPRO spectrocolorimeter (left), and the X-Rite DTP41 spectrophotometer.

Courtesy of ColorVision, Inc. and X-Rite, Inc.

A World of Profiles

Where do printer profiles come from? There are three main sources: *generic* or *canned*, *custom-made remote*, and *do-it-yourself with profile-building software* (see Table 5.1). (For information about acquiring and using printer profiles with outside service providers, such as photo labs with Fuji Frontiers or printmakers, see Chapter 11.)

Table 5.1 Printer Profiles

	Generic	Custom	DIY Scanner-based	DIY Spectro-based
User level	Beginner and up	Serious amateur and up	Amateur/serious amateur	Professional
Convenience level	Very easy	Easy	Moderately difficult	Difficult
Supported printers	OEM only	All	All	All
Type of profile	RGB	RGB/CMYK	RGB/CMYK	RGB/CMYK + specialty
Cost	Free	$100 average per profile	$79 to $329 per package	$1,000 to $10,000 per package

Generic Profiles

Canned or generic profiles come in two basic varieties: (1) preloaded in the printer-driver software by the manufacturer for use with its recommended inks and media, and (2) available from third-party providers of inks and media for use with their products. Keep in mind that these profiles are made for all printers of the type you have. They don't take into account any individual characteristics of your printer or anything that's specific to your workflow. They're made for the average printer, and for that reason, they may or may not be adequate for your needs. Consider them as starting points to get you in the ballpark of good printing.

Generic profiles are often free, especially if the supplier is trying to sell you something else. However, you can also buy them from several sources for under $50 each. The emphasis is on the word *each*. If, for example, you needed a profile for an Epson 2200 running original Epson inks on Arches Infinity Smooth paper, that's one profile (see Figure 5.6). If you wanted to switch to Arches Infinity Textured paper, that requires another profile. Hahnemuhle Photo Rag? Yet another, and from a different vendor. You can see why people collect *lots* of profiles.

HOME	COMING SOON	PRODUCT INFO	ICC PROFILES	GALLERY FEATURE	SPECIAL OFFER	CONTACT US	WHERE TO BUY

Arches Infinity ICC Profiles Each download includes installation instructions, use in Photoshop, output print settings, and the printer specific profile.

Printer	Driver/RIP	Ink Set	WT g/m^2	Paper	ICC Profile	Size
Epson 2200	Epson	Epson UltraChrome	230/355	Smooth	AISM _EPS2200Ultra.zip	231k
			230/355	Textured	AITX _EPS2200Ultra.zip	232k
Epson 7600	Epson	Epson UltraChrome	230/355	Smooth	AISM_EPS7600Ultra.zip	231k
			230/355	Textured	AITX_EPS7600Ultra.zip	231k
Epson 9600	Epson	Epson UltraChrome	230/355	Smooth	AISM_EPS9600Ultra.zip NEW!	1.17mb
			230/355	Textured	AITX_EPS9600Ultra.zip Nash Editions Profiles	1.17mb
Epson 10000	Epson	Epson Archival	230/355	Smooth	AISM_EPS10000Arc.zip	221k
			230/355	Textured	AITX_EPS10000Arc.zip	221k
HP5000	HP5000PS	HP UV	230/355	Smooth	AISM_HP5000UV.zip	235k
			230/355	Textured	AITX_HP5000UV.zip	234k
Roland Hi-Fi Jet	Onyx	Roland Pigment	230/355	Smooth	AISM_RolHIFIPig.zip	416k

Figure 5.6 Most third-party paper suppliers like Arches provide free downloadable ICC profiles for many popular inkjet printers.

Courtesy of Arches North America

Also realize that profiles require that you use specific printer settings. You cannot change these settings without invalidating the profile. (You can also adjust or modify profiles.)

Custom-Made Remote Profiles

The next step up in printer profile quality is to have someone with professional-grade equipment make custom profiles for you. These will be more accurate because they're specifically created for your unique set of variables including inks, paper, environment, driver settings, etc. It typically works like this: You download a single-page target with numerous color patches that have known values and print it out to exact instructions that include printing with uncorrected settings—you want to capture the good *and* the bad about your printer. You send that printed page to the profile maker who then scans it, builds a profile, and either e-mails or ships it back to you on a CD (or allows you to download it from the web). You need to carefully record all the printer settings when you make the test print, and then use those same settings for all your printing with that profile (which can also be edited or tweaked if needed). Costs average around $100 or less. Again, that's for *each* separate ink/paper/printer combination.

If you don't want to invest the time or money into a profile-making system of your own (see below), and you don't anticipate many printer/ink/paper changes, this can be a good solution. Custom, remote profiles can be purchased from providers such as CHROMiX/ColorValet, InkjetMall.com, and from independent color consultants.

DIY Profiling

As with monitor profiling, you can purchase a profile-making package and create your own printer profiles. Profile-making systems either bundle the printer-profile function with monitor calibration or sell it separately. Doing it yourself has the highest start-up cost (one hundred to several thousand dollars), but if you anticipate needing a lot of profiles, and aren't fazed by the learning and experimenting curve, this may be your best choice.

The workflow is the same as with custom profiles: A reference target is output to your print device using identical print settings, ink, and paper as the final prints made with the resulting profile. Those same patches are then measured with either a regular flatbed scanner or patch reader (lower cost, less accurate) or a spectrophotometer or spectrocolorimeter (more expensive but more accurate). The variances are recorded by the software in the form of an ICC printer profile for that particular combination of variables.

Printer profiles can also be edited or fine-tuned by most profile-building and profile-managing software programs.

Some of the most popular scanner- or patch-reader-based profile-making packages include (at the time of this writing) ColorVision ProfilerPLUS, ColorVision PrintFIX (see Figure 5.7), Digital Domain Profile Prism, and MonacoEZcolor.

Figure 5.7 Designed for amateurs to prosumers, ColorVision's PrintFIX is the first affordable, integrated hardware/software product for printer profiling. As a plug-in for Adobe Photoshop or Photoshop Elements, PrintFIX prints a target that's read back into the computer with a USB patch reader. The software quickly creates an RGB ICC profile for supported inkjet printers.

Courtesy of ColorVision, Inc.

A Color-Managed Workflow

Let's get this out of the way first: The easiest way to obtain adequate print quality is to use the original equipment manufacturer's (OEM) papers, inks, and printer settings. They've already been optimized to work together, and all you have to do is follow the instructions.

But, because most photographers, imagemakers, and artists hope to squeeze the last drops of quality, longevity, and uniqueness out of their images, they're willing to go a little further to get the color they want.

Since space doesn't allow me to explore all the choices and complexities of various color-managed workflow options, I will explain one common digital workflow: desktop inkjet printing with a printer profile.

Using Profiles with Photoshop Elements

You now have a set of color standards (ICC) and understandable, affordable tools to implement them. A color-managed workflow with a calibrated monitor and the use of either generic, custom, or do-it-yourself printer profiles can give you accurate, consistent color. It does work if you spend the time to understand and experiment with profile-generating and profile-savvy software.

Using printer profiles should be seriously considered if

- You're using non-OEM-recommended, third-party inks or media (paper).

- You're using OEM inks and media but want to compensate for their variations over time.

- You're discovering that your printer is inconsistent and you want to characterize its current behavior.

I will now walk you through a few steps of a color-managed workflow. This will be an abbreviated tour focusing primarily on the color-management aspects; I go into a more complete printing workflow in Chapter 9. I'll be using Photoshop Elements 2.0, a calibrated monitor, an Epson Stylus Photo R300 printer, Ilford Galerie Classic Pearl paper, and ColorVision's PrintFIX profiling package.

I've accumulated lots of different paper samples (haven't we all!), and I wanted to see how a 35mm color negative scan would print on a different paper. A perfect assignment for profiles!

1. Open File
I open the scan of my two nieces Kira and Katie in Elements (see Figure 5.8).

2. Edit Image
The scan clearly needs some work, and I do basic image editing with Levels to darken it, remove the overall green tinge, and more, including some retouching and fixing of Katie's (red top) left eye, which is missing its highlight. I create a new master file (see Figure 5.9).

3. Print
Because I had already created a do-it-yourself ICC printer profile for this paper combination with PrintFIX, I select it in Elements by choosing File > Print Preview, and then select Show More Options > Print Space > Profile (see Figure 5.10).

Figure 5.8 The raw scan, ready for corrections.

Photo courtesy of Karen Inga Morgan

Figure 5.9 Raw scan (top left), fixed file with layer adjustments (top right), and final image (bottom).

Figure 5.10 Choosing the printer profile and rendering intent in the Print Preview dialog box of Photoshop Elements.

Rendering Intents (the Intent choices under Profile) are the guidelines or the rules that color systems follow to handle their color gamut transformations or "mapping." There are four available in this drop-down box, and I like the way Relative Colorimetric looks on this print.

The print on Ilford Galerie Classic Pearl is great; better than a control print made without any color management (Note: Ilford also provides generic profiles for this specific combination of paper, inks, and printer, but I wanted to use my own.)

Color management works!

With a better understanding of color under your belt, it's now time to take a look at one of the most controversial and often-debated topics in the digital printing universe: print permanence.

6

What About Print Permanence?

Most imagemakers working digitally are rightly concerned about print permanence. Image stability researcher Henry Wilhelm brings the point home with a dramatic example. "The entire era of picture taking from 1942 to 1953, when people were using box cameras and Kodak's new Kodacolor print process, is lost forever," he once explained to me. "There is *not one single known print* that survives today in reasonable condition; they are *all* severely stained and faded." Pictures and prints are important to people. Maybe not all of them, but that doesn't mean that *none* of them are! And in the digital age, this becomes even more important because, chances are, the digital files will not survive, but the prints will. "It's always been about the print," says Wilhelm, "and we can actually produce right now, at very low cost, extremely stable photographs and prints in color. Do we want to? Ask anybody, 'Which would you rather have: a longer-lasting print or a shorter-lasting one?' What do you think the answer will be?"

Anyone who's concerned about print permanence must grapple with two simple questions:

1. How long is long enough?

2. How do I know if a print will actually last that long?

Family photos have value, but most color prints from the '40s, '50s, and even '60s are now faded or stained. Compare my family's Kodalux print on the left from 1968 with the Kodak black-and-white print on the right from 1953, which, apart from a slight yellowing on the edges, is otherwise in perfect condition. Both were stored in the same shoe box.

How Long Is Long Enough?

I believe most imagemakers sensibly want to be confident that the prints they are making—for themselves or families, or for sale or gift to others—will last for a reasonable amount of time under normal conditions. (What "reasonable amount of time" and "normal conditions" actually mean is, of course, up for grabs.)

The Meaning of Permanence

If we're going to talk about print permanence, then we should at least agree on what that means. Unfortunately, that's no easy task. Here are some different ways to define it:

Image Stability. The dictionary meaning of image stability is "resistance to chemical decomposition," but for the purpose of printing an image, we're talking about what photo conservator Martin Juergens calls "the stability of image-forming substances." These include the inks and/or dyes (together termed *colorants*) and the paper and coating materials (the *media*) used to produce the print. It's the inherent stability of not only the colorants and the media separately, but the ink/media *combination* that is vitally important.

Archival. Although ink and paper manufacturers love to throw around the term "archival," there is no uniformly accepted definition of what is archival and what is not. In fact, the word just means that something is in an archive, being stored,

but not necessarily monitored or preserved. *Archival* has become a marketing term, and it's been appropriated by just about anyone with something to sell in the printing business. They would have you believe that archival—and hence, their product—means "long-lasting," when in fact it may not mean that at all.

Lightfast. Lightfast means resistant to fading. But for how long? Some testing organizations (primarily WIR and RIT/IPI—see "Who's Doing the Testing?") attach usable-life predictions to lightfastness. In essence, they're saying, "Based on certain display or storage assumptions, a print similar to the one tested should last for X years without noticeable fading or should only change this much in terms of its colors or densities." As you will shortly see, there are dangers with this approach.

Permanence. Permanence refers to resistance to *any* physical change, whether it be from light, heat, acids, etc. As an example, an ink can be lightfast but impermanent because it is prone to fast fading when exposed to atmospheric contaminants. How long is permanent? The U.S. Library of Congress, which is responsible for the care of 125 million cultural artifacts, uses "as long as possible" as its goal for preserving and making available to the public its vast collections.

Because no one really knows what permanent or "archival" is, they are relative terms that anyone can claim. In the end, you—the digital imagemaker—must decide how long is long enough.

The Granny Standard

Since there is no accepted time-length standard for image permanence, I decided to invent one. Consider this a benchmark or reference for determining what is "long enough." Here's what I propose:

The Granny, Three-Generation Permanence Standard

The standard answers the following question based on this assumption: A pregnant 30-year-old digital artist and fine-art photographer makes a color print of her favorite image and frames and displays it proudly in her living room. On her son's 30th birthday, the artist gives him the framed print as a present just after his baby daughter is born. The son hangs the print in his living room, and then gives it to his daughter on her 30th birthday. It's now been 60 years. *Question:* Has the print lost any of its image quality or experienced any noticeable fading or other deterioration? (It turns out that Granny was pretty smart and kept a duplicate copy in an acid-free envelope stored in a dark, dry dresser drawer all these years. When her granddaughter asked the question, she was able to pull that print out and compare it to the family-heirloom version.)

The Granny Standard is 60 years of time, which I believe is long enough to be concerned about a color print's permanence. (Note: Determining the measuring criteria and the acceptable limits of fading/color shifting is, of course, another issue and covered later in this chapter.)

What Affects Permanence?

Everything disintegrates eventually, and there are a whole host of enemies willing and able to do damage to your beautiful prints. No matter which type of digital print technology is used, certain *influencing factors* (environmental conditions) can and will affect print permanence. Following are the main culprits.

Light & UV Radiation

Light negatively affects prints through a complicated combination of processes, including photo-oxidation, photo-reduction, photocatalysis, and other photo-chemical reactions that are not completely understood. But, we're all familiar with one of the results of light striking a print's image: fading. Anyone who has seen a faded or discolored poster in a store window knows what this means.

Most fading occurs at the higher-energy end of the light spectrum, especially near the border where visible light becomes invisible UV radiation (in the 380–400 nm range). UV rays—natural light plus fluorescent and some halogen lamps emit significant amounts of UV radiation— can be very damaging to printed images. Regular window glass (or Plexiglas) can do a lot to filter the shorter UV wave-lengths (see Figure 6.1), but beyond that simple procedure, every material—including inks, dyes, and papers—has its own spectral sensitivity and will be

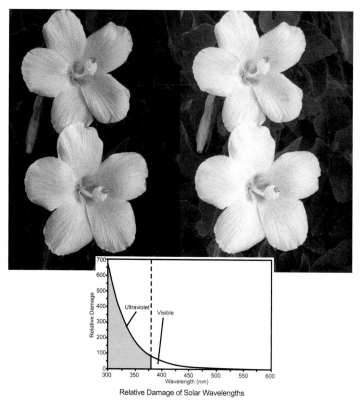

Relative Damage of Solar Wavelengths

Figure 6.1 The print on the left was displayed on a wall for nine months with a standard glass covering in a frame. The one on the right is exactly the same except it was framed without glass. The increased fading is probably due to UV exposure and/or atmospheric contamination. Scientists at the U.S. National Bureau of Standards (NBS) found that UV wavelengths were about three times more damaging than the visible spectrum. The graph at bottom shows the NBS relationship between the wavelength of the radiation and the resulting relative damage. This helps explain why even standard window glass (with a UV cutoff at around 330 nm) is effective in slowing down fading, at least to some extent.

Courtesy of Royce Bair
www.inkjetART.com

affected by light in a different way. In general, the higher the intensity and/or the longer the exposure, the worse the damage from light.

Temperature

Any student of chemistry knows that as the temperature goes up, chemical reactions speed up as well. So it stands to reason that a photochemical reaction such as light fading will be accelerated by higher temperatures. Studies have found this to be true in general. High humidity also frequently aggravates the situation. Extremely low temperatures, on the other hand, can also be a problem, when some materials will become brittle or even crack.

Water & Humidity

Water in its liquid form or as moisture in the air can have a big—negative—impact on prints, primarily those made with dye-based inks and/or on non-porous surfaces. Water dripping, spills, water leaks, flood damage—these are just some of the most obvious potential problems. The original uncoated IRIS prints were so sensitive to moisture that unknowledgeable framers ruined prints with only their own saliva while talking near them! High humidity can also cause problems and, often linked with higher temperatures, makes things even worse.

Paper Comparison (8 Weeks at 73°F)

20 % RH 50 % RH 80 % RH

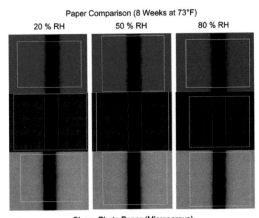

Glossy Photo Paper (Microporous)

Glossy Photo RC Paper (Microporous)

This group of images shows the effect of high humidity on image sharpness. Note how the enlarged 0.4-mm black line bleeds into the adjacent background area on certain resin-coated (RC) papers as the humidity increases. From a study by Creative Memories; printed with dye-based inks on an Epson Stylus Photo 890 printer.

Courtesy of Dr. Mark Mizen Creative Memories

Atmospheric Contaminants

Not only are air pollutants, such as cigarette smoke, cooking fumes, nitrous oxide, and sulfur dioxide, dangerous for most prints, but ozone levels in possible combination with UV radiation may also cause severe problems. And all of that is exacerbated by open air flow across the face of a print, which is one reason why you want to frame all prints under glass or acrylic (Plexiglas) or store them in an album or in sleeves. The resulting problem is also known as "gas fading."

Acidity

As I discuss more in Chapter 8, acidic components in either a print or the accompanying support, backing board, or mat can be eventually destructive. Many inkjet papers on the market are, in fact, produced with an acidic paper base. These papers may have good light stability but will typically have worse dark stability.

Poor Handling

And finally, folding, creasing, smudging, scraping, and fingerprinting, plus poor display and storage procedures—all are possible, and all can reduce the permanence of prints (especially with inkjet prints that do not generally have a protective coating).

Testing for Permanence

As with many areas of human endeavor, knowledge about print permanence can be gained from scientific testing. Just like dropping feathers and apples from tall buildings to investigate the effects of gravity, tests can help explain real-world phenomena if they're carefully constructed and performed under accepted standards. Once you have an idea of what can cause the deterioration of a print (the "hypothesis"), you can test for it.

Types of Tests

Print permanence tests fall under several broad categories.

Accelerated versus Real-Time Testing

Accelerated testing exposes a printed sample or specimen to much higher levels of light or whatever is being tested than would occur under normal conditions. This simulates in a short amount of time any deleterious effects, if any, that a print might experience.

Real-time testing, on the other hand, just lets the test run over the course of weeks, months, or even years under normal display or storage conditions. (A variation of this is real-world testing under extreme conditions; see the "Indoor versus Outdoor Testing" section.)

Indoor versus Outdoor Testing

By "indoor," I mean that the test conditions mimic the environments in which most prints will find themselves: living rooms, offices, or even gallery walls. This is where most of the manufacturer-contracted testing by inkjet and film companies using fluorescent or xenon arc exposures would fit.

What Are Normal Display Conditions, and How Are They Measured?

What's normal? It depends on where you are and whom you ask. According to independent researcher Barbara Vogt, the average amount of light an image is exposed to in U.S. homes is about 215 lux (lux is an illumination measurement) with the temperature and humidity at an average of 21° C and 50% RH (relative humidity). The Eastman Kodak Company says that 120 lux (with 23° C and 50% RH) is a good overall estimate for "typical home display." Henry Wilhelm has adopted 450 lux for 12 hours per day (24° C and 60% RH) to simulate "standard" indoor display conditions. The Montreal Museum of Fine Arts uses 75 lux and 100 lux illumination levels for its exhibits, which it rotates between display and dark storage.

Conclusion? There are no normal display conditions! In fact, there isn't even agreement that lux should be the measurement used. While the photographic world promotes lux because it's based on the human eye's response to light, prints are also affected to a significant degree by the shorter wavelengths (320-400 nm) that typically go undetected when using lux as the metric.

The foyer in this house is lit by a combination of diffused, indirect window light and overhead incandescent spotlights. The midday illumination level at the sailboat painting is around 200 lux.

"Outdoor" tests are typically done either outdoors or with outdoor, real-world conditions prevailing. An example is what Q-Panel Weathering Research Service does (Q-Panel also performs accelerated laboratory tests, and it makes and markets testing equipment). In its Florida and Arizona facilities, Q-Panel conducts fade-resistance testing with real-world sunlight on outside exposure racks (see Figure 6.2). This is considered a "worst-case" scenario, where high sunlight and UV levels combine with high temperatures and high relative humidities to provide an extreme environment.

The theory is that sunlight is full-spectrum and contains all the components of light plus UV and infrared radiation (heat) that can fade a print. The high dosage of these sunlight test exposures also can speed up the testing procedure so that results can be obtained in weeks instead of the years that normal real-world tests would take. This is exactly how many industries—automotive paint, for example—test and improve their products.

Figure 6.2 Q-Panel Weathering Research Service Test Facilities in Florida and Arizona perform fade-resistance testing of ink and media samples on outdoor racks, both glass-covered and not.

Courtesy of Q-Panel Lab Products

Comparative versus Predictive Testing

Is the goal of the test to give results so that different print products can be compared, or is it to give an effective-lifespan prediction for any one print? Big difference.

A *comparative* test compares how different choices perform under that test. How long did it take Sample A to lose X percent of its density? Sample B? Sample C? A rank ordering of the results can then be compared. Assuming identical test conditions, you're testing for the *relative* changes among the samples.

A predictive test, on the other hand, uses a specific set of conditions, and then projects those results out to a predicted lifetime before a predetermined amount of deterioration would occur. It's a calculated guess of a print's "useful" or "service life."

Predictive tests should be viewed skeptically. Compounding the problem is the fact that (1) manufacturers often do not clearly disclose the conditions of predictive tests, and (2) people often don't read the fine print or pay close attention to the conditions on which the tests are predicted.

Visual versus Measurement Testing

The simplest way to test print deterioration is to run different samples under one test, and then visually compare those samples with a control set that wasn't exposed to the test conditions. For a lightfastness test, the controls are either covered up next to the test samples, or they're stored in the dark nearby. Visual tests are usually run by individual imagemakers because they're relatively easy to do. Just line up the samples and visually decide which you like best, or in the case of a lightfastness test, determine which appears to have faded the least.

Most testing labs and serious testers, however, run instrument-measured tests (using a spectrophotometer, colorimeter, or densitometer). Printed color samples are measured before, during, and after the test is complete. The test ends either when a stated period of time has elapsed, a certain amount of irradiance (exposure) has accumulated, or a specified densitometric *endpoint value* is reached. The measurement values are then computed or graphed for analysis (see Figure 6.3).

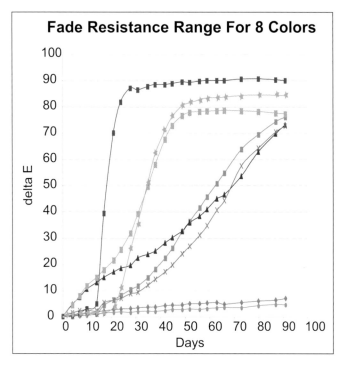

Figure 6.3 A graph of fade resistance for eight lithographic inks using total color change expressed in ΔE (Delta-E) units.

Courtesy of Q-Panel Lab Products

Lightfastness Tests

All prints will *photodegrade* in the presence of light. That means that they undergo a photochemical reaction when exposed to light-waves, and they start to deteriorate. The changes can be in the form of fading, darkening, or changing hue (color). The more resistant a print is to this inexorable process, the more lightfast it is.

One problem with lightfast testing is that it may or may not take into account all the other factors that cause prints to fail. Is it really just the light that makes a print fade? Or is it also the humidity, the temperature, and the air quality? As you might expect, it's usually all those things and possibly even others that have yet to be discovered.

Another problem with lightfast tests is that the methods and test protocols vary from tester to tester. From endpoints to reference display conditions and light-source choices, there is no uniformly accepted way to conduct a lightfastness test. Creative Memories' Dr. Mark Mizen has a good analogy to fit this state of affairs: "It's as if Ford decided to measure gas mileage only going downhill, while Chrysler

chose a level road. Both methods would give a gas mileage; yet the numbers would be very different and would not allow a fair comparison." You can see why this testing business is so tricky.

Other Tests

Other important tests that are currently being carried out or being developed by standards groups include

- **Dark Fading.** Dark fading is usually the result of the inherent instability of the colorants and the media, or because of the effect of other influences such as heat, humidity, and environmental contaminants. Dark fading can be exacerbated by high temperatures and/or humidity, and this type of test is frequently conducted in high-temperature ovens or "accelerated aging chambers."

- **Gas Fading.** For air pollutants, air flow, and ozone.

- **Waterfastness.** For water fastness and outdoor durability: the drip test, the pour test, the standing water evaporation test, the standing water plus gentle wipe test, and the water smear test (see Figure 6.4).

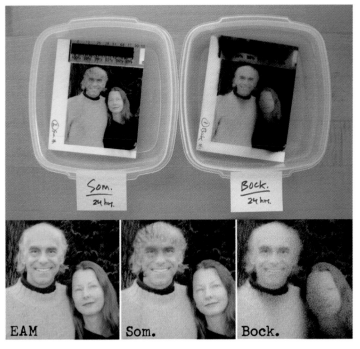

Figure 6.4 Part of a waterfastness test from the author's testing of several inkjet papers. Top: Portions of the print tests were cut out and immersed into separate Tupperware bowls of water. Bottom: After only 24 hours of water immersion, the differences were striking among three different ink/paper combinations.

- **Humidity-fastness.**

- **Fingerprint Test.** For handling damage.

- **Chemical and Biological Stability**. To test resistance to attack by chemicals and biological agents.

Who's Doing the Testing?

There are three kinds of groups doing print permanence testing and making permanence claims: *independent testing organizations and researchers*, *manufacturers and marketers*, and *individual photographer-artists*.

Testing Organizations and Independent Researchers

These are the scientists, the university-based, non-profit research laboratories, and the independent labs that do the most well-publicized testing of print permanence.

Wilhelm Imaging Research (WIR)

Henry Wilhelm (see Figure 6.5) is the dominant figure in both photographic and now digital print permanence testing. He wrote the ground-breaking book *The Permanence and Care of Color Photographs* (1993), he is on the key industry standards committees (ISO) and panels, and he is a consultant on image permanence to such prestigious institutions as the Museum of Modern Art in New York.

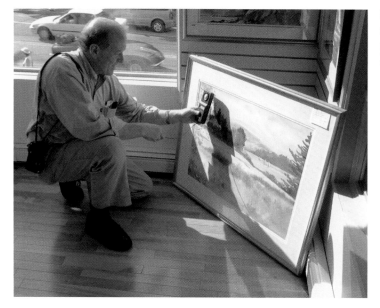

Figure 6.5 Image-stability researcher Henry Wilhelm at the Maine Art Gallery in Kennebunk.

© 2000 Mark H. McCormick-Goodhart

Wilhelm Imaging Research (WIR) is based in the college town of Grinnell, Iowa and does both independent contract testing on prototype materials for companies as well as generic testing for public consumption. When you see permanence claims made by ink vendors or inkjet printer makers, there's a good chance that WIR did the tests from which the results were drawn.

IPI/RIT

The Image Permanence Institute (IPI) at the Rochester Institute of Technology (RIT) is a university-based, non-profit research laboratory in Rochester, New York that's devoted to scientific research in the preservation of visual and other forms

of recorded information. Under the direction of James Reilly, IPI is the world's largest independent lab with this specific scope, and they have sponsors who include the likes of Eastman Kodak Company, 3M Company, Fuji Photo Film Company, and Polaroid Corporation.

Q-Lab Weathering Research Service

The testing service of this Ohio-based company is an accredited independent lab and run as a separate division of Q-Panel Lab Products, which makes testing products such as xenon arc chambers. Q-Lab Weathering Research Service performs accelerated laboratory light-stability and weathering tests as well as natural, environmental exposure tests using its Florida and Arizona locations. (Atlas Laboratory Weathering Testing provides similar services.)

Independent Researchers

Independent researchers like Joy Turner Luke also conduct scientific testing. Traditional artist, art educator, and color expert, Luke conducts skylight (sunlight) and xenon arc tests in her northern Virginia studio where she has been doing inkjet lightfastness testing on her own for more than seven years (see Figure 6.6).

Figure 6.6 Permanence researcher Joy Turner Luke in her studio working with an Atlas SUNTEST XLS+ xenon testing instrument (furnished by Atlas Material Testing Technology for her ongoing research).

Manufacturers, Vendors, and Distributors

Some manufacturers (Kodak, for example) do their own tests and use the results in promoting their products. Others, like Epson, HP, and Canon (who do some internal testing as well), contract with independent testers, like WIR or IPI/RIT, to perform their tests, and then use the results in their marketing.

Some vendors and distributors also do their own testing. InkjetART.com does both internal and contract fade testing on some of the papers and inks that it sells, and Jon Cone's InkjetMall.com does xenon-based fade tests with its in-house ink brand compared to others. Digital printing supplies distributor LexJet Direct contracts with WIR to test its products.

The problem with vendor-sponsored tests and claims, besides an obvious bias, is that they tend to generalize and simplify what is a very complex interaction of separate elements that can contribute to significantly different results, depending on the display or storage conditions. There just is no standardized "miles-per-gallon" way to describe print permanence. At least not yet.

Individual Artist Testing

There are many imagemakers who, in an attempt to compare products and get accurate information about *their specific* materials and methods, do their own permanence tests. For example, working photographic artist Steven Livick (in collaboration with Bill Waterson) combines lux-hour-measured, outdoor-sunlight testing with the use of inkjet coatings to help him determine the longevity of his large-scale murals.

Others who do their own testing include photographers such as Barry Stein, who constructed a fluorescent fade tester for under $50 that allows him to test with and without a glass filter and to adjust the light level from 20 to 60 klux (see Figure 6.7).

Figure 6.7 Barry Stein made this fluorescent light-testing device from inexpensive parts, including a foil-lined trash can, light fixture, and fan. Bottom inset shows the turntable for rotating samples made from pieces of Foamcore and a small motor. All this for under $50.

Courtesy of Barry Stein
www.BSteinArt.com

For more ideas about individual-artist testing, see "Do Your Own Permanence Testing" below.

So How Long Will It Last?

I started off this chapter asking two simple questions: How long is long enough? and How long will it last? That second one is the hardest to answer. Because there is no *one* answer—it all depends. Even the best outside permanence tests and manufacturers' claims will only give you a generalized guesstimate of what's going to happen to *your* prints. There are just too many variables. What is the atmospheric pollution level where the print will be displayed or stored? What is the UV component of the light coming in from the windows? What's the temperature? What's the humidity? These are just some of the influencing factors that will significantly affect the permanence of *that* print.

What Can You Do?

To get closer to knowing about the longevity of your prints—besides waiting around a few decades as they age—you have two basic options: (1) carefully study the existing test data from manufacturers or testing organizations, or (2) do your own testing. In any case, you should also learn how to maximize print permanence.

Study the Test Data

If you're relying on outside permanence test results, make sure you understand what the test conditions and standards were and adjust your expectations accordingly.

By looking deeply, you can start to really understand the meaning of any test result and see if it matches your needs.

Do Your Own Permanence Testing

Can you do your own permanence testing? Absolutely. There are as many ways to conduct a print permanence test as there are ways to make a print. It can be done, and I highly recommend it.

Here are the basic steps of an actual lightfastness test I conducted:

1. **Decide on what you want to test for.** I decided to test the fading of four different inkjet papers using the same desktop printer and inks.

2. **Select test type, conditions, and testing procedure or standard.** This is actually the most important step, and many people rush through it without much thought. In my case, I did an accelerated, comparative (relative), visual, lightfastness test.

3. **Set up test conditions and apparatus.** I built a crude light-testing apparatus with full-spectrum fluorescent tubes and standard window glass over the target samples (see Figure 6.8).

Figure 6.8 The author's fluorescent light-fading test unit. Fluorescents should only be used if the intended display environment relies on this type of lighting.

4. **Prepare and print the targets.** I created my own test target in Adobe Photoshop combining personal and stock images and "color ramps" (pure color patches of varying densities).

5. **Run test.** With the targets in place, I turned on the lights and didn't turn them off, checking in each day and rotating the targets under the lights each week to make sure they all received the same average exposure.

6. **Terminate test and make evaluations.** On the 100th day (the equivalent of 6.7 "Wilhelm Years" at my light intensity), I turned off the lights and compared the test specimens along with the dark-stored references in my viewing booth and decided which ones looked best (see Figure 6.9). Those that matched their controls the closest had faded the least.

Figure 6.9 Visually comparing the targets after the lightfastness test is over.

Remember that this was just one way to do a test. I could have, instead, used a different light source, run the test longer, tested different inks on the same paper, instrument-measured the samples before and after, or changed any of the other factors. I wanted some quick, basic information to make an informed decision about what material combinations would best meet my needs for a specific display condition.

Others do it differently. For example, you could simply make a sample print and expose half to daylight (sunlight preferred) in a south-facing window while covering up the other half. Compare after a month or two. This may not be the most scientific test, but it's something.

Maximize Print Permanence

Depending on whether you self-print or have someone make prints for you, there are things you can do to maximize print permanence (see also Chapter 8 and Chapter 10 for more about inks, paper, coating, framing, and display):

- Always select/specify long-lasting colorant and media *combinations.* The key is in matching your colorants to your media. Realize that permanence is specific to a particular type of ink or dye on a particular type of medium (paper). Don't mix them up and expect the same results.

- Study paper and coating specs. Swellable polymer coatings on inkjet papers protect against light and ozone but are more sensitive to humidity. Microporous coatings are less sensitive to humidity but more sensitive to light and ozone.

- Keep prints on display away from strong light, especially sunlight. (Your goal should be to *never* let one ray of sun strike a display print.)

- To protect against gas-air fading, display your prints behind glass or acrylic (or store them in an album or in sleeves) whenever possible. This reduces airflow and some UV exposure problems. If using fluorescent lights, filter them with glass or plastic covers to cut down on the UV emissions.

- If you can't or don't want to display prints—on canvas, for example—behind glass, consider using a coating, lamination, or spray. Keep in mind that post-print coatings sometimes add a new element to the chemical interaction of ink and media; under certain circumstances they could even reduce print life.

- Store your prints in a dark, dry, and cool place; light and moisture are real print killers. Try to minimize temperature and humidity changes; keep them as constant as possible. High temperature and humidity levels can speed up print deterioration, and very low humidity or fluctuating humidity can cause prints to crack or peel. Model conditions are 68° F (20° C) to 77° F (25° C) with 30 to 50 percent relative humidity. (See more print storage recommendations in Chapter 10.)

■ Communicate to and impress upon anyone receiving your prints all the points above. You'll save yourself and them a lot of disappointment.

Coatings and Permanence

More and more photographer-artists are coating or laminating prints to increase permanence (see more about inkjet print coatings in Chapter 10).

Wilhelm Imaging Research now has separate display permanence ratings for some ink/paper combinations that are sprayed with PremierArt Print Shield, a lacquer-based spray designed specifically for inkjet prints. A quick review of WIR's ratings show significant longevity increases when the spray is used.

Inkjet expert Dr. Ray Work is another believer in coatings. "Coating, or better yet, laminating with a pressure sensitive lamination film, will give increased protection from moisture, which can interact with other variables and accelerate image degradation," he says. "Coating or laminating is also important for microporous, fast-drying papers that can soak up air pollution and cause rapid fading."

A further twist on this subject is the new inkjet "infusion" formulation that's added as part of the paper-making process. According to its inventor John Edmunds, "this is the only type of built-in inkjet coating that actually increases the longevity of the paper and the inks that are applied to it."

A. 3 drops* of water for 45 seconds, then wiped away with a sponge.
B. Moist sponge with 3 passes.
C. 3 drops* of water for 4 minutes, then blotted with a paper towel.

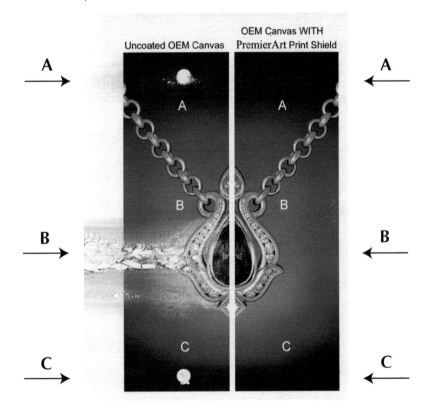

* Drops were administered with a pipette. Approximate total volume is 0.13 ml.

A water-resistance test showing the protection of Print Shield spray coating.

Courtesy of Premier Imaging Products, Inc.

The Imagemaker's Responsibility

Prints begin deteriorating the moment they're made. Some faster, some slower. Whether because of light, temperature, or other factors, your prints are going to degrade. Your goal should be to use your knowledge about materials and processes to make the wisest choices that will improve the permanence of your work. This applies to inkjets, digital photo prints, color lasers, everything.

Realize that there are three main factors that affect print permanence: colorants (inks, toners, etc.), media (paper, film, etc.), and display/storage conditions. (Most people erroneously think that the printing device is the main factor, but it's only important in that it can limit the others.) To optimize permanence, you need to carefully control all three factors. If you make prints to sell or give away, you've just lost one leg of the stool because you can't control the conditions where the prints will end up. But you can do your best with the other two.

Knowing what we now know about the ability of printed images to fade, deteriorate, degrade, and literally become shadows of their original selves, imagemakers cannot simply shrug off this issue of permanence, or call it "artistic freedom." In the case of commercial print sales, the legal term *implied warranty of merchantability* (a warranty that the property is fit for the ordinary purposes for which it is used) applies to artists and photographers just like it applies to makers of other products.

Even if you're not selling prints but only making them for family and friends, it is my opinion that it is the responsibility of every printmaking imagemaker to learn about and communicate the particulars of his or her print methods and how they affect a particular print's longevity.

Study the technical data that's available, do your own tests if you have to, and use the best materials to make the best prints you can.

You've now covered what I consider to be the basics of digital printing. Let's move on to the subject that everyone is talking about: inkjet.

7

Selecting an Inkjet Printer

Inkjet printers are the output devices of choice for many photographers, artists, and imagemakers. In this and the next three chapters, I will focus on what I like to call the main event of digital printing: inkjet.

In Chapter 3, "Comparing Digital Printing Technologies," I gave a big-picture overview of the main digital printing technologies. Now, it's time to dive a little deeper and explore the world of inkjets. Whether it's a desktop or a wide-format, whether you're looking for your first printer or ready to trade up, or if you're planning to self-print or use an outside print service—the more information you have about inkjet printers, the smarter your decision-making will be.

When you go to the grocery store, you take a list. It's the same when shopping for an inkjet printer. Instead of a list of items, you need to know which questions to ask. So rather than giving you a rundown of all the printers with a detailed inventory of features and specifications (with new printers constantly coming onto the market, no book can hope to be up to date), I'm going to present you with nine important questions and ways to think about answering them. Add or subtract questions to suit your situation, then finalize your own list and start shopping! (The printer brands and models I mention are current as of this writing. For the latest information about inkjet printers, visit my website DP&I.com— www.dpandi.com.)

1. Can I Use It to Print…?

The foundation question is, What do you want to do with the printer? It's best if you have an understanding of the type of printing you'll be doing in order to pick the best printer for the job.

You may even decide that inkjet is not the best solution for you. Looking for "good enough" quality at a lower cost per print? Consider color laser, especially for multiple copies. Want top-end photographic output with the look, feel, and smell of a photo lab print? Think about using a service with a digital photo printer (refer to Chapter 3 for more about these). However, there are plenty of advantages to inkjet, and it's a safe bet that an inkjet printer will meet most, if not all, of your requirements for high-quality digital output.

Even within the inkjet category, there are many choices depending on the type of printing desired. Do you want to print on CDs or DVDs? Epson makes several inkjet printers that do this. Want to combine printing with additional functions like scanning, copying, and faxing? Consider the popular "all-in-one" category with multi-function devices from Canon, Epson, HP, Lexmark, and Dell. Dying to make black-and-white or quadtone prints? Then consider either one of the newer HPs or Epsons with multiple black inks or consider an inkjet that can be retrofitted to use specialized black-and-white inks. Need oversized fine-art prints? Consider wide-format printer brands, such as ColorSpan, Roland, Epson, HP, Mimaki, or ENCAD.

The Epson Stylus Photo R800 desktop inkjet printer (and also the R200 and R300) lets you print directly onto inkjet-printable CDs and DVDs.

Courtesy of Epson America, Inc.

Sometimes, a printer designed for one purpose is used for another. Take the Epson Stylus C84/C86. It's really an office printer, but digital photographer-artists instantly saw its advantages—high quality, low price, waterproof, pigmented inks—and claimed it for themselves. Similarly, HP's Photosmart 7960 or the newer 8450 is a consumer printer that's great for black and white, so pro photographers immediately "stole it" for themselves.

What Size Output?

A subset of the "Can I Use It to Print…" question is: What sizes can I print? This is usually a top-level question, since you must, at a minimum, have a printer that can handle the largest size you intend to output. In addition, this is where the decision between desktop and wide-format printing is often made.

Desktop

As I've already defined it, desktop (sometimes called "narrow format") means anything *less* than 24 inches wide. This refers to the media (paper) size and not the physical dimensions of the printer. Practically speaking, the largest common paper size for desktops has been 13 × 19 inches, also called Super B, Super A3, or A3+. Some people, especially in the UK, like to call the A3+ format "wide-carriage" or, confusingly, "wide-format," but I'll stick with the U.S. industry standard definition. The Epson Stylus Pro 4000 prints on paper up to 17 inches wide, but I (and Epson) sometimes put this printer in the "wide-format" category, although it could, technically, fit onto a desktop—only a big one!

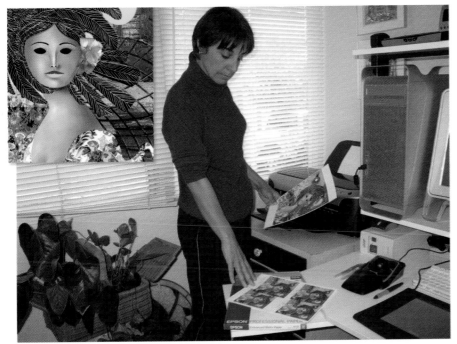

Left: *Bird Woman* (2004) by Ileana. Right: The artist checks digital print proofs up to 13×19 inches on her Epson Stylus Photo 2200 in her home studio. For final prints, Ileana works with an outside print-service provider to make larger prints.

Courtesy of Ileana Frómeta Grillo
www.ileanaspage.com

Desktops can squeeze more size out of their limited dimensions by turning the image sideways and printing on roll or cut-from-roll stock. Not all desktops can do this, but if you have long panoramics, roll-feeding desktops can be lifesavers. Desktops like the Epson Stylus Photo R800, 1280, and 2200 are good examples of printers that can provide this function. Keep in mind that the image length on a roll is not unlimited. For instance, on the Epson Stylus Photo 2200, the maximum printable area is either 13 × 44 inches or 13 × 129 inches, depending on your computer's operating system and the application software.

Another issue that may be important to you is the ability to make "borderless" prints. Epson introduced this capability (also called "borderfree" or "edge-to-edge printing") with its newer Stylus Photo printers, and Canon soon followed suit. Canons make borderless prints by slightly enlarging the image and over-spraying beyond the edges of the paper.

An occasional tradeoff with borderless printing is a slight reduction in image quality near the edges where paper handling and other issues sometimes cause problems.

Wide-Format

Any printer that can accept media 24 inches or wider is called "wide-format" (or sometimes "large-format"), with the Epson 4000 (and the classic Epson 3000) exception already noted. Another distinguishing characteristic of wide-formats is that they can generally take both roll and sheet media. Granted, some desktops can also do this (mostly Epsons), but virtually all wide-formats can. The reason is simple: Wide-format printers are designed for high-production environments. Service bureaus, high-volume outputers, professional printmakers—these are the typical users of wide-formats with a practical paper width of 24–60 inches or even more. If you only want to print 4 × 6-inch snapshots, you could use a wide-format, but unless you wanted thousands of them, it would be overkill—and expensive!

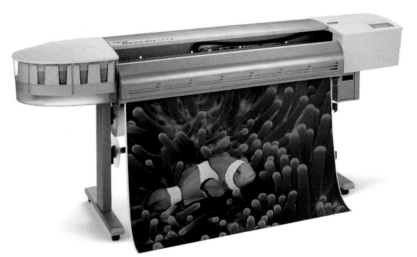

ENCAD's NovaJet 1000i comes in 42- and 60-inch-wide models.

Courtesy of ENCAD, Inc.– a Kodak Company

Any outside printmaker you use will undoubtedly have wide-format print devices. Remember, wide-formats can always print a smaller image, but a desktop can't print a larger one (with the exception of panoramics).

2. How Old Is It?

Pay attention to the age of the printers you're considering. By this, I don't mean when a particular unit was manufactured, but rather, when that particular printer model was introduced. For example, when the Epson Stylus Photo 2200 was announced in April 2002, it effectively wiped out the demand for the 2000P, which was released in May 2000 (the 2200 was also positioned as a step-up printer for those with 1280s). The same can be said for Canon's i9900, which improved on the i9100 that was announced only the year before, and the HP Designjet 5000/5500 series, which replaced the older HP2000/3000CP and 2500/3500CP series. Each of the newer products introduced innovative technology that everyone immediately wanted to have.

I'm not saying that older printers can't do a good job for you; they obviously can. For certain specialty uses, some older printers are highly desirable, even to the point of being sought out and stockpiled when they go out of production. The Epson Stylus Color 3000 had been around for seven years, and it was still available from Epson at the time of this writing! However, you may not want to be on the trailing edge of a technology just as a new type of printer is introduced.

How do you know when a printer is being replaced? You don't. However, by using some of the clues I've already given, you can bet that any printer that's more than 12–18 months old will soon be on the chopping block (wide-format "professional" models typically have longer life expectancies than do desktop models). Also be aware of any large price reductions in a printer model; these tend to be used to clear existing stock before a replacement model is announced.

3. What's the Print Quality?

In a nutshell, any of the newer "photo" inkjet printers can produce stunning prints. Inkjet output is now as good as—and in some respects, better than—traditional ways of printing images. High-quality, continuous-tone digital printing has finally become a reality. Here are three quality features to consider when looking at printers (keeping in mind what I said in Chapter 2 about image or print quality resulting in the combination of many factors, not just these three):

Printer Resolution. Each printer manufacturer highlights different features to help tell its marketing story, so don't worry too much about the "Battle of the Resolution" claims. The difference between 1440 dpi, 2880 dpi, 4800 dpi, and

5760 dpi is hardly discernable to the naked eye, and most newer printers are more than adequate in terms of printer resolution. Maximum dpi resolution, however, can be used to compare different models of the same brand.

Number of Colors. When possible, go for at least six colors for desktop inkjet printing. The extra two colors (usually a light cyan and a light magenta for CMYKcm) will smooth out subtle gradations, color blends, and skin tones. Four-color-only printers with lower resolutions tend to show grain in highlight areas. Epson, HP, Canon, and Lexmark all have six-color desktop printers. The seven-color Epsons 2200, 4000, 7600, and 9600 (CMYKcmk) have an extra low-density black to reduce graininess and improve the neutrality of grays. Epson's R800 has eight "channels" but only six colors: CMYK with a selectable Matte Black, plus extra Red and Blue inks (see Figure 7.1). This printer doesn't need the lighter colors for smoothness because its dots are so small; it takes advantage of using other colors to increase its color range. The Canon i9900 has eight true colors: CMYKck plus an additional Red and Green. The HP 7960 and 8450 also have eight colors with three blacks for excellent grayscale (black-and-white) printing.

Figure 7.1 Epson's Stylus Photo R800 has six different colors in eight channels. This was Epson's first printer with Red and Blue inks and a separate "gloss optimizer."

Six, seven, or eight colors is currently as far as desktop inkjets go, but wide-formats go even further. The ColorSpan DisplayMaker X-12 comes with 12 separate printheads, which allows you to choose different print modes and inksets. The Mimaki JV4 Series printers offer a similar feature.

Ink Droplet Sizes. The smaller the drop or dot sizes, the finer the detail and the smoother the color variations. The smallest drop size currently available (at this writing) in the U.S. is 1.0 picoliters (a picoliter is a liquid measurement unit) from the Canon PIXMA iP5000 desktop.

Variable droplet sizes are a further advancement for increasing fine highlight detail and for optimizing photographic quality. The Epson 3000 was the first desktop printer to incorporate variable droplet technology, but it used only one dot size per print. Following Epson models began offering differing dot sizes within an image. Now, several brands offer different drop sizes per line.

Notwithstanding what I've said in this quality section, the numbers alone do not tell the whole story. More important is what your eyes tell you when looking at a print. That's why it's important to request sample prints (see the "Sample Before You Buy" note), figure out a way to see others' prints (this is one benefit of joining a "Print Exchange"), or have prints from your files made for you on any potential printer.

Sample Before You Buy

As part of your research into printers, try to gather actual printed samples for review. For desktops, office super stores will frequently have sample prints available next to the printer on display. Online retailer inkjetART.com offers custom sample prints from several of the inkjets it sells for evaluation/comparison. (InkjetART.com also has some excellent output comparisons and recommendations on their website.)

In addition, most manufacturers will send you sample prints from their various printer models. Narrow your list down to the top few, and call their 800 numbers for samples and product brochures. For desktop samples in the U.S., call these OEM pre-sales numbers:

Canon: (800) OK-CANON Dell: (800) 624-9896 Epson: (800) 463-7766
HP: (800) 888-0262 Lexmark: (888) LEXMARK

4. What Different Inks and Media Can I Use?

Some imagemakers consider printing merely the final step in a long digital workflow. They're mainly concerned with accurately reproducing on paper what they've worked hard on and now see in front of them on their computer monitors. Others are true printmakers and view the selection of ink and media as an integral part of the creative process. How you locate yourself on this continuum will help determine how important inks and papers are to your decision-making process.

Inks

I'll go into much more detail about inks in the next chapter, but here are a few issues that might affect your printer-picking process.

Dye or Pigment?

Most inkjet printers come from the factory preconfigured to run either dye-based or pigment inks. Desktops come one way or the other, while some wide-formats let you switch between the two systems or even run them simultaneously.

If you're concerned about print permanence (see also "How Permanent Are the Prints?" below), your choices are either one of the pigment-based printers (or one that can be adapted for third-party pigment inks) or a dye-based printer that can offer long-lasting prints on specific swellable-coated media. For dedicated pigment printers for the desktop, your choices are simple and all Epson. For wide-format, the field opens up considerably with Roland, ENCAD, Mimaki, Mutoh, MacDermid ColorSpan, HP, and Epson all offering several models from which to choose. For long-lasting dye-based prints, HP leads the pack at the time of this writing.

Cartridges and Capacities

Out-of-the-box inkjet printers use ink cartridges or tanks to feed the printer; in general, desktops have small cartridges, while the wide-formats have larger ink tanks, which makes them run longer before ink changing and also helps economize ink costs. At one end of the spectrum, a single desktop ink cartridge might hold as little as 17 milliliters of ink (approximately one-half fluid ounce), while the tanks on the ColorSpan DisplayMaker X-12 have a whopping 960-ml (almost a liter or 28 fluid ounces) capacity.

Desktop inkjets use multi-color cartridges (top left and bottom right; note the foam inserts) or separate-color carts (bottom left). Most wide-formats use larger, single-color "bag-in-a-box" carts (110 ml shown).

For desktops, Canon pioneered individual ink cartridges (one cartridge or "tank" per color), but Epson, and then HP, quickly responded with the same idea for several of their newer printers. Whether having separate tanks will actually save you any money (one main benefit cited) is open to debate, although separate tanks do have the benefit of reducing wasted ink from discarded multi-color carts with only one color exhausted.

The way around the high-price and inconvenience of tiny ink cartridges is to use a bulk ink system. These are also called continuous-flow (CFS) or continuous-inking systems (CIS), and they pump bulk ink from large containers to the printer, bypassing those puny cartridges entirely (see the next chapter for more about these). The rub is that the bulk systems can be finicky, and they only work with certain printers. (Primarily desktops utilize bulk-ink systems; wide-formats normally don't need them because of their larger-capacity ink tanks.)

Third-Party Inks

The ability to use third-party inks can be an important consideration, and Epson is the clear favorite in being supported by third-party ink makers. You'll have a harder time finding these inks for HPs, Lexmarks, or Canons. Some of the older Epson models don't use the smart-chipped ink cartridges (see Figure 7.2), which makes them easily convertible to third-party ink solutions. (Many of the newer "intelligent," microchipped printers can also accept aftermarket inks and bulk-ink systems, but it usually takes third-party marketers at least six months to a year to come up with workarounds for the printers after they hit the market.) Another important thing to keep in mind is that the OEMs don't like it when you replace their brand of inks (and media) with an outside source. That's understandable if you consider that they've gone to a lot of trouble to develop the right printer driver

Figure 7.2 Two Epson smart-chipped ink cartridges. Note the green circuit boards.

settings to match their inks and media for the best results. (And the fact that they stand to lose lots of money if you switch to Brand XYZ!) One way to help insure that you use their consumable supplies—inks, primarily—is to state that you will void the printer's warranty if you stray from the OEM flock, although this is a shaky legal position.

Media

Most major desktop OEMs recommend their own specific papers to use with each printer model. The reasons are two-fold: (1) the engineers can optimize the print quality for a specific selection of paper and coatings, and (2) they'd like to sell you more of their own paper. So if you like the paper selection (and prices), you're in good shape; if you don't, well, luckily, many outside companies are now offering high-quality third-party papers that work well with most inkjet printers. (See the next chapter for more about printing papers.)

Paper Options

For desktops, the widest range of OEM desktop paper choices belongs to Epson, followed by HP. While both companies offer basic choices in "photo papers" in gloss, matte, or satin/luster finishes, Epson also has "fine-art" papers as a stock item for some of its desktop printers. HP does too, but only for wide-format. Canon offers only basic "photo papers."

Wide-format printers have more media options, including specialty papers like artist canvas, watercolor, and translucent films (see Figure 7.3). Epson has several 100-percent cotton, acid-free, fine-art papers, while HP has a Photo Rag and Watercolor paper, both made by German papermaker Hahnemuhle. Some wide-format paper is not available for desktop printers. For example, Epson's UltraSmooth Fine Art Paper comes only in rolls and in sheets starting with 13 × 19 inches, while HP's Photo Rag by Hahnemuhle comes only in 36-inch rolls.

The other way to go is to use non-recommended, third-party papers. Ilford, Hahnemuhle, Arches, Crane, Somerset, Legion, Hawk Mountain, Red River, and Moab are only some of the paper makers or distributors offering top-notch third-party papers for inkjet printers. Larger online retailers like MediaStreet.com ("Generations," "Royal," "Renaissance") and inkjetART.com ("Micro Ceramic") also sell high-quality media under their own brand names. (InkjetGoodies.com sells its related-division Moab paper line in addition to other brands.)

Figure 7.3 Artist and fine-art printmaker Jan Steinman uses translucent film to produce his signature Translesce prints.

Courtesy of Jan Steinman
www.Bytesmiths.com

Paper Handling

Maximum paper thickness is an important consideration for many. Epsons shine in this category with most newer wide-format models (including the 4000) able to print on premounted papers and boards up to 1.5 mm thick.

Most regular users, however, don't need to print on paper that thick. In fact, according to inkjet supplies reseller Royce Bair of inkjetART.com, most desktop users of photo/fine-art inkjet papers tend to prefer thicknesses below 13 mil, typically 10–12 mil. (A mil is a measurement of thickness, 1/1,000 inch.) That same 1.5 mm would equate to 59 mil, and there is no popular, unmounted paper currently that thick. In fact, the thickest inkjet papers now available are some of Epson's that are 425 and 500 gsm (30-36 mils/.76-.9 mm).

For wide-format, most people prefer 15 mil to 24 mil (17 mil average or .43 mm) for fine-art sheet and roll paper; the HP Designjet 30/130 can handle up to .4 mm. Bair explains, "Beyond 25 mil, it's hard to make and use a fine-art roll paper that will de-curl or flatten out after printing."

If you require thick-paper handling, look for a straight paper path that allows thick papers to be fed from the back of the printer (see Figure 7.4). Not all printers have this capability, so investigate it thoroughly if this is important to you. In addition, many HPs have paper paths with a 180-degree turn; this can be a disadvantage with thicker media.

Figure 7.4 Epson's Stylus Photo 2200 has a rear-feeding option for thicker papers. The inset shows the printer's thickness lever in the correct position for inserting a sheet from the rear.

Courtesy of www.inkjetART.com

Some printers also require single-sheet feeding of certain papers (Bair advises that anything thicker than 11 mil will require hand-feeding on most desktops), while others let you stack up several (thin) sheets. Others have optional or built-in roll-feed attachments that let you print from long rolls. Your production needs will determine how important this is to you.

Another niche consideration is whether the printer has the ability to *duplex* (automatically print on both sides of the paper). HP has the largest number of desktop models that can do this.

5. How Permanent Are the Prints?

If you've been paying attention so far, you know that this is a trick question. Inkjet print permanence is a function of the ink/media combination and the storage or display conditions. The printer itself is only a factor in that it limits your choices of inks and paper.

Based on who's doing the testing and which paper is used, pigmented inks currently offer the most permanent prints available by inkjet printing (more than 100 years predicted by Wilhelm Imaging Research for several ink/paper combinations, based on WIR's test conditions). This exceeds the predicted lifespan of traditional photo prints on Fuji Crystal Archive, the longest-lasting wet-chemistry color photo paper, again according to WIR.

Inkjet printers running pigment inks (either OEM or third-party) still have the upper hand in terms of lightfastness before noticeable fading occurs, although

some dye-ink/paper combinations are closing the gap. For example, WIR rates Epson's UltraChrome inks on Epson Premium Glossy Photo Paper, Epson Premium Semigloss Photo Paper, and Epson Premium Luster Photo Paper indoors under glass at 85, 77, and 71 years, respectively (again, based on WIR display conditions). At the same time, HP's #57 and #58 (Deskjet 5550) and #85 (Designjet 30/130) Vivera dye inks on HP Premium Plus Photo Paper and HP Premium Plus Photo Satin papers are rated indoors under glass by WIR at 73 and 82 years, respectively. As you can see, those longevity ratings are very close! (Don't forget that it's the *specific* combination of inks and paper that counts with permanence ratings. Henry Wilhelm points out that the same 73-year rating with HP inks on HP paper drops to only two years when an office supply store paper is substituted!)

HP's Vivera Ink-based Designjet 130 (shown) and 30 printers are the first inkjet printers to offer predicted WIR permanence ratings (on matched HP media) in the same range as many pigment choices.

Courtesy of Hewlett-Packard Company

The conclusion on permanence? Pick your printers—along with their built-in or third-party ink and paper options—carefully if you're interested in print longevity.

6. Speed: How Long Does It Take to Print?

Newcomers to inkjet printing are, at first, enamored with the high-quality prints they can produce. Speed is usually not a primary concern. However, after a few days of watching that printhead going back and forth as the paper slowly emerges at what seems like the rate of glacial ice flow, speed starts to become more important.

Desktop inkjets typically advertise their pages-per-minute (ppm) rate or how many minutes it takes to print an 8 × 10-inch photo (or 4 × 6). In general, the higher

the quality of inkjet output, the slower the print speed. You can check this your-self by simply changing the Quality (or similar) mode setting on any inkjet printer and timing the same test prints.

Most inkjets have a high-speed option that changes the printer from unidirec-tional printing to bidirectional; the head or heads now print in both directions. (Unidirectional printing with Epsons is always from the parked-head position out toward the center of the printer.) This effectively doubles the print speed, but at a slight loss in quality, although careful use of the head alignment utility can min-imize this quality drop.

For the photo-desktop category, the speed champ is clearly Canon. The i9900 Photo Printer has a rated 8×10 speed of approximately 50 seconds, with a 4×6 borderless print at 38 seconds. By comparison, the same-size 13×19 printer from Epson (2200) lists an 8×10 at either 2 minutes 6 seconds or 3 minutes 51 seconds, depending on the paper type and other variables.

What's the primary factor in determining print speed? Simple: the number of inkjet nozzles available. The more nozzles available shooting out ink over a wider print-head area, the faster the printing speed. You can easily see why the desktop Canons are so speedy: The i9900 has a total of 6,144 nozzles (768×8 colors), while its sister imagePROGRAF W6200 printer has even more (7,680 nozzles at 1,280 noz-zles per color). To accommodate all these nozzles, the printheads are giant (over 1 inch wide). By comparison, the much-larger Epson 4000 printer has only 1,440 total nozzles, and the even-larger Epson 7600 has only 672 total nozzles.

Canon's i9900 Photo Printer is the desktop inkjet speed champ.

Courtesy of Canon USA, Inc.

There are workarounds to deal with slow printing speed (besides buying a faster printer). I've gotten into the habit of having several in-progress projects ready that I can immediately move to while waiting for a slow print. Organizing my office studio, emptying the trash, that sort of thing (it also gets me out of my computer chair). If your printer allows it, you can also take advantage of unattended printing. You load several pieces of paper, hit the print button, and move onto other tasks. Finally, you can always print at a lower quality mode setting. Many imagemakers report little or no visible difference in quality when using the next-lower setting.

7. How Easy to Set Up and Connect? How Big? How Noisy?

The first lesson that all serious imagemakers learn is that, regardless of the marketing hype, high-quality digital printing is not a push-button operation. Don't expect magic right out of the box. To be sure, you will get something with your first print, and there will be some—perhaps many—who will be perfectly thrilled and satisfied, with no need to explore further. But many others—undoubtedly you, if you've read this far—will need to learn and advance their knowledge to get the kind of superb prints that are achievable with inkjet.

Desktop

Several important ease-of-use parameters for desktop inkjet printers follow:

Printer Size. The size of the printer may be a minor issue for some, but if you're living in a one-room apartment and sleeping on a Murphy bed, you probably pay close attention to such things. While their shapes may vary, letter-size printers all take up about the same amount of desk space. They're approximately 16–17 inches wide, and the particular configuration of paper support and output tray extensions will determine how much desk depth you need. However, you should count on one entire section of desk to devote to an inkjet printer. Move up to a 13 × 19-inch, and you've increased your width to approximately 24 inches, with only slightly more depth required. Only a few desktop printers don't fit this mold—the HP Designjet 30 is larger in comparison, and the Epson Stylus Pro 4000, which straddles the desktop/wide-format categories, is gigantic, measuring 33 inches wide and weighing a back-breaking 84 pounds.

Keep in mind that the same printer is sometimes available in two different sizes; only the media handling capacity is different. For instance, the HP Designjet 130 is the larger version of the Designjet 30. The same can be said for several Epsons; the wide-formats even use the same drivers and connection modes as their desktop siblings. The resulting short learning curve in moving from desktop to wide-format has been one key to the popularity of Epson's wide-format printers.

Setup. We've reached the point in desktop inkjet evolution where equipment setup is plug-and-play. Buy any desktop inkjet on the market, and you should be up and running in less than one-half hour. Unpack the box, hook up the printer to your computer, insert the ink cartridges, load the paper, install the printer software (from CD), maybe run a head-alignment check, and you're done. This doesn't mean that printing, itself, is plug-and-play—just the setup.

Compatibility. The first question is, Are there drivers for my OS? You must have printer drivers that support your computer's current operating system. In general, most newer desktops come ready to play with all the usual OSs, both Windows and Mac; only Dell is Windows only. Again, you can usually download the most recent drivers from the printer manufacturer's website.

Want to skip the computer altogether and go direct-to-print from digital camera memory cards? Canon, Epson, HP, and Lexmark all allow this kind of direct-to-print capability. In addition, a new standard called PictBridge lets you transfer images directly from your digital camera to your printer without a computer or image-editing software. This kind of direct printing previously existed, but only for the same manufacturer's products. With PictBridge, you can print a photo from, say, your Canon digital camera on your HP inkjet printer, provided both are PictBridge-compatible.

Photo-direct printers, such as this HP Photosmart, can read—and print from—digital camera memory cards. They can also print from a computer.

Connectivity (or Interface). This means how you physically connect the printer to your computer. Since the printer OEMs want to connect as many printers to as many computers as possible, they all offer the basic options: IEEE 1284 parallel (Windows) and USB (Windows and Mac). The newest printers also support FireWire ports.

Noise. All desktops make those characteristic back-and-forth, mechanical sounds when they print (see Table 7.1). It's a sound you get used to, and for some, it becomes the background noise of their lives!

Table 7.1 Noise Levels of Selected Printers (in Printing Mode)

Printer/Source	Max. Decibel Level (dB)[1]
Canon i9900	37 dB(A)[2] (in quiet mode)
HP Photosmart 7960	37–43 dB (depends on quality mode)
Lexmark P707	40 dB(A)
Epson 2100/2200	42 dB(A)
Canon W6200	55 dB
Epson 4000	50 dB(A)
Epson 7600/9600/10000	50 dB(A)
Roland Hi-Fi JET Pro II	65 dB
Common Noise Levels	
Quiet whisper	15–20 dB
Airport terminal	55–65 dB
Subway	90 dB
Chickens inside a building	105 dB
Loud rock music	115 dB

[1] A decibel (dB) is the unit used to measure the intensity of sound. Each increase of 6 decibels doubles the noise level. Twenty decibels is not twice as loud as 10 dB, but three times as loud. Sound above 130 dB causes pain. [2] Because the human ear doesn't respond equally to all frequencies, sound meters use filters to approximate how the ear hears sound. The A weighting filter (dBA) is widely used.

Wide-Format

Printer size, setup, and connectivity are important factors when deciding about wide-format inkjets.

Printer Size & Setup. As can be expected, wide-format inkjets are bigger and typically more complicated to set up and use (count on at least a half-day for set up). Add up the printer and stand, plus the space needed for paper loading and output, and any extras like a separate print server, and you'll probably end up devoting at least a portion of a room to a wide-format printer. However, some wide-format owners, like digital artist and educator Teri Brudnak, are able to maximize space by putting their printers on rollers and moving them around as needed (see Figure 7.5).

Figure 7.5 Artist Teri Brudnak and her Roland Hi-Fi JET in her home studio.

Courtesy of Teri Brudnak

Even with the added complexities, once you nail down your workflow, wide-format operation is fairly smooth. In terms of noise, wide-format inkjets are only slightly louder than their desktop cousins. But you still have to learn to live with that bzzzz, bzzzz, bzzzz sound!

8. What About Printer Software and Service?

In addition to the required printer drivers, inkjet printers now include various software tools to make your printing more efficient (many will also come with bundled third-party software trials and demos).

Printer Management Software

Today's inkjet printers have very sophisticated software to help with various printing tasks. Take, for example, the *ink status monitor*. Lexmark's Ink Levels Indicator counts the number of dots you place and uses that to calculate the remaining ink. HPs use a smart chip on the ink cartridge to monitor how much ink has been used and how much is left. Additionally, smart chips in the HP printheads monitor the amount of ink that flows through the heads plus the status of the printhead's health. The Canon i9900 has a unique optical, low-ink sensor that pops a warning on the screen when an ink tank is getting low.

Wide-format printers offer even more sophisticated usability features to make your printmaking more efficient. For example, the HP Designjet 5500 not only checks the printhead to make sure that all nozzles are firing, but it will also try to recover as many nozzles as it can by priming and cleaning them while printing. It also has a "fault-tolerant" print mode that makes unattended printing a less-risky gamble. You go away for lunch, and the printer will not allow more than one bad print to come out. HP also offers a print-accounting function through a unique web-access interface. It not only tells you what the status of all your ink supplies is, but it can track how much ink you're using on any job, and how much paper you've used. It will even calculate exactly how much media is left on a roll whenever you change rolls, allowing you to swap media as often as you like without having to worry if you're going run out of paper mid-print.

What About Service, Repairs, and Warranties?

Just like with cars, you will want to take maintenance and service into account when picking a printer. Being able to do simple parts replacements is an area where thermal inkjets have a slight advantage. When an Epson printhead goes bad, you have two options (after the warranty period): (1) spend the money to have it serviced or replaced at a service center or by an on-call technician, or (2) throw the printer away and buy another. Clearly, if you're paying $99 for a printer, you wouldn't spend double that for a new printhead, nor, conversely, would you trash a $5,000 printer because of a bad printhead. On thermal printers where the head is part of the ink cartridge, that becomes a non-issue; change cartridges and you've changed the printheads! With individual-color printheads, it's easy and relatively inexpensive to replace them.

Tech support is one reason to go with an all-OEM solution, and *not* to mix different printers, inks, and papers. The manufacturer will help you solve problems when you're using their products. As soon as you don't, fingers start pointing in other directions, and the tech support people are less willing—or able—to help.

All the major desktop printer makers (Epson, HP, Canon, Lexmark, and Dell) offer one-year limited warranties. What this means is that you can exchange a bad printer for a new one if there are any manufacturer's defects, subject, of course, to certain conditions and restrictions. Sending back a printer due to ink clogging if you've used third-party inks won't work; that's one of the conditions. Wide-formats go even further in offering next-business-day exchange or on-site service under the standard one-year warranty, plus the ability to buy extended warranties and service contracts after that.

9. What Does It Cost?

You might think that this would be the first question, but I like to bury it at the bottom of the list. If all the questions above bring you to a choice between two printers, then make your decision on price. But never make a decision about buying or using an inkjet printer solely on cost. You may be getting a good deal, but if the printer doesn't solve your printing problems, what good is it?

"What Does It Cost?" is also a complex question. There's much more involved than just the cost of the printer.

Desktop

Virtually all desktop inkjet printers cost less than $1,000, most are under $500, and some are even under $50! In terms of a low printer-only cost, you really can't go wrong with the lower-end Canons, Epsons, HPs, Lexmarks, or Dells, which are made by Lexmark. They're practically giving these printers away. But remember, through a marketing strategy called *cost-shifting*, these printer manufacturers make their profit on the consumable supplies: the inks and the media. *That's* where your money will go, so make sure you figure in those costs, too.

Ink

Once you realize that ink is the most expensive part of desktop inkjet printing, you'll undoubtedly be looking very carefully at this element. Much has been said about the cost benefits of having a printer that uses individual ink cartridges or tanks. So the argument goes: If you print images with a lot of blues, you will obviously run out of cyan ink before one of the other colors. And if you have a printer that uses a combination color cartridge (plus a separate black one), then you're basically throwing away all the unused ink when the printer indicates it's time to change ink cartridges. It's all or nothing with these combo color cartridges. The solution is to have individual ink carts that can be changed separately as needed; and even though the savings are not always quite what people imagine, there are several desktop manufacturers (Canon, Epson, HP) who have picked up on the idea and now offer individual cartridges for some of their models.

Manufacturers have attacked this problem in a couple other ways, as well. The Epson 4000 (if you consider it a desktop printer) has not only very large ink cartridges (110 ml or 220 ml), but you can use either size at the same time. The list price of light magenta ink in a 220-ml cart (from Epson at the time of this writing) was $0.51 per milliliter; in a 110-ml cartridge, it was $0.64. In a 17-ml cart that goes into the Epson 2200, it was $0.67 per milliliter.

In the HP Designjet 30 printer, not only do the inks come in individual cartridges, but the colors typically used most often, such as light magenta and light cyan, are in larger (69-ml) carts, while others (cyan and magenta) come in smaller (28-ml) carts (see Figure 7.6).

Figure 7.6 Newer HP Designjet printers come with different-sized ink carts based on expected normal usage.

However, the real savings with desktop inks is by getting rid of the expensive cartridges altogether. There are now several bulk-ink delivery systems that allow you to buy and use large, more economical ink bottles to provide bulk ink to the printer. Unfortunately, not all printers will accept this type of system, which I discuss in more detail in the following chapter.

Media

The second important element in figuring ongoing inkjet costs is paper or media. Inkjet paper in cut sheets can run anywhere from $.50 to $5.00 or more *per sheet*, depending on the size and brand. Zeroing in on the U.S. standard letter size (8.5 × 11 inches), you should be able to find high-quality paper under $1.00 per sheet with quantity purchases.

One way to save money on paper is to buy it in long rolls. However, the selection for desktops is limited, and it's only practical if you have a roll adapter for your printer (unless you cut your own sheets from the roll and hand-feed them). Wide-formats, on the other hand, are set up for roll media, and that's one way they can economize paper costs. Owners of both types of printers have been known to use the wide-format's roll cutter to produce cut sheets as needed for their desktop printers.

Cost Per Print

Adding these two cost components (ink and media) together brings you to the important "Cost Per Print" (or cost per page). For one example, Epson America has provided a cost-per-print analysis for the Stylus Photo 2200 printer. In their analysis, an 8 × 10 glossy print runs $1.25 in consumable costs based on certain papers used. That is, if you make a print on the recommended paper with ink coverage that matches their assumed average image (a big assumption!), then the total cost of the inks and the media used to produce the print should be about $1.25.

So how does that $1.25 compare to other digital or traditional print costs? My local pro photo lab charges $5.50 for a single, Fuji Frontier 8 × 10 digital print from a digital file, $14.25 for a LightJet print of the same size, and $20 for a traditional enlarger print, although they are now phasing those out. Factor in the cost of the printer, software, training, and your time, and you can see where inkjet printing starts to pay for itself.

Other analyses by different media, ink, or print-device suppliers, of course, will vary, but you can use this kind of information to compare different printer/consumable options. (Another way to estimate the true cost of a printer is by *Total Cost of Ownership*. The TCO takes into account the printer price, cost per print, and the annual number of pages printed. Add it all up, multiply by three to five years, and you have the *Lifetime Total Cost of Ownership*.)

Wide-Format

Wide-format inkjet printers are *much* more expensive than desktops, running anywhere from $1,500 to $30,000. However, again, the purchase price is only part of the equation. Because wide-formats are widely used by commercial print-service providers who need to keep an eye on the bottom line, a Running Cost Analysis is a standard factor in selecting a wide-format. Similar to print speeds, ink and media costs are usually figured on a cost-per-square-foot basis.

We've been talking a lot about inks and media for inkjet printing. Let's now get more details on choosing your consumables.

8

Choosing Your Consumables

Anyone who does a lot of inkjet printing discovers very quickly that the consumable supplies (ink and media) are important keys to the whole process. Not only are they typically the most expensive aspect of digital printing in the long run, but the ink and paper will also make or break the quality of your final inkjet output.

Inks

Stating the obvious, it's important to remember that all inkjet printers use ink to form the image—not electrostatically charged toners, not RGB laser lights, not photosensitive silver halide, but liquid inks. (Solid-ink printers use resin-based inks that turn into liquid after heating, but I won't be covering them here. See Chapter 3, "Comparing Digital Printing Technologies.") Which ink is the question, and there are plenty of choices. (Note: As with printers, this chapter is a snapshot of what's available at the time of this writing. Check with suppliers for their latest products or with the DP&I.com website—www.dpandi.com.)

Inkjet ink formulation is a complex, scientific undertaking, with modern day alchemists spending their days paying microscopic attention to chemical and physical ink properties, such as dispersants, solvents, pH buffers, solubilizing agents, viscosity modifiers, antioxidants, biocides, and more. While making informed choices about which inks to use doesn't require a Ph.D. in chemistry, a certain amount of knowledge is necessary.

Ink Components, Dyes versus Pigments

Inks are made up of two main components: a *colorant* and a *vehicle* or *carrier*. The vehicle is the transport medium that holds or contains the colorant (either solvent- or water-based), with water (*aqueous*) being the dominant type for the kind of printing that's the subject of this book.

Added to the water base are other ingredients or additives, such as *humectants*, *surfactants*, and *penetrants*, that help the inks perform better in an inkjet-printing environment.

The colorant (technically called *dyestuffs*) gives the ink its color. Based on what you've already learned, the colorant of an ink absorbs certain wavelengths of visible light and reflects others that are then perceived by your eyes as color. Colorants come in two basic types for inkjet printing, *dyes* and *pigments*, and each has its strengths and weaknesses. See Figure 8.1 for a visual comparison of the two types.

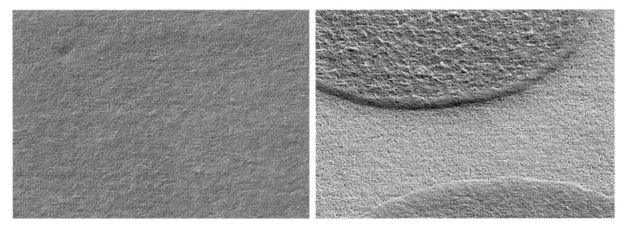

Figure 8.1 These two microscopic views show the difference between dye-based and pigment inks. Left: Dyes interact with the paper to form a uniform surface. Right: Pigment particles form a thick film on the surface of the paper.

Courtesy of Hewlett-Packard Company

Dye-Based Inks

Dye-based inks are a large part of inkjet printing. All thermal desktops (Canon, HP, Lexmark) come ready to print with dye-based inks. Epson desktops come either in dye or pigment types.

Dyes are made up of extremely small, individual colorant molecules, and because they penetrate below the surface of the paper coating, dye-based inks provide excellent image quality with rich color depth and a gloss that's usually more uniform than with pigments. The main disadvantages (in most cases) of using dyes for printing are higher susceptibility to light fading, higher susceptibility to humidity influences, higher susceptibility to environmental gases, like ozone, and greater variability of longevity with differing media.

The reason I say "in most cases" above is that, in terms of longevity, certain dye-based inks and media combinations are definitely getting better. As already explained in the last chapter, HP has carefully matched its newest Vivera Inks with specific HP media and swellable coatings in order to come up with combinations that rival the permanence predictions of popular pigment-ink solutions. The way this works is that the dyes interact with ingredients in the coated paper to gain the permanence. Print those same dyes on a different paper, and the projected permanence is significantly reduced.

Pigment Inks

Unlike dyes, a pigment is a solid material comprised of many colorant molecules tightly bound together and "stacked up" in a particular order into a single particle. These "super-molecules" (actually crystalline solids) are more complex and are much larger than their dye counterparts. While a dye molecule might be 1.5 to 4 nanometers in size (a nanometer is 1/1,000th of a micrometer or a micron, which is 1/1,000th of a millimeter), pigment particles are typically in the 0.05–0.2 micron range or 50–200 nanometers. Even though this might seem large in relation to dye molecules, these pigment particles, which have been carefully ground down to microfine sizes, are easily small enough to flow through the smallest 10-micron inkjet nozzle orifice that is 50–100 times as large (see Figure 8.2).

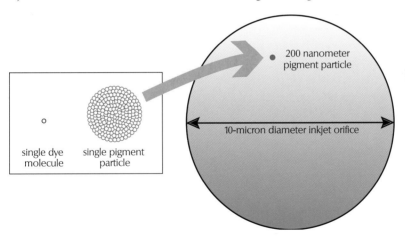

Figure 8.2 A relatively large pigment particle (left) is still very small compared to an inkjet nozzle orifice. As ink researcher David Matz likes to explain it, think of a golf ball falling into a six-foot-diameter cup.

Recreated from diagrams of Dr. Ray Work (left) and Dr. David Matz

Because pigment particles are insoluble in water, pigments remain in a solid state dispersed throughout the liquid vehicle that will deliver them to the paper. One goal of a good pigment ink is to keep the particles suspended for a long period of time. Epson uses *microencapsulation* with pigment particles encased in a polymer resin medium to help with this. (Not all of Epson's pigment inks are microencapsulated. The Matte Black in the UltraChrome inkset, for example, is not, which makes it problematic for use on glossy or semiglossy papers where there can be "rub off" of the ink without a top coating of some kind.)

The main advantage of pigment inks is that, in general, they are more stable than dyes, being more lightfast and less sensitive to environmental gases. Why? Due to the relationship between surface area and volume, the smaller the particle size, the greater the relative surface area and the more likely that a photo-fading agent like light or a chemical attack agent like ozone can reach it. Because pigments are more complex with many more molecular components, gases will only reach a small percentage of the colorant molecules while leaving the others untouched. In addition, the electronic structure of pigments is less vulnerable to light. The result is that, in general, pigments fade more slowly than dyes.

When it comes to humidity sensitivity, again pigments are usually better. With dyes, the printed colorant can begin to "redissolve" in high humidity and become "mobile," the last thing you want on a print. Pigments don't dissolve in aqueous vehicles, so they can't do this when exposed to high humidity.

But there are downsides to pigments: The larger particles of pigmented inks cause more light scattering at the surface, which reduces color range, or *color gamut*, and makes some colors look weaker or duller (see Figure 8.3). Rich reds are particularly hard to print with some pigments.

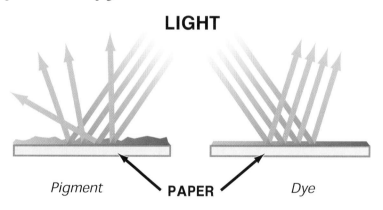

LIGHT

Pigment **PAPER** *Dye*

Figure 8.3 Although the paper surface itself also plays a very important role, the larger particles of pigmented inks (left) typically create irregular surfaces and more light scattering, causing colors to look duller. A print with dye inks (right) has a smoother surface that reflects the light back uniformly with more strength and saturation.

Courtesy of Lyson, Inc.

Other pigment problems include

- A greater tendency toward *metamerism* (shifting colors under different types of lights). This is a common complaint of the earlier Epson pigmented printers (such as 2000P) with neutral tones (also skintones) that turned green under natural daylight. The more recent Epson printers (2200, 4000, 7600, 9600), with their newer UltraChrome inks, are designed to help reduce this problem.

- Pigments tend to sit on top of the paper forming irregularities on the surface. In fact, some—not all—pigments are *not* recommended for glossy papers since they either do not dry completely, do not adhere well, or they exhibit what's called *gloss differential* or *bronzing*, where one part of the image will have a sheen or look duller and obviously different than another. (One solution from Epson

to this problem is found on the R800 printer that includes not only special High-Gloss pigment inks but also a separate Gloss Optimizer that helps fill in the non-ink dull areas.) The flip side of this problem is that pigments are also not recommended for use on uncoated, fine-art papers; the inks tend to get lost in the paper's fibers and look muddy. Most pigment inks are designed to go on coated papers. (Epson Durabrite pigments are an exception; they're designed for uncoated papers.)

■ A related issue with some pigments used on glossy or luster-type papers is smudging, or "rub-off," where the ink can smear, especially in darker or black areas. Newer pigment ink formulations, such as Epson's microencapsulated inks that "stick" better to the paper have attempted to fix this problem.

■ Pigment ink particles can separate, or "settle out," over time, especially if the printer is not used on a regular basis, and this can cause inconsistent printing, including weak colors. Tony Martin, President of ink supplier Lyson USA, has a couple of good analogies to illustrate this: While dye inks are like Kool-Aid or apple juice that, once stirred, never separates again, pigment inks are more like the sandy water in a river or at the beach. If you look closely, you can see the particles of sand dispersed in the water. One easy solution to the settling problem is to occasionally shake pigment ink carts or tanks, although Martin advises that it is difficult to sufficiently redisperse the pigments with this method so that the ink returns completely to its original color intensity.

In theory, the basic trade-off between dyes and pigments has traditionally been that dye-based inks are more "colorful" on a wide range of media but also prone to being less stable or permanent, while pigment-based inks may offer less color gamut, but they are more lightfast, humidity fast, and gas fast (see Figure 8.4). In reality, the gap is closing, and ink manufacturers are continually trying to come up with compromise solutions between color gamut and permanence.

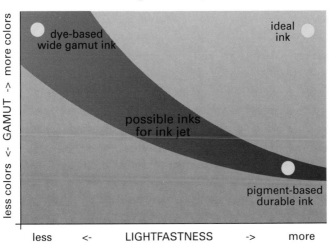

Figure 8.4 Photoconservator Martin Juergens' view of the basic trade-offs between inkjet dyes and pigments.

Courtesy of Martin Juergens

OEM or Third-Party Inks?

The major inkjet printer manufacturers (OEMs) have inks they want you to use with their printers, and many desktops come with a starter set of cartridges ("carts") ready for installing and printing. For many people, this is all they want to know about inks, and they are content to use these standard recommended inks that can usually do a perfectly good job of making prints. After all, the OEMs have carefully researched and developed ink formulations to best match their equipment and their recommended media. For example, thermal inkjets involve the quick heating and cooling of the printhead elements to create the ink droplets. Consequently, thermal inks have to be carefully formulated with this in mind. Epson's piezo ink technology, on the other hand, is pressure-based, which has its own requirements. This is one reason why you can't simply switch inks between inkjet technologies.

While OEMs don't like it when you bypass their ink supplies (and threaten to penalize you for doing so by voiding the printer's warranty), there are some legitimate reasons to consider using third-party inks: *reduced cost, increased color gamut and permanence*, and *special uses*.

Warning: Putting third-party inks in your inkjet printer is not without risk. Besides potentially ruining the printer, you may be in violation of the printer's warranty, although the OEM's have little legal foundation for this. Check the compatibility specs of any third-party inks before using them.

Cost

One reason OEMs push their inks is because they make a lot of money on them. Walk into any office super store and take a good look at the inkjet supplies rack (see Figure 8.5). It will quickly become obvious that all those $35 ink-cartridge packages (plus the paper) are what provide the profits for much of the inkjet printing business. It's the old Gillette business model at work: Sell cheap razors but expensive blades.

If you feel like you're feeding your printers liquid gold, consider using third-party inks that can reduce your ink bill by as much as 50–75 percent or more. A flourishing mini-industry has developed that provides compatible, non-OEM inks in various ways to consumers who want to save a significant amount of money. For example, ink supplier MediaStreet.com likes to point out that while a $100 bottle of champagne equates to $3.94 per ounce, a typical OEM desktop ink cartridge is about $24.00 per ounce. MediaStreet claims that using one of their bulk-ink systems (see Table 8.1) can save you up to 90 percent in ink costs compared to single-use OEM cartridges.

Figure 8.5 Cartridge inks are a major profit center for the inkjet industry.

Increased Color Gamut and Permanence

Certain third-party, *dye-based* inks are designed to exceed OEM ink permanence. Suppliers such as Futures, Lyson, Luminos, MediaStreet, Pantone, and MIS offer extended-life dye alternatives to OEM inks (see Table 8.1). Third-party *pigment* inks that either match or exceed OEM color gamuts and/or longevity predictions are also available from several companies, including American Imaging Corp., Lyson, M&M Studios, MediaStreet, MIS, and Pantone.

Specialty Uses

There are some applications where the OEM inks just can't do the job as well as third-party inks. Multi-monochromatic black-and-white printing is a good example. With the exception of certain printers, like HP's 3-black-ink Photosmart 7960 or 8450, it's difficult to get the highest-quality black-and-white prints out of inkjet printers using stock color inks. However, there are numerous third-party solutions that expand the possibilities significantly. For examples and more about multi-monochromatic specialty printing, see Chapter 12.

The three main ways of using third-party inks are with *replacement cartridges*, *refill kits*, and *bulk-ink systems*.

Replacement Cartridges

Non-OEM replacement cartridges come in rebranded, OEM-compatible cartridges from ink dealers and makers (including MediaStreet, inkjetART.com, Inkjet Goodies, InkjetMall, Luminos, MIS, Pantone, and Lyson) for most of the popular inkjet printers in use today. The cartridges are either new or recycled, filled with non-OEM inks, and usually less expensive than the real deal. (You can also buy factory-original OEM cartridges from several of these and other suppliers.)

Table 8.1 Sample Third-Party, DYE-BASED Color Ink Brands

Ink Supplier	Brand	Acceptable Printers	Works Well with These Papers	Profiles Provided?	Comes In
Futures/EIC *www.futuresinkjettechnology.com*	Futures Ink	All Piezo Wide Gamut	Various	Yes	Carts & bulk bottles & complete bulk system
Luminos *www.lumijet.com*	Preservation	Select Epsons Series	Preservation media	Yes, for Preservation media	Carts
Lyson *www.lyson.com*	Fotonic Photo Lysonic Archival	Select Epsons Select Epsons	Lysonic media Lysonic media	Yes, for Lyson media Yes, for Lyson media	Carts & bulk bottles Carts & bulk bottles
MediaStreet *www.mediastreet.com*	Plug-N-Play (OEM-compatible inks)	Various	Various	No	Carts & bulk bottles
MIS	Factory originals	Various	Various	No	Carts
www.inksupply.com	Aftermarket	Various	Various	Yes	Carts
	OEM-compatible	Various	Various	Yes	Bulk bottles

The key issues to consider are *match* (How close are they in terms of quality to the OEM inks they're replacing? Are they made to OEM specifications?), *compatibility* (Are they 100-percent compatible with your inkjet printer, and is there a guarantee backing this up?), and *age* (How old is the ink?).

You can also buy virgin, empty cartridges for do-it-yourself filling with the inks of your choice from some ink suppliers like MediaStreet, Inkjet Goodies, and MIS.

Non-OEM replacement carts come in different shapes and sizes. Shown are ink carts from Lyson, MediaStreet, and MIS Associates.

Fooling the Printer

Many of the newer inkjet printers have smart-chipped cartridges with built-in microchips (Epson's are called Intellidge chips). Although they are advertised to help keep track of ink usage, one maybe-not-so-unintended result has been to thwart the use of cartridge refills and third-party inks. But as soon as each generation of chips appears, entrepreneurs get busy and come up with ways to defeat and fool them.

Two inventions are auto-reset chips and chip reprogrammers or resetters that (1) allow cartridges to be refilled, (2) make it possible to use certain bulk-ink systems and non-OEM replacement cartridges, or (3) let you get the last few prints out of a cartridge that would normally be thrown away with some ink remaining (as they are designed to be).

For example, MIS Associates sells three chip-resetting products for Epson-only inkjet printers:

Auto Reset Chips. Auto reset chips reset the ink level to full when the printer power is turned on or when a cleaning cycle is completed. They are now used in the MIS Continuous Flow Systems as well as bulk systems by other suppliers. Not recommended for refilling.

F-16 Chip Resetter. This is a hardware device that connects to the printer (Epson only) and works on Macs and PCs. It will reset the printer even if the Red "out of ink" light is on. Meant for use with MIS Continuous Flow Systems only, and not for refilling.

SK168 Universal Chip Resetter. The SK168 is a self-contained unit with an internal battery and seven small pins that contact the cartridge chip. When held against the chip for 6 seconds, it puts the chip back to its electronic FULL setting. Requires that cartridges be removed from the printer. Not ideal for use with Continuous Flow Systems, but great for use with refilling.

Refills

If you don't mind the sometimes-messy and exacting work of refilling cartridges by hand, you might consider one of the refill kits that are produced by companies like MediaStreet, WeInk.com, and MIS. These kits (see Figure 8.6) typically include syringes and blunt needles, empty cartridges, and replacement inks for select Epson and Canon printers.

Figure 8.6 A MediaStreet Plug-n-Play refill kit from Inkjet Goodies for filling your own ink cartridges.

Courtesy of inkjetgoodies.com

Bulk-Ink Systems

Bulk-ink delivery systems—variously called by their popular acronyms CIS, CFS, or CRS—are popular for two main reasons: cost and convenience. The cost savings are obvious. Because you buy the ink in bulk, it's cheaper (the systems themselves can cost up to $350 for desktop printers, and more for wide-format). And because you only need to hook up the system once and then replenish or top off the bottled ink as needed, it's much more convenient than continually having to buy, change, or refill cartridges. Another advantage is that long, unmanaged print runs can occur; you can't print all night with tiny carts, especially individual ones, but you can with a CIS.

There are several manufacturers of these bulk-ink systems, and you will also find them sold under different rebranded names. They all work the same basic way: External reservoir bottles supply ink to the printer via tubing, which then connects to special cartridges that replace the printer's original ones.

One example is the MediaStreet Niagara II and III Continuous Ink Flow System. The Niagara system replaces single-use inkjet cartridges with a specially modified OEM-compatible cartridge that is connected to individual reservoir bottles of ink (4-, 8-, and 16-oz.). Once installed, maintaining the ink level is as simple as visually checking each bottle.

The Niagara II is custom-built and preassembled for a specific Epson or Canon inkjet printer. The system comes with a choice of Generations G-Chrome, Enhanced Generations, Generations ProPhoto, Generations Elite, or Plug-N-Play inks.

The Niagara III only differs from the Niagara II in that it does not include the prefilled carts.

MediaStreet's Niagara II Continuous Flow Ink System that replaces standard Epson or Canon ink carts.

Courtesy of MediaStreet.com

Other popular bulk-ink systems include MIS Continuous Flow Systems, NoMoreCarts CIS, Camel Ink Systems CRS (by WeInk), JetBlaster, and a bulk-ink system by American Imaging.

Keep in mind that only specific printer models (mostly Epsons and some Canons for desktop) are adaptable for bulk-ink-delivery use, depending on the physical design of the printer housing and, more importantly, the method of bypassing the printer's designated ink cartridges. Check with each manufacturer or dealer to make sure your intended printer is on the list.

Third-Party Overview

The use of third-party inks is increasing on some fronts, especially as image-makers become more sophisticated and more familiar with digital printing processes. However, you must weigh the disadvantages as well as the advantages. A few observations follow:

■ **Source.** Who makes which brand of ink is a closely guarded secret. There are only a handful of primary ink manufacturers, and they provide the finished inks or the raw ingredients to both the well-known OEMs and third-party marketers alike. Suppliers and percentages of business held by each are constantly changing, so it's fruitless to try to pin down the ink sourcing with any accuracy.

- **Quality.** With third-party inks, you may or may not get the same quality as you would using the OEM-recommended inks that are made for the printer. OEMs maintain that they are selling printer-ink-media systems, and that you forfeit consistent results and quality if you break that chain. That's why the best third-party inks try to exactly match the OEM's specifications for physical properties (density, viscosity, drying time, surface tension, and so on). The only way to know is to try them and find out for yourself.

- **Printer Settings and Profiles.** Realize that when you use third-party inks, the normal printer settings may no longer work, since you've changed the inks for which the manufacturer designed the printer. The same goes for any printer profiles that you've made or bought. Change the ink; change the profiles.

- **Availability.** Don't forget that you'll have a harder time finding third-party inks for non-Epson printers or for the latest ones with smart-chipped ink cartridges. It usually takes third-party ink distributors 12 months or longer to come up with ways to get around the intelligent OEM ink cartridges. Of course, by this time, your one-year warranty will have expired, and you won't be so worried about voiding it.

- **Back-and-Forth.** Some third-party inks require that you flush or purge the existing OEM inks from the printhead. This is usually done with cleaning cartridges. This is especially important with third-party inks that are chemically incompatible with the original OEM inks and can damage the printer. Third-party ink makers sell purging or cleaning kits where needed. (Some printmakers make their own home-brewed concoctions.) This obviously causes some ink wastage and limits how many times you'll want to go back and forth between OEM and third-party inks. With desktops, and even more so with wide-format printers where a large amount of ink must be purged from the lines and reservoirs, the best advice is to plan on dedicating the printer to only one type of ink and leaving it that way.

Media

If inks are the left hand, then media are the right to inkjet printing. You can't have one without the other. And, even more so than with inks, the variety available is tremendous. There are coated and uncoated papers, watercolor papers, high-gloss and backlit films, canvas, satins, fabrics, vinyls, plastics, polyesters—you name it. If it can hold ink and be run through an inkjet printer, it's a media candidate for somebody.

But before you get too excited, let's back up and try to understand how media are made and how they work.

Paper

Media is what you put through a printer. It's what you print on. Because paper is the most common type of media used in inkjet printing, let's study it in more detail. (Non-paper media are described in the "Alternative Media" section below.)

Types of Paper

Paper for inkjet printing falls into two main camps: uncoated and coated.

Uncoated Paper

Uncoated paper is the paper that we all know. This is the plain "bond" paper used in laser printers and copiers in every office around the world. On the opposite end of the quality scale, uncoated paper also includes those beautiful, mould-made (made on a cylinder mould machine) "fine-art" papers that have been lovingly used for centuries for watercolors, drawing, and traditional printmaking (see Figure 8.7).

Figure 8.7 Arches uncoated watercolor papers in different weights and finishes can be printed on with inkjet.

There are two main components of uncoated paper: (1) the base or *substrate* and (2) any *sizing*. The substrate forms the structure of the paper and determines its thickness, weight, and strength. Sizing can be added either internally to the substrate or to its surface to seal or bind the fibers and to provide resistance to the absorption of moisture.

Uncoated paper substrates, such as newsprint, are produced with an acidic process and made up of wood pulp, which contains *cellulose* fibers and *lignin*, a natural glue that holds the fibers together. The main problem with lignin is that it builds up over time and ultimately destroys the paper along with any image printed on it (lignin is what causes newspapers to yellow).

The majority of bond paper is produced via an alkaline process with AKD or ASA sizing, and it does not contain lignin. Bond paper is also *calendared* (sometimes spelled *calendered*), or smoothed between two metal rollers. However, bond paper is still not a good choice for inkjet printing, except for solid-ink printers and for some inkjets like Epson's C84 and C86, which are designed to handle this bottom-of-the-barrel paper medium. Bond papers do not have an inkjet receptive coating, which leads to poorer image quality due to ink wicking or bleeding (see Figure 8.8).

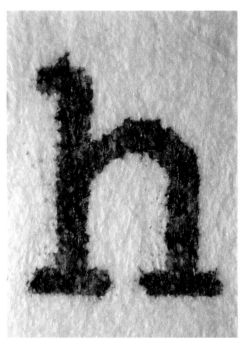

Figure 8.8 Ink on uncoated bond paper, 40x magnification, showing wicking and print density loss due to ink penetration, which leads to a decrease in image quality.

Courtesy of Martin Juergens

What sets uncoated fine-art papers apart from their lowly office paper cousins are the ingredients, the most important of which is cellulose fiber. Cellulose can come from a variety of plant sources including wood (the most common) and cotton. The highest-quality art papers are made from 100-percent cotton content, usually rag trimmings (that's where the term "cotton rag" comes from). Cotton fiber contains mostly *alpha cellulose*, the purest form of cellulose, and it's this cotton content that yields highly stable paper that is more resistant to deterioration than wood-based paper. There is also no rosin sizing nor lignin (and

hence no acid-forming compounds), but, instead, alkaline buffering agents like calcium carbonate are frequently used to raise the paper's pH. The surface of uncoated fine-art paper is sometimes sized with starches or gelatins.

Uncoated art papers can be used with inkjets, but normally only with dye-based inks. Arches, Rives BFK, and Somerset are three well-known brands, and they typically come in rough, cold-pressed (smoother), and hot-pressed (smoothest) finishes.

Coated Inkjet Paper

This is where most of the action is for inkjet printing. Coated papers, which can include versions of the fine-art papers mentioned above, have a *receptor coating* added to the paper's surface to better receive the inks and render the image (see Figure 8.9). This coating can contain a whole host of substances such as alumina, silica, clay, titanium dioxide, calcium carbonates, and various polymers. Coatings are specifically designed to enhance a desired effect like better image quality, better binding with the ink, higher-color gamut, less ink bleeding into the substrate, greater brightness, and so on. The coating can also change the surface finish of the paper to be more glossy, matte, or anything in between.

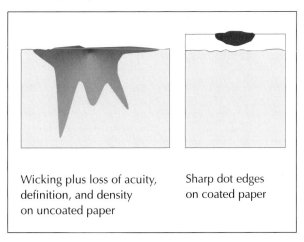

Figure 8.9 Coatings affect how the ink interacts with the paper.

Courtesy of Martin Juergens

Wicking plus loss of acuity, definition, and density on uncoated paper

Sharp dot edges on coated paper

Sulphite paper (also called "alpha cellulose" paper) is widely used and an alternative to 100 percent cotton paper. Instead of using cotton fibers, sulphite papers use pulp made from wood chips that are cooked in calcium bisulphate or sodium sulphite. After bleaching and buffering agents are added, you end up with a 100-percent alpha cellulose paper that is pH neutral. See Table 8.2 later in this chapter for examples.

There are so many coated inkjet papers available now, it's even hard to keep track of the categories for organizing them. But that won't keep me from trying.

One way that suppliers like to classify coated papers is with the terms "photo paper" and "fine-art paper" (see Table 8.2). Photo papers tend to have a resin-coated (RC) component structure (see below) and a glossy or semi-glossy finish just as their traditional counterparts have. Fine-art papers frequently resemble watercolor paper. However, there is really little reason to limit your thinking to only these two categories. There are plenty of cross-over choices that don't fit neatly into either camp.

Another way to classify paper is by finish or surface texture type: glossy, matte, satin, and so on. This, however, tells you very little about the type of paper and its appropriateness for use with different inks or printers.

A final way to categorize papers is by the coating technology: *microporous* or *swellable*, plus the misnamed *resin coated*. These help tell you what you can and cannot do with a particular paper.

- **Microporous.** A relatively new solution to the problem of inkjets printing faster than the ink can dry, microporous coatings (sometimes called "particulate" or "microceramic" coatings) contain very small, inorganic particles of either alumina or silica to create voids or cavities in the coating. The ink is absorbed into these cavities by capillary action, and the particles prevent the ink from spreading. The good news is that this results in fast-drying prints that can be handled immediately and that have a high resistance to moisture and humidity. The bad news is that the open areas of the coating allow the ink to come into contact with air and all the atmospheric contaminants it contains.

- **Swellable.** Swellable coatings are made with organic polymers (gelatin is one) that swell up to surround the ink after it hits the paper. Only a very thin layer of ink is then open to direct air exposure; the rest is protected. The finishes of these papers tend to be either glossy or satiny (luster), and the image quality is excellent. Another positive is that because the swelling tends to isolate the ink drops, print permanence is increased. Negatives include being more sensitive to contact with water or high humidity and also requiring longer drying times before the print feels dry. Swellable-coated papers are primarily for dye-based inks. OEM swellable examples include Epson ColorLife Photo Paper, HP Premium Plus Photo Paper, Kodak Ultima Picture Paper High Gloss, and ILFORD Galerie Classic Gloss and Classic Pearl.

- **Resin Coated (RC).** This is *not* a coating but a different way that papers are constructed. RC papers have been around for a long time; they are well-known in the photographic world and have now migrated to inkjets as well. Typically, a standard substrate is sandwiched between two layers of polyethylene, and one of the receptor coatings described above is then applied on top (see Figure 8.10). It's the inkjet receptive layer that determines the printing performance of the paper. The in-between polyethylene layer acts as a barrier

and helps reduce wrinkling that could result from heavy ink coverage. Many microporous- and swellable-coated inkjet papers aimed at photographers are in fact, RCs. The goal of many of these papers is to look and feel the same as a traditional photo print. Not always appropriate for pigment inks, some RCs are specially designed to accept them. Check for compatibility.

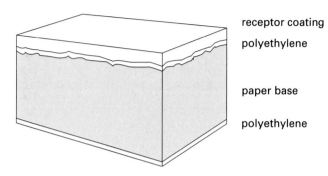

receptor coating

polyethylene

paper base

polyethylene

Figure 8.10 The layered structure of RC paper for inkjet printing.

Courtesy of Martin Juergens

Deciding on Paper

Choosing among all the different types of papers for inkjet printing can be either an exhilarating or exhausting experience. The assortment available has become bewildering. Where do you start? With the recommended printer papers.

OEM Printer Paper

Just like with inks, desktop inkjet printer manufacturers market their own lines of papers, and this is how I define "OEM" papers or media, even though some paper suppliers take issue with this because they consider themselves to be the true OEM suppliers.

In terms of choice, this is where Epson takes the lead with photographer-artists interested in high-quality inkjet media. At the time of this writing, Epson listed seven different 100-percent cotton "fine-art" papers on its product list. This is in addition to all the other types.

HP comes in second with two different fine-art papers (by Hahnemuhle) and several photographic papers.

So again, as with inks, the question is, Do you stick with the recommended media of the printer maker, or do you experiment with the smorgasbord of third-party choices that awaits you? And again, the answer is, It all depends. If you're happy with the recommended papers, you can be confident that they will be optimally designed for the printer's inks and printing technology. The permanence of those combinations will have been researched and well-advertised. In most cases, you know what you're getting.

But what if you want to spread your wings a little to see what's on the other side of the door?

It's time to open that door.

Third-Party Paper

The first thing to acknowledge is that printer OEMs discourage you from using non-recommended papers. The rationale is the same as it is with inks: (1) they lose money if you buy your paper elsewhere and (2) they lose control of the performance of their product because you are now introducing an unknown element to it. OEM-branded papers are designed to work in conjunction with OEM printers, drivers, and inks in a coordinated system.

However, because there are no smart chips embedded in papers (yet), you are free to use and print on whatever you can find, within reason. Of course, some papers will work better than others, depending on your needs. See Table 8.2 for only a partial list of third-party media choices.

Key Paper Characteristics

What follows next are the key factors and characteristics you should be aware of (and questions to ask) when going paper hunting, whether for OEM or third-party brands.

Size: As I mentioned in the last chapter, size is one of the primary factors in deciding between inkjet printers. Most inkjet papers come in normal, commercial print sizes: 8.5 × 11, 11 × 17, 13 × 19, and so on. These sizes are based on those used in the U.S. for standard office paper products (see Table 8.3). Paper marketed in Europe or other parts of the world comes in different sizes and matches the paper sizes of that area. Some paper suppliers will also list standard photographic paper sizes (4 × 6, 8 × 10, 11 × 14, and so on).

Table 8.2 Sample Third-Party Media (a Partial List Only)

Family	Name	Substrate Type	Coating Type	Weight (gsm)	Acceptable In
Fine Art					
Arches	Infinity	100% cotton	Microporous	230/355	Dyes or pigs
www.archesinfinity.com					
Breathing Color	Elegance	100% cotton	Swellable	310	Dyes or pigs
www.breathingcolor.com					
Hahnemuhle	Photo Rag	100% cotton	Microporous	188/308/460	Dyes or pigs
www.hahnemuhle.com					
Hawk Mountain	Osprey	100% cotton	Microporous	250	Dyes or pigs
www.hawkmtnartpapers.com					
Innova	Soft-Textured Art	Alpha cellulose	Swellable	315	Dyes or pigs
www.innovaart.com					
Legion	Somerset Photo Enhanced	100% cotton	Microporous	225	Dyes or pigs
www.legionpaper.com					
Moab	Entrada Bright White	100% cotton	Microporous	190/300	Dyes or pigs
www.moabpaper.com					
PremierArt	Hot Press Fine Art	100% cotton	Microporous	325	Dyes or pigs
www.premierimagingproducts.com					
Photo Glossy					
Brilliant	Supreme Glossy	RC	N/A	270	Dyes or pigs
www.calumetphoto.com					
ILFORD	Smooth High Gloss	RC	Microporous	235	Dyes or pigs
www.ilford.com					
InkjetART	Micro Ceramic Gloss	RC	Microporous	250	Dyes or pigs
www.inkjetart.com					
Lexjet	Photo Gloss	RC	Microporous	10 mil	Dyes or pigs
www.lexjet.com					
Lyson	Darkroom Range Gloss	Alpha cellulose	Swellable	320	Dyes
www.lyson.com					
MediaStreet	Generations G-Chrome Gloss	RC	Microporous	10+ mil	Pigs
www.mediastreet.com					

Table 8.3 Standard Paper Sizes

U.S. Name	U.S. Size	Metric Equivalent
A (letter)	8.5 × 11 inches	216 × 279 mm
Legal	8.5 × 14 inches	216 × 356 mm
B (ledger)	11 × 17 inches	279 × 432 mm
Super B/Super A3	13 × 19 inches	330 × 483 mm
C	17 × 22 inches	432 × 559 mm
D	22 × 34 inches	559 × 864 mm
E	34 × 44 inches	864 × 1118 mm
Metric Name	**Metric Size**	**U.S. Equivalent**
A5	148 × 210 mm	5.8 × 8.3 inches
A4	210 × 297 mm	8.3 × 11.7 inches
A3	297 × 420 mm	11.7 × 16.5 inches
A3+	329 × 483 mm	13 × 19 inches
A2	420 × 594 mm	16.5 × 23.4 inches
A1	594 × 841 mm	23.4 × 33.1 inches
A0	841 × 1189 mm	33.1 × 46.8 inches

Substrate: How is the paper made? What is the substrate material? Wood pulp? Cotton rag content? Plastic or other synthetics? RC? This is the starting point for knowing about a type of paper.

Color: The whiter the substrate the better the reflector under the colors, and the higher the color gamut. However, there's white, and then there's white. Some whites seem too cold. Too creamy, and it will look dreary as you lose color gamut. Again, it's a matter of personal preference. Papers have their characteristic colors, and people gravitate to them accordingly.

Weight: The standard measurement of paper weight for inkjet papers is grams per square meter (gsm). This is more accurate than the Imperial system that measures paper by its "basis weight," or the weight in pounds of 500 sheets of standard size, usually 17 × 22 inches. Knowing a paper's weight is only partially useful information. A much more important thing to know is a paper's thickness, which is not necessarily related to its weight. Within one brand of paper, heavier weights may be thicker, but Brand X of one weight may be thicker than Brand Y with the same weight.

Concorde Rag

EAM

Somerset

Bockingford

Inkjet printing papers are not just white!

Caliper (thickness): Caliper or thickness is a more useful paper measurement, since each printer model prints best with papers of a certain thickness range (and have a maximum thickness they will print). A paper's caliper is measured in *mils*, also called "points" in the commercial printing industry. One mil is 1/1,000th of an inch, and it is determined by the combination of substrate, additives, and coating. Some papers have different calipers for sheets and rolls.

Coating: Although this was covered earlier, it bears repeating. (Note: Coating in this context refers to the precoating on the paper when you buy it. If you're considering any postprinting coatings or sprays, see Chapter 10, "Finishing and Displaying Your Prints.") It's *very* important to match the paper coating to your inks and printer type. Quality, handling issues, ink puddling, smearing, scuffing, flaking, wicking, and excessive dot gain (ink spreading) are all affected by the type—or lack—of the appropriate paper coating.

How to Identify the Coating

How do you know if you're dealing with a microporous or a swellable coating if the box or package doesn't say? I use Henry Wilhelm's "squeak test." Rub your fingers across the paper. If it grabs your fingers or sort of squeaks (most noticeable on glossy papers), you've got a microporous paper. Another easy clue is if it's designated "instant dry" or something similar, it's probably microporous.

Determining the correct printing side of a coated paper is also sometimes a problem with inkjet papers (even if the box clearly says "image side up"). Here's a trick to help you figure it out: Wet two fingers and lightly grip a corner of the paper; the side that sticks to your finger has the printable coating. With experience, you'll be able to tell the coated side just by feel.

Finish: This is the surface texture. The range is high gloss to very rough with all kinds of pearls, satins, lusters (equivalent to the photographic "E" surface), mattes, and more in between. People tend to have strong feelings about their paper finishes. Color consultant C. David Tobie says it well when he states, "Paper is like religion or politics; you will have little success preaching matte to the glossy crowd, or vice versa. Celebrate diversity."

Sample, high-end, fine-art paper finishes: Arches Infinity (Textured and Smooth) compared to Crane Museo.

pH: You want papers that are pH-neutral (pH 7) or a little alkaline because our polluted environment will add acidity over time. Acidic paper is a ticking time bomb; it will self-destruct sooner or later. Look for papers that say "acid-free" and hope they mean it. Acid-free means either that no acids were added to the paper (as with 100 percent cotton) or that any acids used in a woodpulp–based paper have been removed or neutralized with an alkaline buffering agent, such as calcium carbonate or magnesium carbonate, which is added to the pulp. Keep in mind that buffering may lose its effect over time.

Brightness: Brightness is usually given, if at all, in terms of a rating scale of 1–100, with 100 being the brightest. Keep in mind that some papers achieve a higher brightness by adding optical brighteners.

Optical Brighteners: Optical brightening agents (OBAs) are commonly used in the paper, textile, and detergent industries. As the name implies, they're also added to inkjet printing papers and coatings to make them whiter and brighter. The way OBAs work is by absorbing UV radiation and fluorescing (re-emitting as visible light). A common OBA is titanium dioxide, which is added to the paper's outer receptor coating.

It's unclear what long-term effects OBAs have on print permanence. Some believe that they can possibly contribute to print deterioration, but others disagree, saying first that not all OBAs are the same, and then that the worst that can happen is a bright white paper ending up being less white (yellower) as the brightener loses its ability to fluoresce over time. According to Epson, all its standard papers have optical brighteners to improve whiteness and to inhibit the yellowing of the paper. Some paper suppliers will offer a brightened paper and a "natural" unbrightened one as an alternative.

Permanence/Lightfastness: As we already know, print permanence is the result of the interaction of inks, paper, and display or storage conditions. Just picking a paper will not give you any idea as to its permanence. You need to know at least one other part of the equation. Most paper suppliers include permanence ratings based on certain assumptions in their paper specs or marketing material. Make sure you read the fine print carefully to see how those projections are determined. (See Chapter 6, "What About Print Permanence?")

Two-Sided? Most people print on just one side of the paper, but there are times when printing on both sides (also called "duplexing") is a real bonus. Portfolios, brochures, greeting cards, postcards, and digital books—these are all good uses for two-sided printing (see Figure 8.11). However, in such cases, you need a dual-sided, dual-coated paper on which to print.

Figure 8.11 A portfolio book created by Andrew Darlow with Lineco's PopArt post-bound digital album. Andrew printed directly onto the double-sided Lineco Digital Archival Matte paper, which has a post-binding strip with holes ready to fit into the album covers.

Album and photographs © Andrew Darlow www.andrewdarlow.com

There are very few inkjets that can automatically duplex print. One is the Xerox Phaser 8400 solid-ink printer, where the paper is fed back through the machine on a different paper path. Several HP Deskjets can also do it with special two-sided printing modules that hold and then automatically pull the paper back to print the reverse side.

Cost: I've already described ink and media costs in the previous chapter, but I'll mention a cost-saver here. One trick that experienced imagemakers have learned is to do the testing, color balancing, and other preliminary work on similar, but cheaper, paper. Then when they're ready, they pull out the good stuff. This used to be hit or miss, hoping that the proofing paper would use the same settings or profiles as the expensive paper, but now, paper suppliers are starting to offer this combination with uniform coatings. For example, Hahnemuhle introduced their Art Proof paper in early 2004 specifically for "lowering the expense of non-income-earning test prints." It's 110 gsm, and they claim it saves 35–50 percent on the regular Hahnemuhle stocks. Similarly, Moab now offers Kayenta Photo Matte as a lower-cost "everyday" paper (Sulphite) plus as a proofing paper for Moab's Entrada line (100-percent cotton). Finally, Legion Digital Rag is the proofing suggestion for Somerset Velvet.

Alternative Media

I've concentrated on normal paper because it's the most common type of media. However, there are many alternatives to paper for inkjet printing. Wood veneer? Sandpaper? Aluminum foil? Open your mind to the possibilities—but at the same time, be forewarned about the possible fatal dangers to your printer whenever you put non-recommended media through it. (See more about special printing techniques in Chapter 11, "Using a Print Service.")

Canvas: One of the primary media choices for both portrait photographers and artists working with canvas originals and printing giclée reproductions is canvas. Canvas, of course, has been around for hundreds of years as an artist medium, but now, specially treated canvas is also available for inkjet printing. Different canvases have different coatings, different weaves or textures, and they come either on rolls for wide-format printers or in cut sheets for desktops. For example, Fredrix, the oldest (since 1868) and largest maker of artist canvas in the U.S., also has a line of Print Canvas products. These are 100-percent cotton or Polyflax/cotton blends, and they come in either cut sheets or bulk rolls. Other inkjet canvas suppliers (of their own or rebranded canvas) include Breathing Color, Bulldog Products, Hahnemuhle, Hawk Mountain, HP, Legion Paper, LexJet Direct, Luminos, MediaStreet, PremierArt, and Moab. Epson also carries a 100-percent cotton canvas, but it only comes in 24-, 36-, and 44-inch rolls.

Photographer and print-service provider David Saffir frequently uses canvas for printing portraits. In the example shown, his clients chose a traditional frame for the 20 × 24-inch print.

Courtesy of David Saffir
www.davidsaffir.com

Exotic Papers: There are lots of specialty papers available for inkjet printing. Paper vendor Digital Art Supplies carries an entire stock of handmade Japanese papers and even has a sampler pack devoted to them. With names like Harukaze, Kinwashi, and Yanagi, you are actually printing on mixtures of hemp, kozo, bamboo, or straw. Different from the Japanese papers found at art supply stores, these are specially treated for inkjet printing.

Red River Paper carries Silver and Gold Metallic papers that yield an unusual effect when printed with dye-based (only) inks.

Specialty Films and Plastics: While they are normal materials for sign and display print shops, backlit films, vinyls, polycarbonates, and decal media are coming under the scrutiny of imagemakers who want to print on something different. Clear or translucent films, for example, can be used to make digital negatives and the kind of window art you saw in the last chapter.

- At this writing, John Edmunds' Futures Wales, Ltd., was announcing its own brand of durable, high-resolution, inkjet-printable film with the ability to accept up to 6000-dpi printing.

- Pictorico's Photo Gallery Hi-Gloss White Film, used for photo reproduction, is made entirely with DuPont Melinex polyester film as the substrate (it's also coated with ceramic particles).

- Consultant Dr. Ray Work has come up with a Cibachrome-like solution for digital photographic output. It's an all-synthetic sandwich comprised of a base of 8-mil DuPont Melinex polyester film with a microporous inkjet coating, pigment colorants that form the image, and a laminated Teflon topcoat. There is no paper. There's also nothing to degrade, and, since there's no contact with the air, there are no gas fading problems.

- DuPont Tyvek is a spun-bonded polyolefin (a hydrocarbon polymer like polyethylene). Known mostly as a signmaker's medium, a wrap in home construction, and for FedEx and other shipping packaging, Tyvek is gaining popularity with adventurous digital printmakers willing to search it out. Tyvek is available from Océ, HP, and digital supplier Azon.

JD and Miriam Jarvis hold up their Tyvek print of *Le-Com-Bo*, which has been shown in exhibitions hung with bungee cords attached to the grommets (inset).

Courtesy of JD Jarvis
www.dunkingbirdproductions.com

Textiles and Fabrics: Inkjet printing on textiles and fabrics has come a long way, and very quickly. In addition to the well-established use of digital printing on banners and flags in commercial settings, there is an accelerating trend for printing directly onto fabrics for more utilitarian uses, like home decor textiles and clothing.

The original use of this textile printing technology was (and still is) to produce commercial samples and "strike-offs" quickly and cheaply without having to go through the traditionally complicated and expensive process of cutting screens, etc. This can be very important when you realize that 95 percent of fabric designs

never make it into production. However, individuals are now using their own inkjet printers to print on fabric for personal use. (A variation of inkjet printing on fabrics is the use of dye-sublimation transfers.)

Futures Wales, Ltd., has a new line of fabrics that include the same patented infusion formulation for inkjet printing as used with paper. These Futures Fabrics can be printed with ordinary acqueous inkjet inks, both dyes and pigments. When printed with pigment inks such as Epson UltraChromes, they can be hand-washed with little or no bleeding. They can also be ironed, stretched, twisted, pulled, and wrinkled, and they are claimed to be very durable, even when printed with dye inks. There are currently (at this writing) three Futures Fabrics available in rolls of various sizes: Gainsborough (100-percent cotton, 320 gsm), Hogarth (100-percent cotton, 230 gsm), and Landseer (polycotton, 100 gsm). Uses for the fabrics include custom wall coverings, window treatments, floor tiles, and banners. Compatible inkjet printers include HPs, Epsons, Mimakis, Encads, Lexmarks, Canons, and ColorSpans.

See more examples of printing on fabric in Chapter 12.

German company 3P InkJet Textiles shows off its digitally printed silk fabric at a trade show.

Finding Media

Where do you find all these wonderful printing papers and other media? With the crazy quilt of paper mills, converters, manufacturers, importers, coaters, suppliers, distributors, repackagers, dealers, and so on, it would be impossible to come

up with a comprehensive list of *all* the media and their sources. However, there are two good ways to track down the media of your dreams: Start at the top and at the bottom. By the top, I mean go to the major manufacturer/distributor websites (see some in Table 8.2) and research the features and specs of an entire product line. You can also go to the bottom of the food chain—retailers and dealers—and see what they have to offer and for how much.

Because media are so personal, it's always best to sample them yourself before deciding on a larger order. One of the best ways to try out different media is to order sample packs; most major brands offer them. If, however, the goal is to evaluate different brand samples, then go to the dealers that carry more than one brand. For example, Digital Art Supplies has "A Bit of (Almost) Everything Multipack" with paper samples from various brands and mills all in one box. They also have themed multipacks like "Dual-Sided Multipack" and "Photographer's Multipack." It's a great way to touch, feel, and try out different inkjet papers.

Matching Ink to Media

If there is one lesson to take away from this chapter, it's this: You must carefully match your inks and media to get the best and the most permanent inkjet output. Think of it as a system—everything has to work together. Some points to remember:

- If you want to print on *uncoated* fine-art paper, use dye-based inks; pigments will look muddier (Epson DuraBrites are an exception). But be aware that the dye inks may fade more quickly.

- Use pigment inks on coated papers; use dyes on both coated and uncoated papers. Check the paper specifications carefully for compatibility.

- In general, use pigment inks if you require maximum print permanence, or use a dye-ink/media combination that specifically offers greater permanence.

- If you want to use pigment inks on glossy or semi-glossy papers, carefully check for ink/paper compatibility. You may need a protective coating or spray.

- Although dye inks can usually produce brighter colors, pigments on carefully matched media can come very close to dyes in terms of color gamut.

- Try to use matching ink/media systems when possible. These can come from OEMs or from third-party suppliers.

As soon as the ink hits the paper, a chain of events takes place, and you want to understand and control the resulting physical and chemical interactions as much as possible.

Carefully matching inks to media takes effort, but the results are worth it.

You *may* have a better chance of achieving this goal with the consumables recommended by the printer manufacturer. As I've already said, companies like Canon, Epson, and HP have spent a great deal of time and money to come up with a complete system of inks, media, and printers that optimize print quality.

You can, of course, stray from the herd if you choose (taking into account certain restrictions like smart-chipped ink cartridges). Third-party providers of inks and media have also done their homework, and they offer many compatible products that compare favorably with—and are sometimes better than—the OEM's. But you will have to spend your own time and money to do the research needed to prove this to yourself (one of the reasons you're probably reading this book!).

The bottom line for consumables is this: Inkjet printing has finally evolved to the stage where photographer-artists can now choose a specific printer, inkset, and medium to produce the kind of output or look they have in their mind's eye. You just have to make the right choices to make the perfect match.

Enough background information; let's make a print!

9

Making a Great Inkjet Print

I can't give you instant, hard-earned experience in the digital trenches, but I can illuminate the key steps—and pitfalls—of the inkjet printing process. However, before you can start printing, you need the right front-end system.

System Setups

The tools of a digital imagemaker—besides curiosity and imagination—include the computer hardware and software that make it possible to create, process, and, ultimately, output digital prints. In addition to providing a few words about each major equipment category, I will also show you the actual setups of two serious digital-printing imagemakers: photographer Larry Berman and his PC Digital Darkroom, and digital artist Ileana and her Mac Digital Studio.

Can you get by with less? Of course. You may not even need a computer at all if you like printing directly from a digital camera or a memory card. However, these two examples should give you something to aim for.

Healthy Hardware: Advanced Equipment Setups

Just like socialites in Palm Beach who can never be too rich or too thin, digital artists can never have too much digital horsepower or too much disk space. It's not the printers themselves (if outputting to a desktop printer) that require it; even the newest inkjet printers need only a basic setup. But when it comes to the large image files that many imagemakers process, and inevitably end up with, more is definitely better.

① Left Monitor:
Sony 21" 1620HT

Right Monitor:
Gateway 21"

Radeon 9600
128 MB DDR ATI
dual monitor card

Monaco Optix
for calibrating
dual monitors

② Olympus P-440
Photo Printer
(dye sublimation)

③ Wacom ArtZII 6x8"
serial port graphics tablet

④ APC Back-UPS Pro 1000
uninterrupted power supply

⑤ Windows XP Pro
P4 2.8 GHz, 1 GB RAM
dual 200 GB
7200 RPM hard drives
DVD burner

⑥ Nikon Coolscan 5000ED
35mm film scanner

⑦ Epson Perfection 1640SU
flatbed scanner

⑧ dual backup 160 GB
USB2 external hard drives

⑨ Lexar Firewire
card reader for
digital camera files

Not shown:
Linksys wireless
G broadband router
Internet connection
sharing to Win XP Pro
Pro laptop

Photographer System Setup: Larry Berman's PC Digital Darkroom

Pennsylvania photographer Larry Berman is a serious imagemaker, seen here working on one of his new color X-ray digital photographs that he sells at juried art shows throughout the U.S. He considered this a "power user" setup when he purchased it last year. It's a 2.8 GHz P4 system with a gigabyte of RAM. He's also added a Nikon Coolscan 5000ED, which he uses to scan client's slides for the new art show digital jury system.

Courtesy of Larry Berman/www.LarryBerman.com, www.ColorXrays.com

Computing Platforms, Operating Systems, and CPUs

Like fanatical sports team fans, digital imagemakers are usually die-hard defenders of either the PC/Windows or Macintosh computer platform. The fact is, it doesn't make much difference which you go with. Most image editing programs (but not all) and virtually all high-quality desktop printers run just as well with both. PCs tend to be cheaper and easier to find, and Macs are still preferred in an almost cult-like way by certain groups such as high-end photographers.

Each operating system's (OS) software also has its band of adherents. Microsoft Windows reigns supreme on the PC with its many incarnations, although XP is the latest as of this writing. On the Mac side, most Macophiles are shifting to OS X, although some are still holding on to OS 9.x for as long as they can. Once the image editing or printer software you're running can no longer work with your old OS, it's time to upgrade it. At that point, many Windows users just opt for a whole new computer, with the latest OS built in.

CPUs and Processing Speed

The central processing unit (CPU) is the heart of your computer. Intel Pentium (3 or 4) and AMD Athlon are two obvious choices for the PC. PowerPC processors (currently G4s and G5s) on the Mac are the only realistic options.

CPUs come in different "clock speeds," which have a big impact on how fast your work gets done as the computer processes all those binary numbers. Get the fastest CPU you can afford, unless you like staring at the monitor watching little hourglasses or spinning clocks while your files are processed. Note that megahertz or gigahertz ratings should only be used for comparing CPUs in the same family; it doesn't work to compare Pentium speeds with PowerPCs due to different levels of efficiency in using each clock tick, and co-processing functions that may speed imaging work. Dual processors (two main chips) should also be considered for improved performance, especially with Mac OS X.

RAM

The other big key to processing large image files is Random Access Memory (RAM). These days, RAM is cheap, so buy all you can. Sophisticated image editing programs like Adobe Photoshop are real RAM hogs, so load up on it. If you can get and utilize more than 1GB (1,000MB) of RAM, get it. You'll be smiling when your work flies off the screen.

Connections

One of the real limitations with older computers is the printer interface or connection. Most contemporary desktop printers, whether inkjet, dye sub, or laser, require a USB or parallel (IEEE-1284) connection. Even better, upgrading to a system offering USB2 or FireWire can be important for downloading large numbers of digital photos or gaining high-speed access to scanners, drives, and printers.

Older computers don't have these options, although special cards can be installed for this purpose. When nothing can connect to your computer anymore, that's usually the time to buy a new one.

Hard Drives and Other Storage and Transport

As with RAM and processing speed, large image files require a lot of digital storage space. Since you have to store all those files somewhere, you should get the largest hard-disk storage capacity you can, 120, 250, even 500 *gigabytes*. Again, as with RAM, per-megabyte storage costs have dropped significantly, so be generous to yourself.

For small-scale or temporary storage (or for file transport), you'll definitely want some kind of removable media system. Most file transport these days is done either with microstorage drives or on CDs (650MB) and DVDs (4–9GB). You'll either need a built-in CD/DVD writer/reader on the computer or use an external, stand-alone unit.

A ScanDisk USB Flash drive. It's easy to carry one of these in your pocket and then just plug it into any computer's USB slot.

Displays

Again, bigger is definitely better when it comes to monitors. With the menus and palettes multiplying on the latest image editing software, screen real estate has become a priceless commodity. Most photographer and digital artists work on 19"–21" or even larger screens, and some use dual monitors, one for the main image, the other for all the tools. Mitsubishi, NEC, LaCie, Apple, and Sony make models popular with imagemakers.

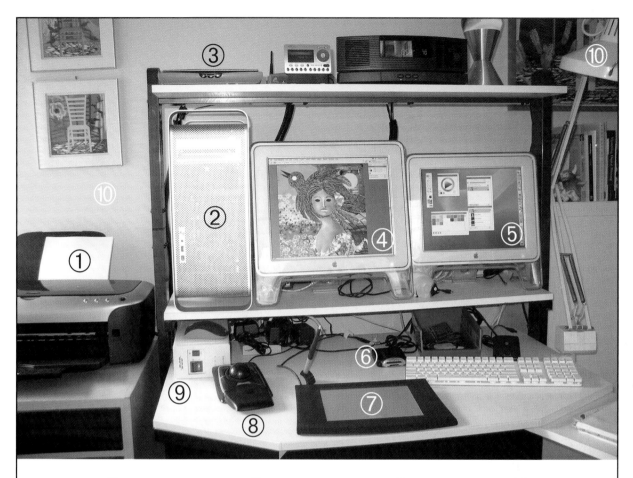

①
Epson Stylus Photo
2200 inkjet printer

②
Apple G5 2.0GHz
Dual Processor
3.5 GB RAM
160GB hard drive
Mac OS X 10.3 Panther
Pioneer DVR-106 DVD-RW
ATI Radeon 9600
Pro AGP 64MB

③
Canon LiDE 30 Scanner
48-bit /1200x2400 dpi

④
17-inch Apple Studio Display

⑤
15-inch Apple Studio Display
(Apple DVI to ADC Adapter)

⑥
Dazzle Digital Media Reader

⑦
WACOM Intuos II 6x8"
USB graphics tablet

⑧
Kensington
ExpertMouse Trackball

⑨
APC Back-UPS
400 Uninterruptible
Power Supply

⑩
LTS Daylight Glow
portable lamp

LinkSys Wireless-B
Broadband Router

Not shown:
Pantone ColorVision
SpyderPRO

Nikon D70 6.0 MP
digital SLR camera

Digital Artist System Setup: Ileana's Mac Digital Studio

Another serious imagemaker, digital artist Ileana considers her setup above average for someone expecting to make a living doing fine art on a computer. Her dream setup when the budget and sales allow? Add a 30" Apple Cinema HD, Apple PowerBook laptop so she can work remotely, and a state-of-the-art wide-format inkjet printer.

Courtesy of Ileana Frómeta Grillo/www.ileanaspage.com

Another trend is toward flat screen, liquid crystal displays (LCDs) and away from the traditional cathode ray tube (CRT) monitors, although some users still maintain that CRTs are better. (Apple has abandoned CRTs almost entirely with its current product line of displays.) Prior concerns about poor color fidelity on LCDs are fading as the quality improves and as more color profiling devices come online to deal with the new flat screen monitors.

Input Devices

Digital imagemakers work with source material in one form or another that needs to end up in the computer. I've already covered digital cameras and scanners in Chapter 4, however, one tool that needs more description is the digital graphics tablet, which combines a pen or stylus and an electronic tablet that records the pen's position and action.

Besides the obvious help with digital painting or drawing, tablets also allow for easier retouching and other kinds of image handwork. In fact, there are many photographers, artists, and designers who have replaced the mouse on their desk with a tablet for everyday use.

Tablets come in all sizes, shapes, and types, and Wacom (see Figure 9.1) is the dominant player with its popular models: Graphire (basic), Intuous3 (professional), and Cintiq (work directly on the screen).

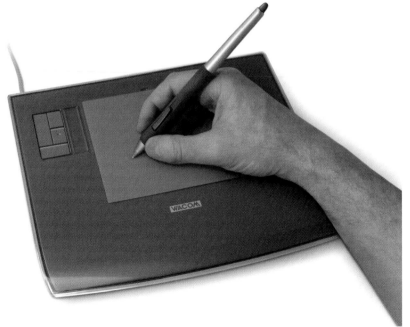

Figure 9.1 Wacom's Intuos3 (4 × 5") graphics tablet in use. Intuous3 also comes in 6 × 8 and 9 × 12 sizes.

Courtesy of Wacom Technology

What are the most important things to look for in choosing a graphics tablet? Size (very personal), resolution (more is better), and pressure (more is still better).

Internet Connection

It's becoming more and more necessary for imagemakers to have a high-speed connection to the Internet. Here are some common uses for the Internet among imagemakers: downloading software and software updates; downloading users guides and being connected to serialize or register some products; researching information; browsing and maintaining websites; downloading images; sending image files to friends, colleagues, or outside printmakers; and quickly perusing and contributing to online forums and discussion lists.

The more time you spend online, the more frustrating the old 56K dial-up connection becomes. Cable modems, DSL, and dedicated high-speed lines are the way of the modern, online world.

Color Management

Most photographer-artists are incorporating some type of color management into their workflows. Color management can take many forms: from simple—and free—onboard monitor calibration to stock or custom profiles to specialized hardware and software packages costing $5,000 and up. (For an overview of this important topic, see Chapter 5, "Understanding and Managing Color.")

Printers

See the in-depth discussion about inkjet printer choices in Chapter 7, "Selecting an Inkjet Printer."

Quick-Start Printing Guide

In the following main section, I will go into some depth about the different printing steps, but here I want to get you printing in the shortest time possible. Consider this an overview or a skeleton approach. (Note: These are the basic steps for self-printing on a desktop inkjet printer; if you plan to use an outside printmaker or a printing service, see Chapter 11.)

Before we begin, I will make certain assumptions, namely

1. That you have, or have access to, a computer system and an inkjet printer and know the basics of how both work. For this Quick-Start section, I will be using a PC laptop running Windows XP Home to print from the Adobe Photoshop Elements (2.0) program to a Canon i960 Photo Printer (see Figure 9.2).

2. That you have scanned in, captured, or otherwise created a digital image file (see Chapter 4, "Creating and Processing the Image").

3. That you have a reasonably calibrated monitor (see Chapter 5).

You don't absolutely *have* to have all these, but it will make what follows a little more understandable if you do.

Figure 9.2 For this workflow, I'm using a laptop computer running Windows XP Home to print from Adobe Photoshop Elements 2.0 to a Canon i960 Photo Printer.

Step 1: Open and Convert the File

I had taken this photo of a farmer in Sweden (Figure 9.3) some years ago, and I scanned the slide myself on an Epson Perfection 4870 desktop scanner with transparency unit. I open the raw scan in Elements and immediately Save As to the PSD format of Elements to create my working file. I start thinking about what editing needs to be done.

Figure 9.3 This is the full-frame scan of my original 35mm slide of the Swedish farmer.

Step 2: Edit and Prep the Image

Because I decide to crop in tight on this image, removing unneeded image areas top and bottom, and because I know that cropping permanently alters the file, I do another Save As to create a new file with the word "crop" in the title. This way, I can always go back to the earlier version

Figure 9.4 The cropped, edited, and sharpened image file.

and start over, if I want to. I check for *squareness* and then *crop* the image to be much tighter.

To continue the editing, I only do minimal adjusting, using the Elements' Levels function. I finish by going over the entire image, removing dust spots and repairing defects wherever I see them.

Normally, I would save a print-specific version of the file at this point, and then sharpen it as needed based on the type of output I'm doing. However, because I'm only doing a basic workflow, I simply duplicate the base layer and rename it "sharpen" before doing a minor amount of sharpening *to this layer* (using Elements' Sharpen filters). By doing this, I can always remove the sharpen layer to get back to where I was. Figure 9.4 shows the resulting image and its Layers palette.

Step 3: Choose and Load the Paper

I'm using Canon's Matte Photo Paper, which is a recommended paper for Canon inkjets. After I turn on the printer, I load the paper (letter size) so that it's leaning against the back paper support, with the printing side in the correct orientation (see Figure 9.5). Because this paper is thin enough for successful multiple sheet feeding, I load a few sheets.

Figure 9.5 The printer is ready with the paper loaded.

Step 4: Select Image Settings

I first confirm that I have the right scaling and print resolution in Elements under Image > Resize > Image Size. I adjust the Printer Resolution to size the image for my paper. I now go to File > Page Setup to confirm that the paper size and orientation are correct. They are. Then I go to File > Print Preview to access more settings (I could have accessed Page Setup from here, too) and to see a preview of how the image is positioned on the page (see Figure 9.6). All looks good, so I now hit the Print button.

Figure 9.6 Elements' Print Preview screen.

Step 5: Select Printer Driver Settings

The Print menu confirms that I have the correct printer selected (I can also change printers at this point). Now I click on the Properties button to access the printer driver settings. This is where all the goody options are for this printer (see Figure 9.7). I check the basics at the top and pick my paper under Media Type ("Plain Paper" is showing only as an example). Because I want to see first if I'm even close with this print, I start off with the simplest Standard and Auto settings. This will hand over everything to the printer driver, and I'll know soon enough if this is the right decision or not. I'm ready to make my first print.

Figure 9.7 The Properties button opens the various printer driver options.

Step 6: Make the Print

Before I forget everything, I write down all my settings and the decisions I've made up to this point. This will be an essential record if I want to make alterations later.

Finally ready, I click the OK button, and the printer comes to life. Soon, I have my first print, and I evaluate it under the diffused window daylight of my studio space (see Figure 9.8). It looks great!

Figure 9.8 Not bad for a first print!

Making a Serious Print, Step-by-Step

Now, I'll go into more depth with a decidedly more serious approach. This workflow may go over the heads of some, but others will find it just challenging enough. In this section, I'm going to elaborate on the previous steps, add some more, and also give more options for some. I'll change printers (Canon i960 to HP Designjet 130), printer type (consumer desktop to professional wide-format), and media type (swellable coated satin from microporous matte).

The image this time is a vintage shot I took in a Paris cheese shop, and I'm calling my print *La Fromagerie*.

La Fromagerie
© 1970-2004 Harald Johnson

The printer used in this section is the HP Designjet 130nr. The 130 was introduced in May 2004, and it is a 6-color (CMYKcm), thermal, wide-format inkjet printer. The Vivera Inks and the HP Premium Plus Photo Satin paper are also from HP.

For this print, I'll be working on a Mac (G4) in OS X 10.3 with Photoshop CS, but the same basic principles and procedures apply to Windows workers with only a few minor changes, which I'll note below.

As I walk you through my printing procedure, keep in mind that this is only one way of doing it. Use this workflow as a base or a point of reference; don't hesitate to change it to suit your own way of working. These steps are not carved in stone, even for me. I will sometimes change their order just for fun or to see if there are any creative possibilities to discover.

The 11 steps in my inkjet printmaking workflow are

1. Plan the Print

2. Prep the File

3. Edit the Image

4. Save a Print-Specific Version

5. Scale, Res, and Sharpen

6. Select and Load Paper

7. Select Image Settings

8. Select Printer Driver Settings or Profile

9. Make a Test Print (or Two or Three…)

10. Make Adjustments and More Test Prints

11. Make the Final Print(s)

Step 1: Plan the Print

Just like tailors who measure twice and cut once, I spend a lot of time planning out my prints in advance. This may be less fun than jumping in and starting to image-edit, but believe me, you will save yourself a lot of headaches if you take your time with this step.

Once I've decided on my image and the rough print size, I make a full-size mockup. This is the best way to see if what you're planning is really going to work or not. The old-fashioned way is simply to cut down or tape together pieces of white poster board to equal the exact finished size of the print.

Full-sized mockups, done with either blocks of color or low-res versions of the actual image, are good ways to evaluate the size and proportions of a print.

A more sophisticated variation for making a mock-up is to output your actual image in a low-resolution format. For larger sizes, you may need to *tile* the image. I sometimes make a tiled, black-and-white mock-up with my office laser printer. The image can then be taped together and attached to the print backing sheet to evaluate the overall effect.

Again, the purpose of this important step is to have a 100-percent-size mock-up of your intended print. I like to hang or tack them up in different locations around my house over the course of several days. Once I'm satisfied with the image and print size, I'm ready for Step 2.

Step 2: Prep the File

Working in Photoshop CS, I verify my Color Settings RGB Working Space as Adobe RGB (1998), my favorite. I also check my monitor calibration settings or calibrate the monitor again with one of the measured calibration systems described in Chapter 5.

I organize my computer desktop with the appropriate folders and prepare to work on the file. This particular image was in 35mm slide format, and I had it scanned on a film scanner at my local photo lab at 4000 dpi. The 2592 × 1712-pixel file (I had precropped a smaller portion to use for this) is an 8-bit RGB TIFF, and the first thing I do after opening it in Photoshop CS is Save As to the native PSD format. This is now my working file (see Figure 9.9).

Figure 9.9 The original scan is saved to a new file with a new name.

Step 3: Edit the Image

The first thing I usually do in Photoshop is check the *squareness* and the *cropping* of the image. In this case, there's nothing to square it against, so I won't worry about that. However, I do see a little too much emptiness on the right side, so I'll want to do some cropping. Because I know that I can't go back once I've cropped, I play it safe and create another Save As, this time adding the word "crop" to the title.

I'm noticing an overall red cast that's clearly visible in both the sidewalk outside the window and in the highlight top of the metal cheese cutter. One solution is to open an adjustment layer with Levels, and, using the gray eyedropper, click on the metal cutter to make it and the rest of the image more neutral. However, I can't find a good spot where the image doesn't go too green and blue, so I try a different approach. I create a Curves adjustment layer, and in the Red channel, I pull down the end point until the red goes away. By doing it this way, the red goes down, but the green and blue stay where they are. Figure 9.10 shows the final edited image along with the Curves menu. (Sometimes, an image like this with different light sources—shop lighting, daylight—requires selection masks to correct such lighting issues).

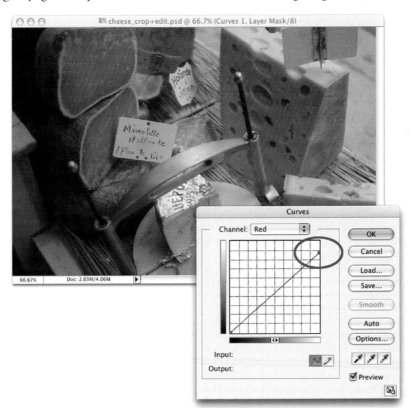

Figure 9.10 The cropped and edited image showing the red-reduction Curves adjustment.

I finish the editing by going over the entire image at 200% view, removing dust spots and repairing holes and defects.

Step 4: Save a Print-Specific Version

Once I have finished, and with the edited master and its companion files tucked safely away on my hard disk and on a backup CD stored in my wife's safety deposit box at the bank (you think I'm kidding?), I now make a print-specific version to my edited (layered) file to continue my work. Again using the Save As command, I create a new file, adding to its name the destination printer—_HP130—or a project name or whatever makes the most sense. See Figure 9.11 to see how my project folder now looks.

Figure 9.11 Work folder with the original files and the new print-specific file.

Step 5: Scale, Res, and Sharpen

Because I'll be printing directly out of Photoshop, I could choose to flatten all the layers into one (Layer > Flatten Image), or I could Save As to TIFF format, which offers a flattening option. This removes the Layer palette clutter and also reduces the file size. However, because the file is relatively small, I decide to keep the file in its layered form. That way, I can easily go back and make minor adjustments to the existing layers if the printing is a little off. Note that if you're sending a file to someone else for printing, they will want a flattened TIFF *without* all the layers.

Size/Scale and Resolution

Scaling means stretching or compressing an image's pixels to fit a certain size on the paper. This is also called *resizing*. With *resampling*, on the other hand, all the pixel information and, therefore, the image itself is changed. With my cheeses, I use the scaling method to reach my desired print size.

Sharpen

I prefer to do all the sharpening as a close-to-last stage when I know what kind of printing I'll be doing. There are many ways to sharpen an image—and I have yet to meet an image that didn't need it. You can use Photoshop's standard unsharp masking filter (Filter > Sharpen > Unsharp Mask), using what's called the High Pass/Hard Light method, or sharpening the L (Lightness) channel in Lab Color

mode (keeping in mind that there is some degree of quality loss every time a file is moved into or out of Lab). Or you can use special software, plug-ins, or procedures (such as only sharpening in 10-percent increments). For this image, I decide to use standard RGB sharpening but with a variation of the Fade Unsharp Mask effect.

I first make a duplicate image layer and start experimenting with the Unsharp Mask filter. Because this image does not have large flat areas, such as sky, I leave the Threshold setting at a lowly 1. I end up with sharpness settings of 99/.7/1.

Then I do a trick. The classic Fade Unsharp Mask (Edit > Fade Unsharp Mask) procedure involves setting the Fade mode to Luminosity and adjusting the opacity on the duplicate image layer. With this variation, I simply make a duplicate image layer, change the duplicate's blending mode to Luminosity, sharpen it, and adjust that layer's opacity; in this case to 85 percent (see Figure 9.12).

After sharpening, it's always a good idea to go over and check the image again carefully, usually at 100–200% view or more. Sharpening tends to add artifacts and to exaggerate any repair work.

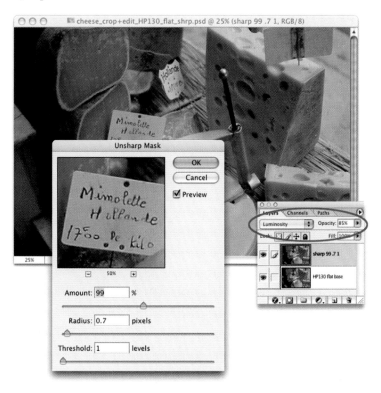

Figure 9.12 Final sharpening with the Luminosity Blend Mode method. Left: The Unsharp Mask filter. Right: The new sharpening layer.

Step 6: Select and Load Paper

I can't tell you how many times I've tried to print a file only to realize that I forgot to load the paper first. That's why I'm highlighting this step here.

I'll be using HP Premium Plus Photo Satin in 13 × 19-inch sheets. It's designed for use with the Designjet 130 (and 30 model), and I like its luster/satin surface as well as the 11.5-mil thickness (286 gsm).

After I turn on the printer (another essential step!), I load the paper in the front tray so that the printing surface is facing down (see Figure 9.13). This is different from the way many other inkjets (including most Epsons) handle paper, and it takes a little getting used to. The printer pulls the paper from the top. (Note that this printer also comes with a roll feeder, depending on the model, and a back-feeding paper slot, but I'm not using either here.)

Figure 9.13 Most front-loading printers, including many HPs, require that you load the paper in trays with the printing side down.

Certain papers can only be loaded one sheet at a time, but this is not one of them, so I load several sheets.

Step 7: Select Image Settings

In Photoshop, I confirm that I have the right sizing and print resolution settings under Image > Image Size (see Figure 9.14). I adjust the Printer Resolution to size the image for my paper. I use the resizing/scaling (not resampling) solution to end up with a print size of 8.6 × 5.7 inches at 300 ppi. (If you see variations in these figures in the screen shots in this chapter, it is because I'm continually experimenting with subtle size changes to see how the image and borders look.)

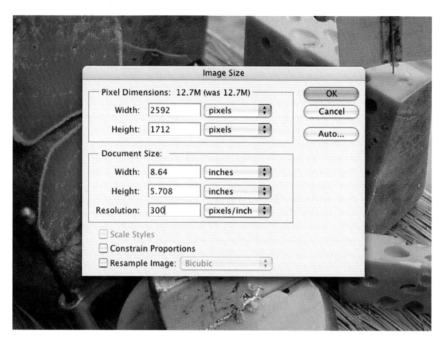

Figure 9.14 The Photoshop CS Image Size screen.

Step 8: Select Printer Driver Settings or Profile

To access the printer driver settings for this printer, I choose Page Setup from the File menu and select the basic page options that I want (see Figure 9.15). (In Windows 2000 and XP, it's Start > Settings > Printers.) These are just the rudimentary choices, such as the printer I'm using, the paper size (if I were printing on a roll, I'd pick it here), the orientation (portrait or landscape), and the scale percentage.

For more options, I now choose Print with Preview from the File menu and select the appropriate print options (I could have accessed Page Setup from here, too—see Figure 9.15).

The top portion of the Print menu is easy to understand, but the bottom (Show More Options checked), includes many options. I'll explain three of them.

Option A: Using the Printer's Basic Settings

Back in the Print menu (Figure 9.15), I confirm the scaling and sizing of the print and see a preview of how the image is positioned on the page. In the important Color Management section at bottom, I select Source Space > Document > Document: Adobe RGB (1998). This was the working space to which I had converted the image file, as it is my preferred working space. If there were no working space associated with this file, it would read instead Document: untagged RGB.

Figure 9.15 The printer-driver settings for this printer start to kick in with Page Setup (top left), and then Print.

For Print Space, I select Profile > Same As Source because I want to start with the basic options at first. Same as Source means that there is no color conversion from working space to printer space going on (other than at the operating system level); the file is sent directly to the printer driver. This can yield very different results, depending on the platform and driver color tools being used. For example, HP's color utility ColorSmart III assumes everything is sRGB, which in my case it isn't. Windows assumes the same thing, but ColorSync on the Mac is much smarter, assuming I know what I'm doing and recognizing whatever working space I have. You'll see the result in a later section.

All looks good, so I now select the Print button on this screen (top right). When that happens, I am presented with another small screen that allows me to quickly confirm settings I've already made, but more importantly, the third drop-down menu is my entrance into the key printer options, with the most important under the Paper tab: Paper Type, Quality, and Color (see Figure 9.16). Here is where I make important choices, selecting my paper (HP Premium Plus Photo Satin), Quality (Best), and Color (ColorSmart III, HP's primary color utility). Note that Epson and Canon have similar screens that look slightly different. There's also a cool Summary option that let's me save and see what all my settings are and even fax them to someone else.

Figure 9.16 Deeper levels of printer settings for this printer include a few basics (top left), the all-important Paper Type, Quality, and Color settings (middle), and a summary of the settings chosen (bottom).

Option B: Using a Built-In ICC Profile

Next, I make a slightly different version by accessing the correct HP-supplied ICC printer profile (installed with the printer software) in the Print Space section of the main printer driver screen (see Figure 9.17). To make this work best, I want Photoshop to make the color conversion, which means I have to turn off all color management at the printer driver level. With this HP, that is accomplished by selecting Application Managed Color in the Color options tab (see Figure 9.17, right screen). This is similar to Epson's No Color Adjustment setting.

Figure 9.17 Selecting the supplied media profile (left oval) requires turning off color management at the driver level (right oval).

Option C: Using an Outside Printer Profile

An alternative to using the onboard printer settings and profiles is to use an outside printer profile, either one you create yourself with a profile software package as described in Chapter 5 or with a purchased custom profile. For this option, I choose the DIY Profile route.

I had already made a printer profile for this combination of inks and paper with GretagMacbeth's spectrophotometer-based Eye-One Photo software, and I am ready to give it a try. I select the profile in the Print Space section and prepare to make a test print (see Figure 9.18). Obviously, if you plan to use a printer profile but haven't made one, now is the time.

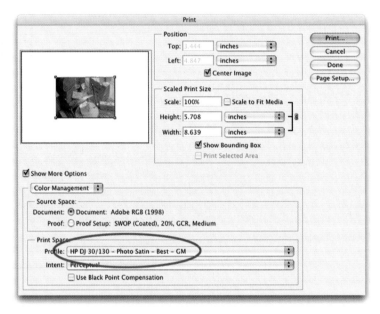

Figure 9.18 Selecting my own do-it-yourself printer profile (left oval), identified with a "GM."

Step 9: Make a Test Print (or Two or Three...)

Whichever workflow I'm following, when I'm satisfied that all the settings are correct, I am ready to send the file to the printer. (I may want to precede this step with a new Color Calibration to make sure the printer is in an optimum state. This Designjet 130 printer is one of the few that offers this option.)

The moment of truth—and an exciting one it is—comes with that first print out of the printer. This is almost never the final print, but it serves as the reference benchmark for all subsequent adjustments.

I make one test print with each of the three workflow versions already outlined. Here are my subjective comments about each:

- **A: Using the Printer's Basic Settings.** To ease my way into this, I used Same As Source and the HP ColorSmart III utility. The print is so-so, with the colors weak overall. I quickly make another one, but this time I first converted my file to sRGB (remember that ColorSmart assumes all files are sRGB). That print is better, with richer colors, but I know I can do much better.

- **B: Using a Built-In ICC Profile.** For this print, I used the built-in ICC profile for the paper/resolution (Best) combination, and it's excellent. More saturated and with more contrast.

- **C: Using an Outside Printer Profile.** Using the Eye-One–generated profile is better yet. Smooth and rich colors.

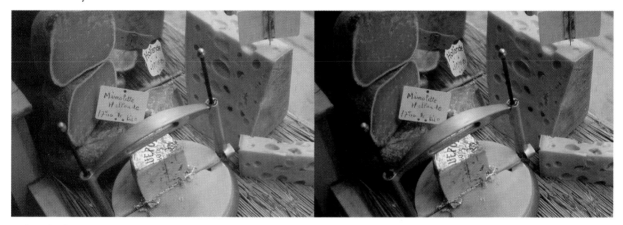

Left is the first print (Option A) with very basic settings. Right is Option B, using the built-in ICC printer profile.

Step 10: Make Adjustments and More Test Prints

You'll notice that I didn't say in this heading "Make Adjustments and *One More Print*." I usually go through at least a few rounds of adjusting, printing, re-adjusting, re-printing, and so on. That's why it's important to take notes and to consistently number the prints as soon as they come out of the printer.

I saw some good potential in the Option B workflow (using a built-in ICC printer profile), so I do more tests by varying the print resolution and the rendering intent, and by making more color adjustments.

I have now made several test prints using three different workflows. Evaluating all my prints near a large window with diffused daylight coming in, I pick the best test print (the one I've been working on) as the final proof, and I check my notes for which settings were used to make it. As a safety measure, I transfer all the setting information to the border of the test print itself.

I'm ready to make my final print.

Keeping Track of Tests

A big part of printing is keeping track of what you've done so that you can use your experience to improve the next prints down the line. That's why I always take the time to pull out a blank legal pad and jot down all the specifications, settings, and decisions made during each step of the workflow.

It's a good idea to keep records of test-printing settings. These were from an earlier test printing.

Step 11: Make the Final Print(s)

Final prints require more planning. Test prints are disposable (or make great gift cards), but depending on how many of the real thing you'll now be printing at once, you need to think through this last step *before* you start:

- How long do the prints need to dry before they can be stacked or stored? (I'll let them air dry for several hours; glossy paper can take up to 24 hours or more. The HP paper with the grainy back takes less.)

- How many are you doing and how will you store them? Do you have an envelope or box that's big enough? (The original box the paper came in is the perfect storage container.)

- How will you keep the prints from being damaged or soiled while handling? Do you have a clean work table? Do you have cotton photo-darkroom gloves to wear? Do you have a good way—compressed air, for example—to clean off surface dust or dirt?

■ Do you need to do any coating, spraying, or other type of finishing of the prints? How, when, and where will that be done?

These are just some of the obvious questions that need answers; you may have more. In my case, since I'm only making one print for framing (and one extra as a backup), I have my drying table, empty paper storage box, and gloves ready.

With everything in place, I re-open my final digital file, inspect and load the paper, do a quick check of the HP ink status icons on the front panel (see Figure 9.19) to make sure I have enough ink remaining for the job, verify all my settings, and hit the Print button.

As soon as the print comes out of the printer, I pick it up at the edges and carefully inspect it. It's perfect, and it goes to the drying area to lay flat while I return to the computer and print a backup copy.

Figure 9.19 The six icons on the 130's front panel refer to the amount of ink in each of the ink cartridges. If any are flashing, they need to be replaced.

A few hours later, I blow off any accumulated dust, and separate the two prints with slip sheets of acid-free glassine paper (available at any art supply store). To protect the edges as well as the prints in general, I put them in the empty paper box they came in. This will keep them away from air circulation and light, and in general, keep them safe and sound until I'm ready to move to the final step: finishing, framing, and displaying—explained in more detail in the next chapter.

After the final prints are safely stored away, I congratulate myself for making a great inkjet print. You should do the same.

The workflow steps made above are meant to apply to anyone making their own inkjet prints. What's the next step after printing? Finishing and displaying. To find out about this post-printing step, turn the page.

10

Finishing and Displaying Your Prints

You've output one or more great digital (inkjet) prints. Now what? It's time to finish them in a way that protects and preserves them, and to show them off for the world to see.

Print Aesthetics

Because digital printing is a new art process, many wonder if the age-old rules of traditional printmaking apply to it. Canadian photographer Alan Scharf introduced me to the question of how to handle *print aesthetics*, and it's a good one. Should a digitally printed photograph look different from one printed in a darkroom? Is glossy paper or fine-art paper more appropriate? Should prints have square-cut edges or deckled ones? Plain borders, printed borders, or no borders? Equal borders all around or the traditional larger bottom border? Over-matted or float-mounted when framed or no frame at all?

One advantage of the digital printing revolution is that there are now many different looks available—everything from muted prints that evoke watercolors to glossy photographic prints and beyond. Digital printing cries out for new approaches.

Finishing Prints

Finishing means anything after the print pops out of the printer, including drying, trimming, embellishing, and more.

Drying

It's essential that your digital prints be completely dry before moving them to the next step, whether that be mounting, framing, storing, or shipping. Certain inkjet ink solvents need extra time to dry, and this can take anywhere from 24 hours to several days, depending on the inks and media used plus environmental factors such as temperature and humidity. Some imagemakers even let their prints dry for weeks! Others have come up with their own creative approaches to print drying, including the use of hair dryers and dry mount presses. Fogging, misting, and clouding inside a glass-covered frame, album, or clear storage bag can be the result of not following this advice.

Photographer Ken Smith lets his Epson UltraChrome (Premium Luster) prints sit for a good hour after printing. He then covers them with plain bond paper to soak up excess ink residue for a minimum of 48 hours. Then he hangs up the prints for another 48 hours (see Figure 10.1). Finally, he top-coats them with Lyson Print Guard spray. "This method is fine if I am not busy, but workspace comes at a premium, and there's only so much room to hang up prints. The place starts to look like a meat locker at times!"

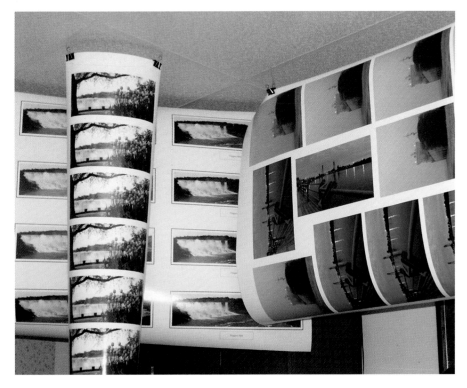

Figure 10.1 Ken Smith likes to hang up his Epson UltraChrome prints for 48 hours as part of his drying process. "The problem is," he says, "I have only so much room to do this."

Courtesy of Ken Smith
www.klsimages.com

Deckling Your Edges

A deckled edge is an irregular or rough edge typically found on fine-art print-making paper. While some imagemakers print directly onto paper with deckled edges, most prefer to tear the edges to give a deckled effect *after* printing. This takes some practice, but it's a skill that can be picked up very quickly.

Here's printmaker Jack Duganne's explanation for tearing the edges of a print: "Punch the front of the paper (where you want the tear to be) with a pin so that you can see the holes through the back of the paper. Turn the paper over and, lining up the holes made on the other side, tear against a straight edge, keeping the pressure against it and pulling the paper that you want to remove. After the tears are made, just smooth the torn paper with a rounded device like a spoon or piece of rubbing bone, and—voilá!—a perfect deckled edge!"

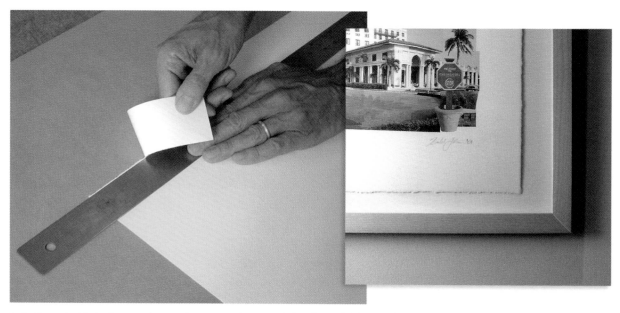

Left: For a deckled edge, gently tear the paper using a straight edge as both a guide and a cutting edge. You will notice that the paper will tear at different consistencies based on speed and pressure. Right: A finished deckled edge.

Deckling Tips

- With some paper stocks, it works well to use short tears (rather than one long one), even ripping toward the straight edge at varying angles to get a different look. All-cotton papers tear best.

- Different straight edge thicknesses will also create different tears.

- Special "deckling bars" or edges are available but not really necessary.

- Some like to wet the paper with a dampened sponge, brush, or Q-Tip, but others find this an unneeded extra step.

- It's best to practice on scraps of paper first. Then when you're ready, move to the real print, take a deep breath, and start tearing.

Embellishing Prints

Embellishing means taking a digital print and adding hand brush strokes, glitter, textures, or other artistic flourishes and enhancements to give the print a more customized look. This is also a form of "digital mixed media," and it's very popular among certain imagemakers and even scrapbookers.

One important question about embellishing is, Do you need to seal the print, and what sort of embellishing media can you use? Some experimentation may be required. For example, Toronto printmaker John Toles at Dragonfly Imaging & Printing works with artists who embellish their PremierArt WR Glossy Canvas prints (Epson UltraChrome inks) by (1) allowing the prints to dry at least 24 hours, (2) using two light coats of Print Shield protective spray coating to seal the prints, and finally, (3) applying acrylic paints (not oils) by hand with a brush. In fact, some artists, like Dorene Macaulay, do much more!

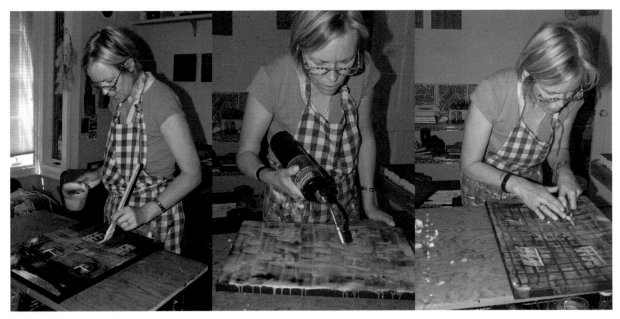

Talk about embellishing! Canadian artist Dorene Macaulay embellishes her canvas prints by painting on colored, melted wax, using a blowtorch, and finally gouging the surface.

Courtesy of Maureen Toles/www.dragonflyprinting.com

Other artists report success after spraying paper prints with an acyrlic sealer, like Krylon brand clear spray, and then painting over that with acrylic medium.

Coating Prints

The decision of whether or not to coat a digital print depends on how the print is made and what problems need solving. Some newer printers, such as Epson's R800, are starting to incorporate a form of gloss coating as a print device option, but the applications (so far) are limited, and many imagemakers are experimenting with coating their prints.

Why Coat?

The main benefit of post-coating digital prints is protection—protection against moisture, UV light damage, atmospheric contaminants, bio-chemical activity (molds), plus the abrasion, scuffing, and fingerprints that always seem to occur with normal print handling.

Coatings can also be used to even out gloss differential and to "punch-up," or add depth, to the color intensity of inkjet inks, especially pigmented ones that sometimes have a reduced color gamut. This is a well-known technique for increasing an inkjet print's dark shadows and overall color saturation.

While this has been a relatively unresearched area in the past with all sorts of wild claims, coating products do seem to be improving with the permanence spotlight now shining on this area of digital printing. However, reasonable caution and adequate research into claims and testing methods are in order for any imagemaker intending to use print coatings.

One popular product is PremierArt's Print Shield spray. This is a low-odor, lacquer-based, aerosol-can spray designed specifically for inkjet prints. Print Shield has even been allocated a special category in Henry Wilhelm's Display Permanence Ratings, and the results, according to Wilhelm, are very encouraging. For example, in the May 1, 2004 testing results for the Epson 4000 printer (www.wilhelm-research.com/epson_sp4000.html), the predicted life for Somerset Velvet for Epson and UltraChrome inks is 62 years for prints displayed under glass. The very next line on the chart shows the same paper/ink combination, again under glass, but this time a sprayed coating of Print Shield bumps the predicted lifespan up to 166 years! (Note that this is with the spray coating *and* glass framing, which apparently provides the almost-triple protection. The same chart shows the identical combination with *only* the Print Shield at 75 years.)

Do you really need to coat prints that will ultimately end up framed under glass or in an album? Some believe that if you're using long-lasting inks that are well matched to the medium or paper, coating your (paper) prints is optional. Canvas prints are more likely *not* to go under glass, so in that case, coating makes much more sense.

PremierArt Print Shield is a lacquer-based spray designed specifically for inkjet prints.

Courtesy of Premier Imaging Products

Other reasons to coat prints include the following: (1) isolating certain pigment inks that tend to smear or smudge on glossy media, (2) providing a base on which to add painted-on embellishments, and (3) giving your prints even more protection for some situations like outdoor exposure.

Types of Coatings

Coatings (also called *overcoats* or *topcoats*) come in different forms, including film laminates, liquid laminates (e.g., clearcoats, acrylic varnishes, photo lacquers), and sprays. These can be further broken down into finish types from high gloss to satin or matte. Ideally, you want an inert, odorless, colorless, non-yellowing, anti-fungal coating that's easy to apply. You also want to avoid a coating that draws coating or buffering agents out of the medium, an early problem often reported that caused the coated prints to turn milky or dusty. And, you want to know that the coating is not going to shorten the life of the print.

Let's look more closely at three popular coating categories for digital, and especially inkjet, prints.

Liquid Laminates

There are many types of liquid laminates—acrylics, solvent-based, water-based, and UV-curable—and they can form a protective shield on your prints. However, these post-print coatings must be carefully matched to the type of inks and especially the media precoatings used so that the image is not destroyed when one attacks the other. Most liquid laminate suppliers will give guidelines for this kind of materials matching.

Brushing and rolling are two popular ways to put a liquid coating onto a print. (Screening and using a "Mayer" or metering bar are two more, but they are beyond what most self-printers want to tackle.)

- **Brush.** Liquid coatings can be brushed on with relative ease, although it takes patience and practice in order to get a thin, uniform coat. Brush choice plus correct thinning technique are essential.

- **Roll.** Rolling on a liquid coating can be a good option for fine-art paper and canvas prints, although it can be tricky and sometimes messy. Printmakers report mixed results with roll-ons. Photographer Ken Smith uses a 4-inch super-smooth foam roller to apply Liquitex Matte Varnish (for matte finishes) and Liquitex Gloss Medium and Varnish (for gloss finishes) to his canvas prints (see Figure 10.2). "In 99 percent of the cases," Smith says, "this method works well. That other 1 percent, however, causes problems when mysterious intruders such as specs of dust are introduced to ruin the coating."

Figure 10.2 Photographer Ken Smith rolls on Liquitex Gloss Medium and Varnish to coat his canvas prints.

Courtesy of Ken Smith
www.klsimages.com

Liquid Coating Tips

- Clean everything before coating, such as wiping down the print and vacuuming the work area and work clothes.

- For some, better protection occurs after first spraying the print with an artist's fixative before liquid coating.

- To keep bubbles from forming with brush-on, try diluting with the recommended thinner and always stir—never shake—the container.

- Make sure the ink on any print is completely dry before any coating is attempted.

- Make sure any coatings are completely dry before framing or storing.

- Always test any coating method on scrap prints.

Sprays

Spraying prints is popular, but it can be dangerous to your health without the proper precautions, including a good mask and *very good* ventilation.

Spraying Safety

The biggest concern with spray coatings are the health and environmental hazards involved.

What can you do to be more safe? Follow these safety tips:

- Because spraying produces airborne contaminants, get a good face mask like the ones professional autobody painters use.

- Wear your face mask whenever spraying, mixing, or handling coating or painting materials.

- Always wear safety approved goggles or glasses when spraying. Try to cover your hands and other areas of exposed skin.

- Never spray near open flames or pilot lights in stoves or heaters.

- Ventilation requirements (indoors): (1) work only in a well-ventilated area, (2) run ventilation continuously, and (3) continue ventilation for at least *one hour* after spraying is completed. The best sort of ventilation is a hood type with direct exhaust (through a filter) to the outside.

With spray coatings, you need to become experienced enough so that you can't see the spray marks on the paper or canvas. Several light coats are usually recommended over one thick coating. InkjetART's Royce Bair has good recommendations for spraying with Print Shield: ". . .[it] produces almost invisible changes to matte or textured fine-art prints when coated with at least three light coatings that do not completely wet the print, allowing one to two minutes of drying time between each coating. The direction of the spray should be alternated between applications (move left to right, then up and down, then diagonally across the print). Glossy, semigloss, luster, or canvas prints should be coated once with enough spray to thoroughly wet the print's surface (the print should lay in a horizontal position so as to not cause the wet spray to run)."

Some imagemakers report that aerosol spray cans sometimes deliver unpredictable results with occasional spurts and blobs landing on prints. A professional spray unit is preferred, although face masks and serious ventilation are required.

Two other options for those who don't want to mess around with proper ventilation and/or face masks are "spray-for-pay" and using a liquid coating machine. Spray-for-pay means finding someone else to do it for you. It may be hard to locate an individual or a shop who will take in your prints for coating without having done the printing, but it may be worth the effort to find them.

Liquid coating machines for photographer-artists are relatively new on the scene, and permanence researcher Bill Waterson has developed a working prototype that was undergoing field testing at the time of this writing (see Figure 10.3). You pour the coating solution into the tray and then pass your print manually under the roller and pull it out the other side. Cost is about $40 in materials, and of course the labor is your own. It can be constructed up to any size; the one shown is intended for 24-inch wide prints. All materials are easily available at most hardware suppliers.

Figure 10.3 Bill Waterson's prototype of a liquid coating machine. The print is drawn under a roller and over a squeegee, which is really just an ordinary door sweep from the hardware store cut to size and then bolted in place using wing nuts for easy removal. Total cost of materials: about $40, or $65 with a stainless steel roller (shown).

Courtesy of Bill Waterson
waterson@ainet.com

Film Laminates

Film lamination is growing in popularity with photographers and artists who are producing digital output.

Dr. Ray Work is a strong advocate for film lamination of inkjet prints. "Lamination provides extraordinary advantages," he explains. "In addition to protection from humidity and pollution, it eliminates the differential gloss frequently experienced with pigmented inks, allows different choices in surface finish, increases the color density, and improves the distinctness of the image. Lamination also improves the lightfastness and provides both physical surface durability and waterfastness. All in all, it's a good idea."

Lamination Equipment and Materials: Whether you are considering hot (with heat) or cold (with adhesives) lamination, laminating requires a laminator. They come in all sizes and shapes from various suppliers, including ProSeal, Coda, LEDCO, and LexJet. The LexJet 2700C (see Figure 10.4), engineered by a company owned by photographer Cris Daniels, is interesting because it may be the first cold-pressure laminating and mounting system designed and created for photographers and fine-art studios. It's a solid-looking machine made with 6061 anodized aluminum, stainless steel, and silicone ground-rubber rollers.

Figure 10.4 LexJet's 2700C cold-pressure laminating and mounting machine (developed by Cris Daniels, inset) may be the first laminator specially made for photographers and others doing high-quality digital imaging and printing.

Courtesy of LexJet.com and danielsimaging.com

The Look of Lamination: Film laminates, while being very protective, have traditionally been disparaged by photographer-artists because the resulting work has looked stiff and "plasticky." After all, this is how restaurant menus at Denny's are coated! Many have not liked the look of lamination on fine-art papers, where the texture or feel of the paper is part of the overall package. However, recent film-lamination advances have resulted in very thin, very flexible overlaminate films that are only 0.5-mil thick. Once applied correctly, they basically disappear. Photographer

Phillip Buzard has had canvas inkjet prints top-coated with a Drytac laminate that was so thin that "I couldn't tell it was there. The canvas texture was still apparent. There was no stiffness, and if I had wanted, I could have rolled them up."

Mounting and Framing Prints

Mounting and framing go together, and they are a good way to protect and display your prints.

Mounting

While many photographers are successful with dry (hot) or cold-adhesive mounting of their prints to backing boards, others follow traditional printmaking methods where prints are adhered at the top only, letting the sides and bottom hang free and exposed. The idea is to have the least amount of bonding with the print so that it is free to expand and contract with environmental changes. This is called "float-mounting," and it creates its own shadow-box effect as the light falling on the print plays over the loose edges (see Figure 10.5).

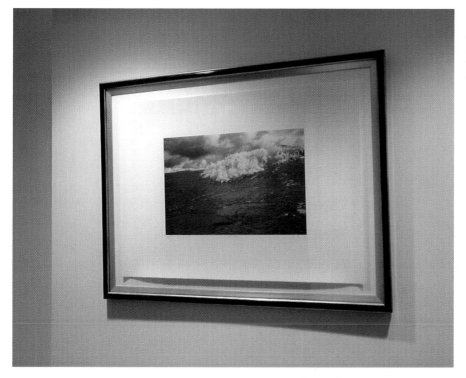

Figure 10.5 The author's photo-based image *Big Wave 1* printed on fine-art paper with four torn edges float-mounted in an antique frame.

In terms of mounting materials and techniques, acid-free corners or archival linen hinges are often used. The key point is to avoid non-archival material, such as rubber cement or masking tape. Use only acid-free mounting, matting, backing, and

framing materials. If dry mounting inkjet prints, make sure to use low heat and always test first—some inks are affected by heat more than others. You can also dry mount canvas prints, but again, test first.

Mats

If loose or hanging edges are not your style, then adding an over-mat (or just "mat") is probably right for you. Most mats slightly overlap the edges of the print, holding them down and also providing an uncluttered border between the image and the edge of any framing. A variation is to have the mat stop short of the edges of the print, so that the edges are exposed (see Figure 10.6). Mats come in various colors and thicknesses with 4-ply and 8-ply (thicker) as the standards.

Figure 10.6 Jonathan Talbot presents his mixed-media work, many of which contain computer-generated elements, by floating the paper (with the edges showing) inside 8-ply, all-rag mats, and then framing them under glass in simple, white-washed maple frames. Shown at left is *Pi Patrin*, a 3-inch-square image on 7 × 7-inch paper in a 12 × 12-inch frame.

Courtesy of Jonathan Talbot
www.talbot1.com

Mats can be made with a mat cutter or bought premade in quantity. Many established photographer-artists buy precut mats from such suppliers as Pictureframes.com, Unitedmfrs.com, and Framingsupplies.com.

A digital alternative to real mats is a "faux mat" created in an image editing or drawing program and printed on the print itself. See Figure 10.7 for an example. Faux mats can be combined with real ones to produce a double-mat effect.

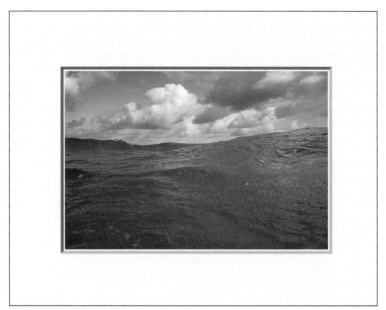

Figure 10.7 A "faux mat" can be created in Photoshop or a drawing program and printed along with the image.

Image © 2001-2004 Harald Johnson

Framing

There are two reasons to frame a print: (1) to help protect it and (2) to present the image or print in an appealing way that separates it from everything around it while at the same time not distracting attention from the image itself. This is not an easy task with so many options for moldings, mats, and special treatments, like French matting, fillets, and finished corners. Framing is a true craft and should not be undertaken casually. You either pay a professional framer, or you buy the equipment and take the time to learn how to do it yourself.

The normal process involves attaching the (paper) print to a backing board (see "Mounting" above), then attaching the mat (if one is used) over the print and the board with conservation/archival-quality framing tape. The whole sandwich is then ready for the frame with either a glass or acrylic front. Canvas prints can also be framed once they are either mounted on board or on artist stretcher bars.

Purchased frames are either custom-made to your specifications, or they come in premade standard sizes or by-the-inch kits that you assemble yourself. A sampling of frame suppliers includes Graphik Dimensions, Frame Fit, and Frame Destination, Inc.

One of the author's do-it-yourself framing projects with a float-mounted inkjet print.

Frame Sizes

Standard-sized mats and frames are the way to go for keeping costs down and for attracting buyers (if you sell your prints). The problem is photo industry frame sizes (8 × 10, 11 × 14, 16 × 20, etc.) do not match printing industry paper sizes (8.5 × 11, 11 × 17, 13 × 19, 17 × 22, etc.).

Another problem for photographers is that the aspect ratio of common film sizes (35mm and 4 × 5) does not match the proportions of all standard frames. The photographer is then faced with a choice: either crop the image (unacceptable by many photographers), or have unequal borders that maintain the integrity of the full-frame image. Most opt to live with unequal borders (or they make custom frames to fit).

Glazing

Glazing means using glass or acrylic (Plexiglas is one brand) when you're talking about framing. Both types come in plain, UV-filtering, anti-reflective or non-glare, and abrasion-resistant versions. With glass, the UV-filtering type is preferred, except it's much more expensive than regular glass. Even plain clear glass will block much of the UV radiation hitting a print.

Glass and acrylic each have their followings. Acrylic is lighter, more expensive, scratches easily, and is a magnet for dust and lint, but it's the best choice if you're shipping prints or if used in high-traffic or dangerous areas, like a child's room. Also, some prefer acrylic, since it will not shatter and hurt the image—or people—when dropped.

This standard wood frame (Profile 952, .75-inch wide, 1.25-inch deep) from Frame Destination has exterior dimensions of 20 × 26 inches with equal 3.5-inch 8-ply mat borders added to a 13 × 19-inch inkjet print (the actual window opening is 12.75 × 18.75 inches). The frame is faced with UV-filtering acrylic (Cyro OP3).

Courtesy of Mark Rogers
www.framedestination.com

Framing Tips

■ Never let a print touch the glass in a frame. Why? Some inks and emulsions can react with the glass and get permanently stuck to it. Also, if condensation ever forms on the inside of the glass, the water could damage the print. Either use a mat or frame spacers to create a gap between the glazing and the art.

■ Always use acid-free (and lignin-free) materials in all phases of the framing process. That goes for mats, backing boards, and the hinging or adhesive material. Much of the commercial framing done before 1980 used poor-quality materials. You should replace all such frames and materials.

■ Don't use acidic brown barrier (Kraft) paper on the back of a frame to seal against air and dust. Use instead conservation/archival-quality paper, or in a pinch, white butcher paper.

■ Make sure your prints are completely dry before framing. This can take anywhere from 24 hours to several days, depending on the inks and media used.

■ Periodically open up your framed prints (five years is a good target) and clean them thoroughly. Replace any problem components.

Framing Alternatives

There are now many alternatives to the traditional picture-frame approach to digital print display. Here are just a few:

- **Unusual Frames.** Feel like breaking away from the standard frame shop selection? Photographer-artist Konrad Poth makes his own frames from recycled wood from old barns and fences. Globe-trotting photographer S.R. Aull spends a year photographing a specific place (Paris, Hong Kong, Manhattan), and then he frames his traditional Ilfochrome color prints in antique wood windows and doors from each respective culture.

- **Canvas.** If you're printing on canvas, you can stretch the print onto the standard artist stretcher bars that painters use, complete with folded corners. Canvas prints can be mounted to board or stretched, and then either wall-hung as is or placed in a frame.

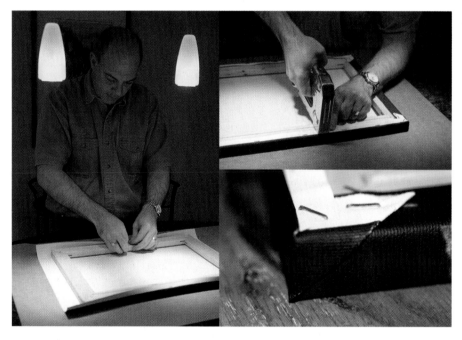

John Toles of Dragonfly Imaging and Printing in Toronto, Canada, stretches a canvas print.

Courtesy of John Toles
www.dragonflyprinting.com

- **Board-Mounted Prints.** Mounting prints (using either cold or hot mounting techniques) to thick composite boards with no borders and no framing is very popular. Board materials include Foamcore, MDF, Sintra, Dibond, and Gatorfoam. These can be purchased from art supply vendors, and they come in various thicknesses and even colors. Black Gatorfoam in 3/4" is a common choice. (Gatorfoam has a polystyrene core and a wood-fiber laminate surface that resists denting. It's very rigid and smooth, and it can be used for dry or pressure-sensitive mounting.) The hanging is a bit tricky, but one solution is

to glue on blocks of wood with framing wire attached. The blocks offset the print from the wall, creating a nice drop-shadow effect.

■ **Scrapbooks.** Scrapbooking is a popular way to store, preserve, and share digital prints. See the next section for more information.

Storing and Shipping Prints

After prints are finished, you have to store and sometimes ship them.

Storing Prints

If you're not selling, giving away, or displaying your prints, then you'll be storing them. Storage enclosures can take several forms, but they have the same goal: to provide your prints protection from light, dust, and physical abuse, plus to reduce the effects of high humidity and atmospheric contaminants. Following are some options and things to keep in mind.

Protective Sleeves

These are a great way to store and even present digital prints to friends, clients, or colleagues. Clear sleeves or envelopes are available in all sizes from such companies as inkjetART.com, digitalartsupplies.com, Lineco, and Clearbags.com. One of the most popular types has a fold-over flap with a resticking, self-adhesive strip (ask for the strip on the bag, not the flap—see Figure 10.8). Don't use regular envelopes or sleeves that contain acid or polyvinyl chloride (PVC) for this purpose, and never use rubber bands, paper clips, or pressure-sensitive tapes.

Figure 10.8 Three different size bags from Impact Images are shown (look closely; they're clear and hard to see). On the smallest, the adhesive strip is exposed by pulling away a thin plastic covering. The large bag at top has already had its adhesive exposed, and on that bag the adhesive is on the flap, which can cause prints to stick to the adhesive when removed from the bag. For large size prints, these bags are best used with a stiffener, such as acid-free matboard.

Photo and all images © Andrew Darlow

Archive Boxes

Archive or museum storage boxes are great for storing lots of prints. Make sure they are constructed with acid-free and buffered materials, and they interleave your prints with glassine or other acid-free tissue or sheeting. Metal corners add strength for stacking. Companies like Lineco, EternaStor, and Light Impressions carry these products.

Albums and Scrapbooks

While early photographic albums and scrapbooks were made with materials that were actually harmful to prints, many contemporary albums follow industry standards for permanence. Album and scrapbook pages are generally safe if they are acid-free, buffered, and lignin-free. If there are plastic sleeves or protectors, these should be made of either polyester, polypropylene, polyethylene, or polystyrene. Polyvinyl plastics or cellophane should be avoided because they are brittle and unstable.

Lineco (PopArt) carries a whole line of high-quality, do-it-yourself albums for digital prints (see Figure 10.9). Ztra and Creative Memories are other well-known album providers.

Figure 10.9 PopArt albums from Lineco are an affordable, do-it-yourself way of creating high-quality albums. Pages come in several sizes and are easily printed using most inkjet printers.

Courtesy of Lineco, Inc.

General Print Storage Tips

- Handle prints as little as possible, but when you do, handle with great care as you would any original artwork. Wash your hands and wear white cotton gloves whenever possible.

- As with framing, make sure prints are completely dry before storing.

- Because heat and humidity significantly shorten print lifespans, store your prints in a dark, dry, and cool place. Shoot for a goal temperature of 68º F (20º C) to 77º F (25º C) with 30 to 50 percent relative humidity.

- Store prints flat, but not in the open. Use dust-free cabinets, acid-free boxes, archival sleeves, or albums. It's okay to stack prints but separate them with sheets of acid-free glassine or tissue.

- Don't store prints in areas with chemicals, such as in a photographic darkroom.

Shipping Large Prints

What's the safest way to ship large prints? In tubes or flat? Royce Bair of BairArtEditions.com uses Yazoo mailing tubes (yazoomills.com), which he believes are the strongest mailing tubes in the world. Here's how he does it: "You want tubes that are large in diameter (5–12 inches) so that your prints arrive with less curl memory, especially if you are using thicker fine-art papers in the 250-gsm or higher weights. Yazoo's 6-inch-diameter tubes will handle super-thick 425-gsm Epson Smooth Fine Art quite nicely.

"For creaseless rolling," Bair continues, "we recommend you roll the print in tissue or Pellon (a semi-transparent, acid-free material used in the sewing industry), image side in, and then loosely around a 4- or 5-inch tube; wrap a strip of junk paper around the print, secure the strip with adhesive tape (to prevent the print from unrolling; you don't want a print that's snug against the inside tube wall), slide the tube out, and then insert the rolled print into the 6-inch tube. Add tissue or padding on both ends to fill any extra space so the print doesn't move back and forth inside the tube. Use the snap-on end caps and tape them securely before shipping."

You can also ship large prints flat, but it's riskier in terms of potential damage. If the prints are already matted and/or framed, they will have to ship flat.

If possible, avoid shipping a print framed with glass; use acrylic instead. The potential for damage and injury is too high.

Displaying Prints

Print display choices range from the simple (push-pinning a print to your home or office wall) to the complex (museum display conditions). In fact, even in lofty museums, I've seen unframed digital prints that were attached to the walls with building nails. When it comes to displaying prints, there are few rules, and even those are frequently broken. I'll break this topic down into two components: *display aesthetics* and *display permanence*.

Display Aesthetics

Continuing the "Print Aesthetics" section that started off this chapter, there are varied theories about the best way to display prints. The purpose of the display is, of course, paramount. Are you trying to maximize print sales in a gallery setting or just mounting a pleasant arrangement that goes well with the room decor?

- **Print Arrangement.** Which is better? Fewer, larger pieces separated by vast wall space or many pieces clustered together in tight groupings? Entire workshops are given to homeowners, artists, and art gallery directors so they can fine-tune their displays for maximum benefit.

Clustered or separated? Aesthetics come into play with print arranging.
Courtesy of Joe Nalven
www.digitalartist1.com

- **Hanging Style.** I have seen everything imaginable, from traditional framing to prints pinned to the wall with arrows shot from bows. Use your creativity!

Display Permanence

I covered print permanence in general in Chapter 6, "What About Print Permanence?," but here is more on that subject as it relates specifically to print displays. Whenever prints are on view, they are usually most vulnerable to the factors that can decrease their longevity. Here are some basic display tips for prints:

The Print Alternative?

There has been talk of digital displays replacing real paper prints for years (just like the predictions of the paperless office!). Two contemporary examples come from Epson and MediaStreet.

Epson's LivingStation comprises a flat-screen HDTV LCD projection television plus an on-board dye-sub digital printer, a CD burner, computer hookups, and digicam media card slots. The goal is to allow imagemakers the ability to move from the office to the living room to do all their work, from computer to photo viewing and printing. $3,000+

Epson's LivingStation for viewing, printing, and storing digital images.

The latest in a long line of "digi-frames" is MediaStreet's eMotion Multimedia Digital Picture Frame. Not as elaborate as the Epson system, the price for the small 7-inch diagonal screen is also more comfortable: $620. It's a combination photo-art-music-movie player, and it accepts all the usual memory cards and CDs/DVDs.

There's no doubt that, eventually, every office and home will have the equivalent of a Digital Frame sitting in a corner or hanging on a wall. However, that day, I predict, is many years away. People still love their prints.

MediaStreet's eMotion Multimedia Digital Picture Frame.
Courtesy of MediaStreet.com

Permanence and Print Display Tips

- Avoid displaying or storing prints outdoors.

- The lower the display light levels, the better. A level of 100–200 lux is usually more than enough. Spotlights are a good choice, but turn them off when prints are not being actively viewed.

- Never expose prints to even one ray of direct sunlight.

- Display paper prints behind glass or acrylic. Use a protective coating on canvas prints.

- Protect against extreme temperature fluctuations with central or room air conditioners and/or heating systems. However, don't display prints near radiators, heaters, or the ducts themselves.

- Avoid high-humidity exposure by using de-humidifiers. Do not hang prints in bathrooms or kitchens unless they are sealed appropriately. To help moderate humidity fluctuations, use vapor barriers or frame desiccants like silica gel in the print frames.

- If prints are unprotected, keep them away from sources of ozone, such as air cleaners, copying machines, or other generators of high-voltage electricity.

- Follow the example of museums and limit the total amount of exposure to light any printed image receives. One way to do this is by artwork rotation, periodically moving pieces from the wall to storage.

The print finishing points made above and the workflow steps in Chapter 9 are meant to apply to anyone making their own digital prints. But what if you want to have your printing done by an outside print provider or service? To find out about this other side to digital printing, turn the page.

11

Using a Print Service

There are advantages and disadvantages to doing your own printing. Sometimes it makes sense to have it done by someone else. Let's take a closer look at the role of retail stores, professional printmakers, and printing services.

Why Use a Print Service?

If you don't want to make digital prints yourself, there are many options now available to you. Outside print providers include fine-art printmakers, imaging centers, mass merchants with digital equipment, photo labs, camera stores, online vendors, and even instant-print chains that are expanding their services to include digital printing.

There are several reasons why print service providers are an important element in the digital printing mix. According to industry statistics, 27 percent of U.S. households will own a digital camera at the end of 2004. That equates to 33 million households, and they are taking more pictures than ever before. What to do with those image files is the question. Some simply store or view them on their computers, while others like to share them electronically with friends and family, e-mailing them back and forth.

However, many others still want to hold a finished print in their hands, even though they may be too busy or not interested in making the prints themselves. This is the target audience for print service providers.

Print service providers range from retail stores all the way up to professional fine-art printmakers. Here, digital printmaker Lynn Lown (left) of New Media Arts works with Santa Fe artist and photographer Barbara Bowles. *Courtesy of New Media Arts www.nmarts.com*

Print Service Advantages

There are many advantages and benefits to using a printing service or print provider.

Knowledge and Experience

Professional print providers are experts at what they do, and they usually have the best, most expensive equipment. Therefore, by using an outside print provider, you shift the burden of learning the craft, and of keeping up with all the latest print technology, to the printmaker, which frees you up to concentrate on image-making or picture-taking.

Quality

Unless you are an experienced self-printer, an outside printmaker may initially be able to give you higher-quality prints than you can do on your own. The fact is, first attempts at digital printing are typically not perfect. It takes time—as well as cartridges of ink and boxes of paper—before the printing process is humming along producing top-quality output.

Time and Convenience

Many photographers, artists, and imagemakers would rather just drop off their images or upload them to a retail service that takes care of all the rest. For them, rather than spending time to learn about the printmaking process, they simply want to pay someone who's already set up to do it.

Size and Practicality

If you need large prints, and you can't afford a wide-format printer or the space to house one, then your only alternative is to use a service provider with wide-format printers.

Similarly, there is no practical way to use certain digital technologies *without* using an outside service. Fuji Frontiers, Océ LightJets, Durst Lambdas, etc., start at $120,000 and go up from there, so the chances of having one of your own in the back bedroom are slim indeed. Photo labs, service bureaus, print shops, and the like are your only hope for making these kinds of prints. (See "Working with Specialized Print Providers.")

Bair Art Editions in Salt Lake City, Utah, is affiliated with InkJetArt.com and is an all-Epson large-format print provider specializing in fine-art print reproduction. Shown are Ted Van Horn (left) and Stephen Bair.
Courtesy of Bair Art Editions/www.bairarteditions.com

Cost Effectiveness

At retail, prints are competitively priced, and they are typically less expensive than prints made at home. "I don't have to keep up with products, materials, and inks, or make that significant investment," says digital artist Ileana.

Some of the *disadvantages* of using an outside print service include the following:

- Loss of some control and flexibility.

- Reduced experimentation and spontaneity that goes with doing your own printing trials.
- Time delays going back and forth.

Note that some imagemakers take both approaches, doing some self-printing and going outside for other work. I, myself, fall into this group.

How to Pick a Print Service

To select an outside print provider, you have to do your homework. Following are several main considerations.

Experience?

How long have they been in the business of making digital prints? Do they understand how to get the best quality from each file?

Referrals?

As with any service, get referrals. Talk to other imagemakers whose output you like, and who are happy with the printing services they use. Then contact those providers.

Physical Space/Location?

Where are they located? Is it local, or does it require online interaction to reach them (see more about online services below)? Do they have hours of operation that match your needs?

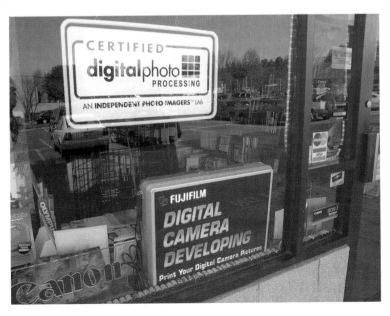

Many retail locations now provide digital printing with fast turnaround.

How Long Will It Take?

What is the turnaround time from file to final print? Make sure you factor in any shipping time, holidays, etc.

Is there an online component with the service? The Ritz camera chain, for example, has a new Internet Xpress Prints service (www.ritzpix.com) that allows customers to upload their digital images to select Ritz and Wolf stores. Finished prints are then ready for pick up in less than four hours. Wal-Mart has a similar service. This effectively removes one trip to the store.

Printer Profiles Provided?

One purpose of a printer-provided profile is so the imagemaker can soft-proof the image on his own computer screen to get an idea of how it will look when printed. This reduces the likelihood of a poor print, and it becomes even more important if the imagemaker is providing a digital file.

Calypso Imaging in Santa Clara, California, is a professional full-service print provider that makes its profiles readily available. (See Figure 11.1.)

Figure 11.1 Calypso Imaging makes it easy to download its printer profiles.

Courtesy of Calypso Imaging, Inc. www.calypsoinc.com

If printer profiles are important to the way you work, you need to ask about them. (See also "Profiles for Digital Photo Print.")

Other Services?

Print services do more than just print. Some offer a complete range of support services and related products, including custom bookmaking, calendars, posters, and more.

Obviously, these related services or products are chargeable and on top of the basic printing costs.

How Much?

Price is important, but even more important is *how* a printmaker charges. Digital fine-art printmakers usually charge by the output size or by the square unit measure (cost-per-square-foot). They take their material costs for ink, media, coatings, etc., and tack on enough to cover overhead and hopefully a profit.

At-retail stores usually charge per print, based on size and quantity.

Horizon USA and HP's Poster Station is a self-service imaging kiosk system for printing enlargements, posters, and banners at select retail locations across the U.S. and Europe.

Courtesy of Horizon USA
www.horizonusa.net

Package Prices

Some professional inkjet printmakers, usually only those dealing with traditional art reproductions, will offer package prices that include an image scan, basic image cleanup and color correction, up to three reduced-size proofs, archiving, and one or more final prints. For example, Staples Fine Art in Richmond, Virginia, has four packages ranging from $165 to $450, depending on the size of the print (see Figure 11.2).

Heritage Giclee Printing High Resolution Digital Scans
Archiving Services Canvas Stretching
Black & White Printing Offset Lithography
Custom Finishes Photo Restoration & Repair
Feathered Edges Giclee Minis

Heritage Giclee® Pricing & Options

Each Initial Image Set-up Includes Finished Prints

When working from photography or digital files the per image setup charges are:
See "prepress options" for direct scans of original artwork*

Small Format Set-up for Heritage Giclee Fine Art Prints $165.00
Includes a high resolution scan, image clean-up and color correction*, two identical 8" x 10" color proofs (one to keep & one to return
to us with approval), archiving the image for future use, and 3 finished Small Format sheets (16" x 22" sheet size) of the final image plus
"Certificates of Authenticity".

GRAND Format Set-up for Heritage Giclee Fine Art Prints $185.00
Includes a high resolution scan, image cleanup and color correction*, two identical 8" x 10" color proofs, archiving the image for future
use, and 1 finished Grand Format sheet (34" x 44" sheet size) of the final image plus "Certificates of Authenticity".

TRÉS GRAND Format Set-up for Heritage Giclee Fine Art Prints $285.00
Includes a high resolution scan, image cleanup and color correction*, two identical 8" x 10" color proofs, archiving the image for future
use, and 1 finished Trés Grand sheet (41" x 58" sheet size) of the final image plus "Certificates of Authenticity".

ÉNORME GRAND Format Set-up for Heritage Giclee Fine Art Prints $450.00
Includes a high resolution scan, image cleanup and color correction*, two identical 8" x 10" color proofs, archiving the image for future
use, and 1 finished Énorme Grand sheet (49" x 70" sheet size) of the final image plus "Certificates of Authenticity".

*Minor clean-up of any scanned transparency is included at no charge. If clean-up becomes excessive, we will contact you with an
estimated cost. Retouching or image manipulation of a digital file is priced at $25 per quarter hour in 1/4 hour increments.

Figure 11.2 Digital print shop Staples Fine Art offers four price packages, based on size.

Courtesy of Mark Staples/www.staplesart.com

A Giclée Workflow

As I mentioned in Chapter 1, "Navigating the Digital Landscape," _giclée_ is the
term used to describe a digital, inkjet, reproduction print made from a work cre-
ated in another medium. Inkjet prints made from paintings, watercolors, draw-
ings, etc., are all giclées, and the process has its own workflow. While some of the
steps are similar to the ones I outlined for self-printing (see Chapter 9, "Making
a Great Inkjet Print") the main difference is that most of the activity is the respon-
sibility of the print provider. This is what you pay them for.

Step 1: Planning the Print

You still need to plan your print, and this is best done in consultation with the
printmaker. Dimensions and prices will come into play to determine the perfect
size, medium, inks, and method to be used.

Step 2: Digitizing the Image

Each printmaker will have his or her own way of turning the original artwork into a digital file. Some prefer a traditional photograph taken on medium- or large-format transparency film, and then scanned. Others will direct-scan the original artwork with a digital scan back or other high-resolution scanning method (see Figure 11.3). If the piece is small enough, it could even be put on a drum (if it's flexible) or flatbed scanner. The final result is a high-resolution digital file that has faithfully captured all the details and colors of the original work of art.

Figure 11.3 The ZBE Satellite digital scanning system at Harvest Productions. Note artwork on riser under camera.

Courtesy of Harvest Productions Ltd.
www.harvestpro.com

Step 3: Image Editing and Color Correcting

Color corrections and other image editing are done on computer workstations by the printmaker's staff. Out-of-gamut colors are adjusted in comparison to the original material provided, whether that's the artwork itself or a photograph of it. The main point of this step is to match the original, and any deviations from this goal should be approved only by the artist.

Step 4: Proofing

How proofing is handled can vary widely among printmakers, but the purpose is to show you one or more proof prints so that you can see with your own eyes how the final prints will look. (The number of proofs will be determined by the policy of the printmaker and what level of service you've purchased.) The best scenario is for you to view the proof in a professional viewing booth at the

printmaker's facility. This way, the people working on the print can be brought out to discuss any alterations or "moves" with the image.

Step 5: Printing

The final print or prints are then output. The advantage of digital printing is that prints can be made one at a time, and it's normal to print in small groups, depending on the discount the printmaker offers for quantity.

Step 6: Finishing

This is the step where each print is inspected for quality (and fixed or rejected if any major imperfections are found), cleaned, finished with any protective coatings, mounted, and framed, as needed. All trimming or special edge tearing or deckling is also done at this point. If the prints are to be hand-embellished, that is also done at this stage.

John Hughs trims inkjet prints at Adamson Editions in Washington, D.C.

Courtesy of David Adamson
www.adamsoneditions.com

Step 7: Shipping and Storing

The job is not complete until the prints arrive at their destination, safe and sound. Unless the imagemaker can physically go to the printmaker's place of business for a pick-up, most prints are rolled and shipped in tubes, although they can be

shipped flat, too. A good printmaker will use only the strongest tubes with plenty of slip-sheeting and end-stuffing to protect each print. There's nothing worse than to have otherwise-perfect prints ruined in shipping.

Working with Specialized Print Providers

There are now specialized print providers who concentrate on certain types of digital output. Many of the larger ones combine both inkjet and non-inkjet output at one facility to cover an evolving market for digital imaging and printing.

Digital Photo Print (Laser Imaging)

One important non-inkjet technology that photographers are especially fond of (although non-photographic digital artists and other imagemakers can use them as well) is digital photo print (described in Chapter 3, "Comparing Digital Printing Technologies"). This category includes the digital minilabs that employ the Fuji Frontier, Noritsu QSS, Agfa D-Lab, or similar devices.

Photo labs, service bureaus, imaging centers, online vendors, and even retailers like drugstores and large discount chains are where you'll find this type of print service. Imagemakers typically submit final, RGB, digital files on CD/DVD or online. Scans from reflective art, slides, or negatives are usually also available.

Camera Center in Charlottesville, Virginia, provides digital photo print services. Owner Gary Alter (right) corrects images onscreen before sending them to the Fuji Frontier 370 in the background.

Profiles for Digital Photo Print

Printer profiles (see Chapter 5, "Understanding and Managing Color") can be just as important for digital photo printing as they are for inkjet. Unfortunately, your success in finding service-provided profiles from digital photo print shops will be hit or miss, and even an understanding of what profiles can do is scattered. My local pro photo lab, for example, doesn't provide them for either its LightJet 5000 or its Fuji Frontier. Larger providers like Calypso Imaging and Boulder, Colorado's Photo Craft Laboratories, however, provide their clients with calibrated workflows, and they make it very easy to download profiles from their web pages.

Kiosks to the Rescue

If you're desperate to have a while-you-wait print made, you can always run over to your nearest drugstore, consumer electronic store, Kinko's, or discount retailer to use a self-service *photo kiosk*. These kiosks are all the rage (in the U.S.) and are made by manufacturers such as Kodak (Picture Maker), Fuji (Aladdin), Sony (PictureStation), HP (Poster Station), and Olympus (TruePrint). They offer a touch screen interface for basic image editing, including cropping, red-eye removal, brightness adjustment, etc. The Olympus TruePrint kiosks come in two models with dye-sublimation printers that sit behind the counter and that can output 4 × 6 or 8 × 10 prints.

Kiosks accept CompactFlash, SmartMedia, PCMCIA memory cards, and Photo CDs, and some have optional scanners for inputting hard copy. Some now include interfaces for printing from camera cell phones. The Kodak Picture Maker Film Processing Station even lets you quickly develop and print pictures from 35mm, without ever having to "turn in" your film to a lab. (See Figure 11.4.)

You're not going to get a lot of expert advice or hand-holding in this situation, but for a $2.99 print at your local Sam's Club in three minutes, what do you expect?

Figure 11.4 The Kodak Picture Maker Film Processing Station is the first self-service, film-processing kiosk for consumers. It functions as a low-cost, self-contained minilab when connected to a retailer's Kodak Picture Maker G3 kiosk, allowing users to print both film images and digital images themselves.

Courtesy of Eastman Kodak Company

There are several ways to deal with any non-profiled lab devices. One workaround is to do what's called *reverse proofing*. Send the lab or store a small target-test file to print. If you like what you get back, either adjust your monitor settings or your image file *to the print*. Yes, this is a backward way to do color management, but it can work if you are pleased with the test prints, and if the lab stays consistent.

Another way of working with digital lab printers is now available through Oregon photographer Ethan Hansen of Dry Creek Photo. Hansen has created an online database (www.drycreekphoto.com) of ICC printer profiles for *local* Fuji Frontier, Noritsu, Agfa D-Lab, LightJet, Lambda, and Chromira lab printers worldwide. In the U.S., this includes many Wal-Mart, Costco, and Ritz Camera locations. If your local minilab provider is listed, you simply download the profile (it's free) and install it on your computer to do your image editing.

Online Printing Services

One example of the inroads that the Internet has made into our lives is the business of online processing and printing. What this usually means is that image files, typically TIFFs or JPEGs, along with order forms, are either sent via e-mail or uploaded to company websites for image processing and printing. Finished prints are then either mailed or shipped back or are available for pick up at a nearby retail store.

Photo Craft Laboratories' online imaging, archiving, and printing services are accessible through its website.

Courtesy of Photo Craft Laboratories, Inc. www.pcraft.com

Some image editing software programs, such as Adobe Photoshop Elements, even have plug-ins to simplify the image uploading process.

One result of all this online activity is that the physical locations of both the providers and the customers is becoming irrelevant.

Image Sharing and Printing

If there's one thing that makes print service providers nervous—besides the tidal wave of people doing their own printing—it's photo or image sharing. This is the process of uploading images to one of the free hosting services so they can be stored, organized, viewed, and shared. You can assign a password to your "albums," and only those you give the password to can see your images. This has become a popular way to avoid the time and trouble of e-mailing pictures and images to family, friends, and other contacts.

But, that's not all. Since most people still like to have a real print in their hands, companies like Shutterfly, Kodak's Ofoto, EZ Prints, and dotPhoto not only offer image sharing but also print ordering. Once you've added images to your personal album, you can "enhance" them (crop, rotate, add borders and effects), instruct the service which image to print and in what size, and the prints arrive a few days later. Shutterfly even has online resolution guidelines to tell you if your images are too low-res to print well on their Fuji Frontier printers (see Figure 11.5).

Figure 11.5 Shutterfly's initial print ordering screen (top) and the actual prints after they arrived in the author's mailbox.

Courtesy of Shutterfly
www.shutterfly.com

Whether you make your own prints or have a print service do it for you, you may eventually want to push the limits of digital printing. Read on to find out how.

12

Special Printing Techniques

While the majority of people are content—and adequately challenged—to output a normal digital print, there are others who want to step outside the box, to go beyond the basics, and to stretch their abilities. Here are some ideas for doing just that.

RIPs and Special Printing Software

While virtually all digital printers come ready to print with the required software, there are options that can take you to a different level of printing.

RIPs

Very basically, a Raster Image Processor (RIP) is a group of software tools that allows you to have more control over your printer. RIPs become, in essence, the brain of a digital printer, taking over that role from the normal printer driver. Here are just a few advantages of RIPs:

- **Screening.** Each RIP has its own way to create an image's screening pattern (there are hundreds of screening patterns registered with the U.S. Patent Office). These screening or dithering formulas replace those of the normal printer driver's, and most RIPs offer a selection from which to choose.

- **Ink Control.** With most inkjet printers, the main control you have over such things as ink-limiting is with the crude Media Type or paper stock selection (some of the newer printers also have a Color Density or Ink Density slider to

help accomplish this). You have only a few choices, and they affect all ink colors across the board. However, with a full-featured RIP, you can specify ink percentages for each ink channel supported by the printer. With this kind of precision, you can avoid oversaturating paper stocks with inks and optimizing ink laydown. This also includes ink mixing, which defines the points at which, for example, the light magenta and light cyan inks come into the image.

ColorByte's ImagePrint RIP helps photographer David Saffir control his ink densities per channel for his Epson 7600 printer.

Courtesy of David Saffir
www.davidsaffir.com

- **Grayscale.** Some specialized RIPs give you a lot of control in making very neutral grayscale or black-and-white prints. See "The Secret World of Digital Black and White" later in this chapter for more about this.

- **Production Tools.** There are many production aids RIPs provide that most normal printer drivers do not. These include such things as *nesting* (arranging multiple images to reduce paper waste), *tiling* (breaking apart very large images into smaller pieces), rotating, cropping, adding trim marks, queuing/spooling, and more. You will have to decide how important these features are to your digital workflow, since some of these production-oriented tools are wasted on individuals doing single prints.

Are there *disadvantages* to RIPs? Yes, and the primary one is cost. RIPs are priced by the size, type, and number of printers supported, and you can figure on spending several hundred to a few thousand dollars on one. RIPs are also complicated

to learn, may require training, and require a longer, more complex process to set up for a new paper, ink, or printer than a standard driver. You will have to decide if the added benefits and features of a RIP are worth the price.

Finding a RIP

Most wide-format inkjet printers either come with RIPs as options, or you can purchase a third-party RIP separately. For desktop inkjet, only Epson and HP currently make optional software RIPs for certain models (Epson 4000 and HP Designjet 130, for example), but again, you can find third-party solutions for this category. (RIP makers will tell you which printers are supported, and many desktop versions have a scaled-down feature list to lower the price.) Epson claims that more than 50 third-party RIPs are compatible with their various printers.

RIPs come in different types ranging from software-only to integrated stand-alone devices. Providers of popular third-party software RIPS include American Imaging Corp. (Evolution), ColorByte (ImagePrint), ColorBurst Systems (ColorBurst), EFI (Best, Fiery), ErgoSoft (StudioPrint), Onyx (PosterShop), PosterJet, and Wasatch (SoftRIP).

Special Color Printing Software

There is another option that falls somewhere between the default printer drivers and RIPs, and that is specialized color printing software. Following are a couple of examples.

Qimage

Qimage (from Digital Domain) is a popular viewing and printing software package. It's sold direct and only for Windows 95/98/NT/2000/ME/XP operating systems, Linux systems running Wine, and Macs running Virtual PC. It's also reasonably priced at $45 (from www.ddisoftware.com/qimage), and it has avid supporters.

Qimage calls itself a "printing application" for improving print quality using internal print-optimization algorithms. It functions as a combination RIP and an image editor, and where it really shines is with "auto-sizing" or interpolation in order to make large prints. (See more about this feature in "Printing Big!")

Artist Linda Jacobs prints custom, holiday wall calendars using Qimage and an Epson 1160 inkjet printer. "I have a low-end digital camera that I use for close-ups," she says. "Without Qimage I could never get by with such low resolution."

Courtesy of Linda Jacobs

Gimp-Print

Continuously upgraded by a group of like-minded volunteers and software tinkerers, Gimp-Print is a package of high-quality printer drivers for Linux, BSD, Solaris, IRIX, and other UNIX-like operating systems (and now Mac OS X, which ships with Gimp-Print). Gimp-Print printer drivers can be used with all common UNIX print spooling systems, by means of either CUPS (Common UNIX Printing System) or Ghostscript (an open-source PostScript interpreter). Gimp-Print is supplied in source-code form under the GPL (GNU General Public License).

The Gimp-Print website (www.gimp-print.sourceforge.net) has a long list of the printers (500+) that are supported with separate drivers, and they can be especially useful with old printers that technology (and driver support) have passed by. As UK photographer Keith Cooper puts it, "I use Gimp-Print for handling several old or PC-only printers that sit on my network. It's nice to not have to consign printers to the scrap heap just because the manufacturers have moved on."

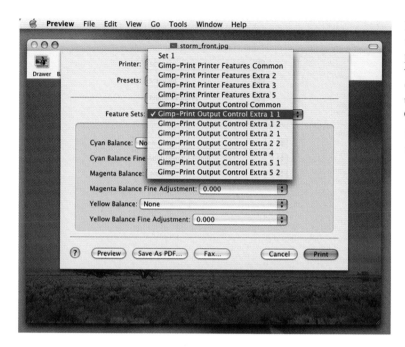

Photographer Keith Cooper uses Gimp-Print to keep older printers running. Here, he's working with Gimp-Print 5.0 (beta2) for Mac OS X 10.3.5 to print to an Epson Stylus Color 3000.

Courtesy of Keith Cooper
www.northlight-images.co.uk

Printing Big!

There are many ways to break out of the confines of a small page and print big. Let's look at two: panoramas and image interpolation.

Panoramas

Some of the most dramatic examples of digital printing are panoramas. There are many ways to accomplish this, usually either by manually blending digitally captured or scanned images (see Figure 12.1) or by using an automatic "stitcher" software program. Photoshop Elements and Photoshop CS both have a Photomerge function, and there are also many third-party software programs that seamlessly combine many separate images into one. Some of the variables that must be understood and conquered include distortion, image equalization, rotation and horizon line-up, and many other factors. However, there is nothing like a long, seamless, horizontal (or vertical) panorama to show off the advantages of digital printing!

Figure 12.1 Photographer Ralph Cooksey-Talbott creates panoramic prints by manually combining a number of Nikon D-100 frames. Counter-clockwise from top: the final 120-MB *Dry Creek Hills* image composed of six separate frames, a 72-inch version of the print coming out of an Epson 9600 printer, mounting the print with a back brace, and the finished print on the wall of the photographer's studio.

Courtesy of Cooksey-Talbott Gallery/www.cookseytalbottgallery.com

Cheating Pixels

When you're stuck with a given resolution of an image, but you want to blow it up and print it big, Photoshop's Bicubic Resampling function does a fair job—up to a point. It creates interpolated pixels in an attempt to trick your eyes into seeing more detail than is actually there. However, the image soon begins to break down as you increase the enlargement. There are several software products that try to improve on the basic Photoshop interpolation method; each has its own group of believers. Here are two:

Genuine Fractals: LizardTech's Genuine Fractals (GF) is a Photoshop plug-in that enlarges images using proprietary fractal technology. You first encode the image in GF's .STN format and save it with a choice of Lossless compression (2:1 savings) or Visually Lossless (5:1 savings). You then enlarge it: 150 percent, 250 percent, or more. The PrintPro version supports all Photoshop color modes including RGB, CMYK, and CIE-Lab, and it encodes and renders 8- and 16-bit images. How well GF works depends on the to-from file size and the type and quality of the image involved. For Windows and Mac.

Qimage: Qimage, the stand-alone image editing and printing software, has nine different interpolation algorithms (including Lanczos, Vector, and Pyramid) to "res up" images. Many users feel that Qimage's interpolation methods are better than those used in most image editors for making large prints from small files.

Qimage developer Mike Chaney explains that, "It's important to note that all interpolation methods have their pros and cons. Some are better for some types of images, while others excel with different ones; for example, images with a lot of diagonal lines versus fine mesh patterns, like screen doors versus 'random' details, like sand on a beach. There is only so much that can be predicted through interpolation, and interpolation definitely has its limits, with each algorithm offering a different bias on the tradeoffs. When going beyond about 4x enlargements (which is a hefty stretch), you can smooth out the jaggies, but you'll never get even close to the amount of detail that you would have had if you were able to capture or create at that 4x size without interpolating!" (See Figure 12.2 to see how these main interpolation methods stack up in one sample image.)

Figure 12.2 Comparing interpolation methods: A–original with 1/4x downsample (inset) used as input to the other 400 percent upsamples, B–pixel resize (simple 400-percent zoom), C–Photoshop Bicubic Smoother, D–Lanczos, E–Vector, F–Pyramid.

Courtesy of Mike Chaney, author of Qimage www.ddisoftware.com/qimage

The Secret World of Digital Black and White

There is an entire subculture of photographers doing super high-quality digital black-and-white imaging and printing. Following are some key techniques (mostly inkjet) from this hidden world.

Getting Results with Digital Black and White

Acknowledging that this book can only be a snapshot in time as technology evolves, here are some equipment, supplies, and workflow choices to get you on the road to great digital black and white.

Image Capture

While you could also use a high-end digital camera or "digital scanning back," many experienced digital black-and-white imagemakers shoot film and then scan it. "Start with a well-cared-for black-and-white negative that is carefully scanned," says Los Angeles photographer and printmaker Antonis Ricos.

Steven Katzman turned heads at a trade show in New York City when he exhibited his large-format digital black-and-white prints including *Young Joe Louis* (shown), which is in the Eastman Kodak corporate collection. "People said that they had never seen digital prints with such a neutral color and smooth transition of tonal values," says Katzman, who uses the ImagePrint RIP from ColorByte with Epson wide-format printers.

Courtesy of Steven Katzman Photography
www.stevenkatzmanphoto-graphy.com

Converting Color and Printing Monochrome

If you're starting from a color capture or scan, there are numerous ways (using software) of converting color images to monochrome for digital black-and-white printing. Adobe Photoshop leads the pack in this ability, but there are other image editors and some excellent Photoshop plug-ins that also convert color to black and white. The following examples are based on using Photoshop.

RGB > Grayscale

It's easy to convert a color image to a monochromatic grayscale in Photoshop (Image > Mode > Grayscale), but how you print this neutral image makes all the difference.

Print Grayscale with Black Ink Only: Most inkjet printer drivers give you a choice of "color" or "black" ink when printing (see Figure 12.3). Selecting the black-ink-only option might seem like a good way to print a monochrome image, but there are drawbacks. With the exception of newer printers using the smallest dot sizes, the prints sometimes lack detail and may have a course dot pattern, since you're only working with one ink. Yet some think black-ink-only prints on certain printers and on certain papers are beautiful. A lot depends on the image characteristics. Test it for yourself.

Figure 12.3 Most inkjet printer drivers give you the option of using black ink only.

One advantage with black-ink-only printing is that the prints are going to be fairly neutral, with only the color of the paper and the inherent tone of the black ink (usually warm, or possibly changing to warm) being the variables.

Print Grayscale with Color Inks: If you print a grayscale image selecting the color-inks option in the normal printer driver, you can usually see the difference in quality (see Figure 12.4). The image is smoother and fuller due to the added ink colors. (Even though the image is in Grayscale mode, most printers still recruit the color inks.) The major drawback to this method is that you will probably get

an overall color cast (the color will vary depending on the paper and the inks), and the ways to fix that problem are limited.

Figure 12.4 The coarseness of a grayscale image printed with a single black ink only (top) can be pronounced compared to the same image printed with color inks (bottom), depending on the type of printer.

RGB > Grayscale > Duotone

You can change the color balance of a grayscale image by converting it to Duotone mode in Photoshop (Image > Mode > Duotone) and selecting any custom color to go along with the base black (see Figure 12.5). If you then print the image with the color-inks option selected, all the ink colors are used as above. The same lack of color image editing adjustments exist, but now you have access to the color slider adjustments in the printer driver for tweaking the overall color balance.

Using the same technique, a Photoshop Tritone or Quadtone adds even more color options to the mix.

RGB > Grayscale > RGB

This is similar to the first method, but by converting the image back into RGB mode, you have access to all the other colors to increase the tonal range. The result is much more color flexibility. If you don't like the overall color balance, it's easy to make it either more or less neutral. For a sepia effect, for example, add a Color Balance adjustment layer and move the sliders to something like -15 Magenta and -15 Yellow (see Figure 12.6). The same effect can be achieved by using the color control sliders in the Advanced section on most inkjet printers. This is similar to

Figure 12.5 Switching from RGB to Duotone mode in Photoshop opens up interesting color possibilities for grayscale images.

darkroom photographers selecting warm or cool papers or toning chemicals to shift the overall colors of a black-and-white print. (You can also use canned printer presets like "sepia," but these have limited use, since you typically have no ability to adjust the settings.)

Figure 12.6 Converting a grayscale image to RGB allows for a full range of color adjustments, such as this sepia effect with the Color Balance tool.

RGB > Channel Mixer

This is a good way to change the relationship of or to emphasize certain colors in monochrome. To do it, make a Channel Mixer adjustment layer, and in the dialog box, check Monochrome. The image instantly changes (if Preview is checked), and now the fun can start. Use the Source Channels sliders to adjust the individual Red, Green, and Blue channels while watching the image change. Make sure that the three Channels add up to 100 percent if you want to hold the overall lightness-to-darkness range of the image.

For my palm tree, I wanted a dark, brooding sky. To accomplish that, I adjusted my Red, Green, and Blue Source Channels in the Channel Mixer to be +55, +55, -10 (see Figure 12.7).

Figure 12.7 Photoshop's Channel Mixer with the Monochrome option checked helps change the relationship of the color values.

Using Specialized Monochrome Inksets

An improvement in the digital printing of black-and-white images is the development of third-party, multi-toned, monochromatic inks that replace the color inks in inkjet printers. This is also called "quadtone" or "hextone" printing; the printer thinks it's printing in color, but the inks that come out are all shades of black or differing densities of gray. Popular inksets include Lysonic Quad Black and Small Gamut (Lyson), PiezoTone (Inkjet Mall), Preservation Monochrome (Lumijet), the Quadtone B&W and UltraTone families that include both Monotone and Variable Tone inksets (MIS), and Septone (Sundance).

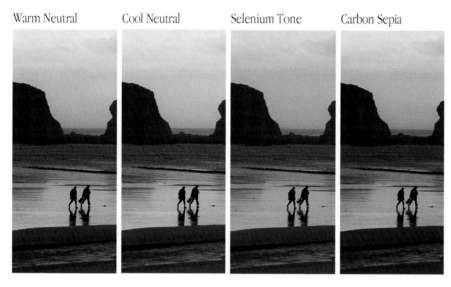

Warm Neutral Cool Neutral Selenium Tone Carbon Sepia

Inkjet Mall's monochrome PiezoTone inks are 100-percent pigmented and come in different Hue Sets.

©Copyright 2002 Jon Cone

One thing that some monochrome printmakers who use these special inks often do is dedicate a separate printer for the job. That way, they don't have to continually switch back and forth between color and monochrome inks, which is a lot of trouble and wastes ink.

Using Specialized Drivers and Software

Some of the highest-quality black-and-white digital prints being made today are the result of specialized printer drivers or RIPs. Popular examples include ImagePrint (ColorByte), InkJet Control/OpenPrintmaker (BowHaus), PixelPixasso (R9), QuadToneRIP (Roy Harrington), and StudioPrint (ErgoSoft).

Using Specialized Printers

Inkjet is not the only way to print digital black and white, but for many, it's currently the method of choice. While at the time of this writing there are no true, all black-and-white OEM inkjet printers, Epson raised some eyebrows with the introduction of its UltraChrome inkjet printer line a couple of years ago. As already mentioned, the Epson Stylus Photo 2200 and Stylus Pro 7600/9600 broke ground by including the first use of seven ink colors (in separate tanks) with two different blacks—one full-strength, one diluted.

HP then raised the bar even further when it introduced several color/black-and-white Photosmart photo printers, led by the 7960 and the newer 8450. These are desktop inkjet printers with eight ink colors including a separate cartridge that includes three different black densities, which are only available when printing in grayscale mode (see Figure 12.8). These printers are capable of producing excellent black-and-white prints right out of the box; the primary drawback (besides a high per-print cost) is the limited output size (U.S. Letter/Legal).

Brooklyn, New York, fine-art photographer Amadou Diallo uses ErgoSoft's StudioPrint RIP to produce his digital black-and-white prints on an Epson Stylus Pro 9000 using PiezoTone inks. *Sunflower* is shown. "With StudioPrint," says Diallo, "quadtone printmakers now have unprecedented control over their printer's behavior combined with the production gains offered by professional layout features. The output is among some of the finest printing I've ever done, darkroom or digital."

© 2001 Amadou Diallo
www.diallophotography.com

Figure 12.8 The HP Photosmart 7960 Photo Printer has a special 3-black cartridge that kicks in when the printer outputs in grayscale mode. The newer Photosmart 8450 is similar.

Integrated Monochromatic Systems

Digital printmakers are used to piecing together black-and-white solutions from different sources, but there is a trend toward integrated inkjet systems all under one roof. One example is Jon Cone's PiezographyBW ICC system that combines monochromatic inks (PiezoTones) and Piezography ICC profiles on CD-ROM.

(Cone also provides a personalized profiling system through his iQuads program.) It's currently for select Epson, and soon Canon, printers from Inkjet Mall.

Lyson's Daylight Darkroom digital black-and-white printing system consists of (1) Quad Black inks in carts or in bulk feed, (2) printer driver software licensed from BowHaus, (3) Lyson Darkroom range of inkjet media, (4) a set of cleaning cartridges for removal of the standard color inks from the printer, and (5) optional Lyson PrintGuard protection spray. The initial list of supported printers includes Epson 2200, 7600, and 9600, with plans to expand to the Epson 4000 and newer Canons.

Another system is the combination of Sundance Septone inks and R9 PixelPixasso RIP software. It provides wide variation in tonal representation using simple software adjustments. Adjustment of the degree of "warmth" and "coolness" over three density channels is available within the ICQ settings of PixelPixasso. The PixelPixasso RIP, which supports the Epson 2200 and Epson 7600/9600 as Septone printers, is Windows-only. PixelPixasso also supports these printers as ICC CMYK printers and as "pure" seven-channel printers (you can send them 7-channel RAW files). A Septone Photoshop export plug-in is available for both Windows and Macintosh. Available from BWGuys.

The R9/Sundance black-and-white system includes the following: (top) the PixelPixasso RIP for Windows with adjustments for selecting warm to cool results; (left) roses show variations of Warm, Mixed Warm, and Cool from top to bottom; (right) the Septone Photoshop plug-in for Mac OS X. (The Mac Classic and Win versions have the same functionality but conform to the standards of their respective OSs.)

Courtesy of R9 Corporation
Rose photo © 2001 Ken Niles

Beyond the Digital Print

Cards, books, emulsion transfers, lenticular prints, and other alternative processes—these are just a few of the ways imagemakers are experimenting with the definitions of digital printing.

Cards and Books

Printing on paper can also take other forms besides single digital prints. Following are some examples to give you a feel for the diversity of paper-print options.

Cards

Greeting, gift, note, and promotional cards are easy to make by self-printers using inkjet or laser printers. There are two basic card-making methods: (1) make a small print and adhere it to the outside panel of a single or a folded card, or (2) print directly onto single or foldable card blanks. (You can also print on a larger sheet and simply fold it down to size by hand.)

Photographer and print-service provider James Respess sends "adhered-print" cards to his clients and contacts. Digital artist Teri Brudnak uses the same idea, except she hand-folds heavy 7×10-inch fine-art paper, and then adheres her inkjet print to the outside page.

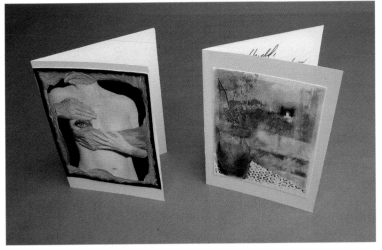

Left: A commercial, folded, blank note card with a small canvas inkjet print (Embrace Me) attached by James Respess. Right: A hand-folded card with a Teri Brudnak Red Orchids print attached. Both fit into standard note card envelopes.

For the second "print-directly-on" category, there are many good sources for these cards. ArtZ has three lines of inkjet-printable cards, and it has teamed up with Moab Paper in creating the CardMaker line of fine-art inkjet cards. These are made from 100-percent cotton Entrada Fine Art paper and are printable on both sides (interior and exterior). Cards come in three sizes, and accompanying envelopes are made of pH-neutral and chlorine-free translucent vellum. Downloadable templates and printing profiles are also available.

Other good sources for precut, prescored (for easy folding), printable cards include Crane (they also have a panoramic card), Strathmore, Red River, Photographer's Edge, Digital Art Supplies, Inkjet Goodies, and InkjetArt. Most of these cards come with envelopes.

Custom Digital Books

Making your own custom books of digital images for limited editions, scrapbooks, or family histories is a great idea.

Producing books has traditionally been a complicated and expensive proposition best left to publishers and beyond the reach of most imagemakers. While the print-on-demand technologies now found at any Kinko's and print shops have changed that scenario somewhat, high-quality color bookmaking has remained an elusive goal for most. Until now. It is possible for just about anyone to make custom books of their digital images with inkjet or other technologies we've been discussing. Here's how:

Fold-a-Book: The simplest way to make a book from your own images is to print and then fold a single sheet of paper in half. Each sheet now becomes four book pages. (Each side of the paper is one page.) Stack all the folded sheets on top of each other, add a cover sheet, staple, sew, or otherwise hook all the pages together, and presto—you have a book (see Figure 12.9). The trick in doing all this is planning the pages. For that, make a simple mockup using office paper. Just fold pages and start writing or sketching what goes on each page.

Figure 12.9 A simple fold-a-book, stapled at the spine.

To produce this kind of book, you'll need to be able to print on both sides of the page, which, naturally, requires double-sided or dual-coated paper. Be sure to let the ink dry completely between printings.

Bound Books: The trickiest part of bookmaking is the binding step. How are you going to collect and connect all the separate pages into a book that doesn't fall apart the moment you pick it up? The old way was to take your loose pages to an instant print shop or copy center. Staples, Office Depot, or Kinko's all offer the inexpensive and standard office binding methods such as comb, coil, post, Velo, tape, or other types that are typically used by businesses and students for reports.

A contemporary option is to print and bind the book pages yourself. There are now several book-binding systems targeted to digital imagemakers who want to make their own hardbound coffee-table books. ArtZ's BookMaker produces leather-covered digital books with two-sided pages that photographer-artists can print and assemble themselves. The paper is Moab's Entrada Fine Art with acid-free translucent fly sheets to protect the first and last pages (or all pages). There are two sizes, 7×7 and 10×10, and the books can hold 10–20 pages.

ArtZ's BookMaker system lets digital imagemakers print and bind their own hardbound coffee-table books. *Courtesy of ArtZ/www.artzproducts.com*

Moab Paper Company itself makes the Chinle Digital Book, which features a leather cover, easy to assemble post-bound construction, and dual-sided 100 percent cotton pages ready for printing. The user can update the pages by simply removing posts and adding new artwork.

Bind-It Photo Corp. has a compact tabletop system for binding self-printed, hardbound books. After the images are inkjet-printed onto ready-to-bind, prehinged Stone Edition art papers, the pages are placed into the binding unit, which uses an acid-free thermal adhesive in the spine of the cover.

Book Services: As with cards, some digital print providers also offer to make custom artist books. Commercial and online suppliers of digital books printed mostly by digital offset technology include MyPublisher.com, Snapfish.com, and Apple's

iPhoto software and service, which produces (via Indigo printing) linen-covered books in North America and Europe.

Digital Mixed Media

For some, a digital print that comes out of a printer is not the end point of a process but only the beginning. Three pioneering artists who have been pushing the digital edge the longest and the farthest were founding members of Unique Editions, which ultimately became known as the Digital Atelier: Dorothy Simpson Krause, Bonny Lhotka, and Karin Schminke (see Figure 12.10). In keeping with their tagline, "a printmaking studio for the 21st Century," even the organization of the group is modern: Each member lives in a different part of the U.S. (Boston, Denver, and Seattle, respectively), and they come together in person only for educational forums, workshops, seminars, and artists-in-residence classes.

As three of the primary investigators and pioneers of digital mixed-media printmaking, they finally published their own book about it—*Digital Art Studio: Techniques for Combining Inkjet Printing with Traditional Art Materials* (Watson-Guptill, 2004).

Krause, Lhotka, and Schminke are well-known for combining traditional and digital printmaking to produce their own original digital prints. Although they each use the computer as a tool, their work and media choices are as varied as their backgrounds. It includes one-of-a-kind paintings, collages, image transfers, monotypes, and prints on all kinds of surfaces as diverse as plywood, silk, rusty metal, and handmade substrates. "When people see our work, they don't think digital," Schminke says.

Figure 12.10 Digital Atelier, from left: Dorothy Simpson Krause, Bonny Lhotka, and Karin Schminke.

Using a digital print as a base or ground, they usually end up with something totally unique. Digigraphs, digital collages, and digital mixed media are some of the terms they've used over the years.

The wide range of their work includes these processes:

- Creating customized surfaces (see "inkAID Precoats.")
- Underprinting digital images as a base for and overprinting images onto other media.
- Wet, dry emulsion, and gelatin transfers (see next image).
- Layering prints with collage and paint.
- Printing on fabric (see "Fabric Printing.")
- Exploring three-dimensional art, including lenticular technology.

Happy Home, final inkAID "decal" transfer with encaustic, 48 × 48 inches.

© *2001-2004 Dorothy Simpson Krause*

Other Alternative Processes

This is only a quick overview of a few contemporary hybrids where digital printing is playing a strong role.

Dye Sublimation Transfers

The transfer dye-sub process involves printing an image onto a medium and then transferring that under heat and pressure to the final surface. The simplest way to produce dye-sub transfers is to buy special transfer paper and print on it with an inkjet printer using dye-based inks. Then all you need is a hot iron to transfer the image. Epson even sells packages of Iron-On Transfer Paper in 8.5 × 11" sizes for image-transferring to T-shirts, canvas tote bags, placemats, and other craft and decorative fabric accessories.

A ceramic tile mural created by sublimation transfer using Tropical Graphics' Mural 7 imaging software.

Courtesy of Tropical Graphics

Sawgrass Systems, Tropical Graphics, and TSS-Sublimation are three companies that provide complete dye-sub systems for inkjet printing. They sell their own sublimation inks plus special software and printer drivers for various desktop and wide-format printers.

inkAID Precoats

Digital Atelier have been "application development specialists" for the inkAID line of *precoats* that give artists using inkjet printers a wider range of substrate options. inkAID can be applied by brush, roller, or spray to a wide range of materials, including papers of all kinds, aluminum, acrylic sheets, wood, and more.

In addition to precoating custom materials, inkAID allows adding an inkjet printed image to the composition when working with paintings, collages, or other mixed media. The coatings are compatible with dye and pigment inks.

Bonny Lhotka says, "inkAID fills in the missing link that artists have needed to create multilayered mixed-media art."

inkAID is available in liter and gallon containers from the Ontario Specialty Coating company.

inkAID precoats can be used on almost anything that can be fed into an inkjet printer.

Courtesy of Ontario Specialty Coating www.inkaid.com

Fabric Printing

Inkjet printers can be used to print on fabric with either textile dyes or pigmented inks. The former are specialty inks (acid or reactive dyes), and they can be made washable with post processes, such as steaming. Pigmented inks on fabric are stiffer and not really washable. Precoated inkjet textiles are available from a number of sources, including DigiFab and Jacquard. Futures Wales, Ltd., is another source, and they claim that their Futures Fabrics can be printed with ordinary dye and pigment inkjet inks with good durability.

Two examples of inkjet printed fabrics by Bonny Lhotka. Left: Bag printed with pigment inks on cotton. Right: Dress and jacket made with acid dyes on crepe de chine.

Courtesy of Bonny Lhotka
www.Lhotka.com

Printing on Metal, Wood Veneers, and More

You can print directly onto thin substrates that can fit through your printer if you coat the material first. Bonny Lhotka has printed on thin metals and even tiles by using an inkAID precoat. This is where printers with wide media clearances are a requirement.

Dennis Brooker of Imaging Alternatives has created an inkjet-printable, real wood veneer. Called SMartGRAIN, it can be used with normal inkjet printers and requires no special inks (see Figure 12.11). In addition to reproducing exotic wood grain patterns, regular images can also be printed. Applications include furniture, cabinets, clocks, marquetry, flooring, wall paneling, signs, displays, and more. You are only limited by the size of the printer.

Figure 12.11 SMartGRAIN is an inkjet-printable real wood veneer.

Courtesy of Dennis Brooker
www.imagingalternatives.com

A related application is with the use of decal paper transfers provided by UK company Lazertran Inkjet. They have one version of a water-slide decal that must be used with color laser printers. They also offer another version of the decal paper that is only for ink printers, including inkjets. These decals can then be transferred to ceramics, wood, paper, cork, plaster, glass, metal, stone . . . you name it.

You have now reached the end of this book's regular chapters. But, you're not done yet. Turn the page so you can explore the resources in the Appendix.

Appendix

Glossary

A glossary can be a useful tool for readers puzzled about strange words like *giclée*. For that reason, a glossary of important words and phrases for the digital imaging field is included on the DP&I website (www.dpandi.com). This lexicon has been prepared with the assistance of the Digital Art Practices and Terminology Task Force (DAPTTF), whose goal is to help counter the general misunderstanding about the terminology and production practices of digital imagemakers and to develop a document of reference terms that will provide a common ground of accurate communication.

Courtesy of Dorothy Simpson Krause/www.dotkrause.com

Resources

Consider this book the base camp for your digital explorations. If you want to go further afield in search of more in-depth information, additional resources are located on the DP&I website (under "Resources"), where they are continually updated. Resource categories include: photographers-artists; print-service providers; vendors of equipment, supplies, software, and related services; online discussion groups; festivals and contests; online galleries and showcases; digital-friendly organizations; workshops, classes, and schools; tradeshows and conventions; and publications and other reading sources.

© 2003-2005 Harald Johnson

Gallery Showcase

A showcase featuring the best examples and the variety of digital imaging and printing being produced with the latest technology and techniques can be found on the author's DP&I website: www.dpandi.com. (DP&I stands for Digital Printing and Imaging, and this website is an internationally recognized resource for photographers, digital/traditional artists, and printmakers.)

Go online and enjoy the show!

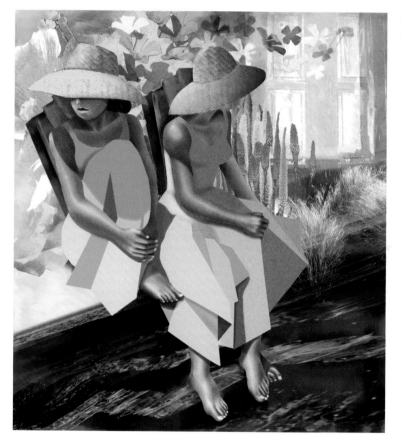

Courtesy of Ileana Frómeta Grillo/www.ileanaspage.com

Index